JONAS LARSEN is Associate Professor and Research Leader, ENSPAC, Roskilde University, Denmark. He is co-author of *Performing Tourist Places*; *Mobilities, Networks, Geographies*; *Tourism, Performance and the Everyday: Consuming the Orient*; and of *The Tourist Gaze 3.0*.

METTE SANDBYE is Head of the Department of Arts and Cultural Studies, University of Copenhagen. She is editor of the first Danish history of photography (*Dansk Fotografihistorie*) and co-editor of *Symbolic Imprints: Photography and Visual Culture*.

'Arguing that the digital snapshot represents a transformation, rather than the destruction, of the personal photograph, *Digital Snaps* provides convincing evidence that it is indeed in the practice of personal photography where all the various effects of digital technology have been most strongly felt. Comprehensive and provocative, the essays collected in this volume measure the shift in the photograph's status from a static documentary record of a past moment to a ubiquitous mode of immediate communication that allows us to perform versions of ourselves for a vast new public. If you want to understand photography today, you must read this book.'

Geoffrey Batchen, Professor of Art History,
Victoria University of Wellington, New Zealand

digital snaps

THE NEW FACE OF PHOTOGRAPHY

EDITED BY
JONAS LARSEN AND
METTE SANDBYE

I.B. TAURIS

LONDON · NEW YORK

770

DIG

Published in 2014 by I.B.Tauris & Co Ltd
6 Salem Road, London W2 4BU
175 Fifth Avenue, New York NY 10010
www.ibtauris.com

Distributed in the United States and Canada
Exclusively by Palgrave Macmillan
175 Fifth Avenue, New York NY 10010

International Library of Visual Culture: 7

ISBN: 978 1 78076 331 6 (HB)
978 1 78076 332 3 (PB)

A full CIP record for this book is available from the British Library
A full CIP record is available from the Library of Congress

Library of Congress Catalog Card Number: available

Text designed and typeset by Tetragon
Printed and bound in Great Britain by
T.J. International, Padstow, Cornwall

MIX
Paper from
responsible sources
FSC
www.fsc.org FSC® C013056

CONTENTS

LIST OF ILLUSTRATIONS

All images reproduced with permission of the copyright holder.

CONTRIBUTORS

Joanne Garde-Hansen, PhD, Associate Professor of Culture, Media and Communication in the Centre for Cultural Policy Studies at the University of Warwick. She has co-edited, with Andrew Hoskins and Anna Reading, *Save As… Digital Memories* (Palgrave Macmillan, 2009), sole-authored *Media and Memory* (Edinburgh University Press, 2011), co-edited with Owain Jones *Geography and Memory* (Palgrave Memory Studies Series, 2012) and co-authored with Kristyn Gorton *Emotion Online: Theorizing Affect on the Internet* (Palgrave Macmillan, 2013). As well as having published journal articles on memory, media, archiving, nostalgia and ageing, Garde-Hansen leads the academic research on a number of community media projects in the UK that focus upon the use of digital storytelling, photographs, television and film for understanding personal memory and local heritage.

Anne Jerslev, PhD, Professor in Film and Media Studies at the Department of Media, Cognition and Communication, University of Copenhagen. She currently researches contemporary processes of celebrification. Jerslev has published numerous articles and books about contemporary film and television culture, media reception and reality television. She has edited *Realism and Reality in Film and Media* (Museum Tusculanum Press, 2002). Together with Professor Lúcia Nagib from the University of Reading she co-edited the volume *Impure Cinema: Intermedial and Intercultural Approaches to Film*, published in 2014 by I.B. Tauris. Recent publications include 'Challenging

genre – genre challenges: new media, new boundaries, new formations'
(*MedieKultur*, 51, 2011; co-edited with Mette Mortensen and Line Nybro
Petersen) and 'The post-perspectival: screens and time in David Lynch's
Inland Empire' (*Journal of Aesthetics & Culture*, 4, 2012).

Jonas Larsen, Associate Professor in Geography at Roskilde University,
Denmark. Larsen's research focuses on mobility, tourism and media. He has
been conducting ethnographic studies and has published on mobile meth-
ods and ethnographic studies of mobility. His recent publications include
Tourism, Performance and the Everyday: Consuming the Orient (Routledge,
2010; with Michael Haldrup) and *The Tourist Gaze 3.0* (Sage, 2011; with John
Urry). He is also the author of 'Performativity, space, and tourism' as part
of *The Routledge Handbook of Tourism* (Routledge, 2011) and 'Tourism and
distance and proximity' as part of the forthcoming *The Routledge Handbook
of Mobilities* (Routledge, 2013).

Sigrid Lien, PhD, Professor at the Department of Literary, Linguistic
and Aesthetic Studies, University of Bergen. She has written the first
comprehensive Norwegian history of photography, *Norsk fotohistorie: frå
daguerreotype til digitalisering* (Det Norske Samlaget, 2007; with Peter
Larsen) and *Lengselens bilder* (SAP, 2009). Lien is currently involved in the
HERA-funded research project PhotoCLEC, which explores how photo-
graphs have been used in museums to communicate the colonial past in a
contemporary multicultural Europe. Recent publications include 'Absence
and presence: the work of photographs in the Sámi Museum in Karasjok,
Norway' in a special issue of *Photography & Culture*, and the upcoming
Museumsfortellinger (Det Norske Samlaget, 2014).

Martin Lister, Professor Emeritus in Visual Culture at the University of
the West of England, Bristol, UK. His recent publications include a second
edition of *New Media: A Critical Introduction* (Routledge, 2008), 'The times
of photography' in *Time, Media and Modernity* (Palgrave, 2012) and a new

edition of *The Photographic Image in Digital Culture* (Routledge, 2013). He is an editor of the journal *Photographies*.

Mette Mortensen, PhD, Associate Professor in the Department of Media, Cognition and Communication at the University of Copenhagen. She has written the monograph *Kampen om ansigtet: fotografi og identifikation* (Museum Tusculanums, 2012) and has co-edited several books and special issues of journals. She has published articles in journals such as *The International Journal of Cultural Studies, Global Media and Communication*, and *Digital Journalism*. She is currently writing the book *Eyewitness Images and Journalism: Digital Media, Participation, and Conflict* to be published by Routledge in 2014.

Gillian Rose, PhD, Professor of Cultural Geography at the Open University, UK. Her current research interests focus on contemporary visual culture, ways of seeing in domestic and public spaces, and visual research methodologies. One long-term project has examined family photos as visual objects that circulate between a range of different practices in the global visual economy, and her monograph *Doing Family Photography: The Domestic, the Public and the Politics of Sentiment* was published by Ashgate in 2010. Another, even longer project has been the book *Visual Methodologies*; a third edition was published early in 2012. She is currently examining how architects work with digital visualizing technologies.

Mette Sandbye, PhD, Associate Professor and Head of Department at the Department of Arts and Cultural Studies, University of Copenhagen. She currently researches the relationship between amateur photography and collective history since the 1960s. She was the editor of the first Danish history of photography *Dansk Fotografihistorie* (Gyldendal, 2004) and has published numerous books and articles on contemporary art photography and photography as part of visual culture. Recent publications include: 'The family photo album as transformed social space in the age of "Web 2.0"'

in *Throughout: Art and Culture Emerging with Ubiquitous Computing* (MIT Press, 2013), 'It has not been—it *is*. The signaletic transformation of photography' (*Journal of Aesthetics & Culture*, 4, 2012), 'Making pictures talk: the re-opening of a "dead city" through vernacular photography...' in *Re-Investing Authenticity: Tourism, Place and Emotions* (Channel View Publications, 2010).

Michael Shanks, Omar and Althea Dwyer Hoskins Professor of Classical Archaeology, a faculty member of the Hasso Plattner Institute of Design and Director of the Revs Program at Stanford University. He is a key figure in contemporary archaeological theory and a prolific author of books, articles and Web 2.0 materials. He has pioneered the use of new media and information technologies to facilitate collaborative interdisciplinary research in culture, design, heritage, memory practices and long-term historical trends. His most recent book is *The Archaeological Imagination* (Left Coast Press, 2012).

Tanya Sheehan, PhD, Associate Professor, Art Department, Colby College. She is the author of *Doctored: The Medicine of Photography in Nineteenth-Century America* (Penn State University Press, 2011), editor of *Photography, History, Difference* (Dartmouth College Press, forthcoming) and co-editor of *Photography and Its Origins* (Routledge, forthcoming). Dr Sheehan is completing a book that examines ideas about race in photographic humour. This project has received support from the National Endowment for the Humanities, the W.E.B. Du Bois Institute for African and African American Research at Harvard University, the Harry Ransom Center at the University of Texas at Austin, and other major research libraries. In addition to serving on the editorial boards of *caa.reviews* (College Art Association), *Photography & Culture* (Bloomsbury Press), *Panorama* (Association of Historians of American Art) and the web project *Mirror of Race*, she is Guest Editor of Photography for *Grove Art Online* (Oxford University Press).

Connie Svabo, PhD, Associate Professor, Head of Studies in Performance Design, Roskilde University, and, at the time of writing, Visiting Scholar at Stanford University, where she collaborates with Michael Shanks. Recent publications include 'Archaeology and photography: a pragmatology', in *Reclaiming Archaeology: Beyond the Tropes of Modernity* (Routledge, 2013; with M. Shanks) and 'Experience: under the influence of things', in *Engaging Spaces* (Museum Tusculanum, forthcoming; with S.M. Strandvad). Currently her research focuses on artistic practice as utopian archaeology of contemporary society.

Mikko Villi, D.A., Lecturer at the Department of Social Research at the University of Helsinki, Finland, and director of the Communication Research Centre CRC. Villi's background is in Communication Studies. He has gathered knowledge and expertise especially on themes related to new communication technology and forms of communication, in particular on mobile, visual and digital media. Lately, he has turned his attention on social media, the media industry and the media ecosystem, where different media, devices and actors converge. His publications include 'Visual mobile communication, mediated presence and the politics of space' (*Visual Studies*, 26(2), 2011; with Matteo Stocchetti) and 'Visual chitchat: the use of camera phones in visual interpersonal communication' (*Interactions: Studies in Communication & Culture*, 3(1), 2013).

Louise Wolthers, PhD, Researcher in Photographic Art, History and Theory at the Hasselblad Foundation, Gothenburg. She has conducted research and curated exhibitions at institutions such as the National Museum of Photography and the National Gallery of Denmark. She has co-edited publications such as *Lost and Found: Queerying the Archive* (Nikolaj Copenhagen Contemporary Art Center/Bildmuseet Umeå University, 2009) and contributed to numerous academic journals and books on photography, visual culture and contemporary art. Recent articles include: 'Punctuating the nation's narratives: history painting and performativity' in *Performing Memory in*

Art and Popular Culture (Routledge, 2013), 'Self-surveillance and virtual safety' (*Photographies*, 6(1), 2013) and 'Mobile monitoring: self-tracking in counter-surveillance art' in *Representational Machines: Photography and the Production of Space* (Aarhus University Press, 2013).

INTRODUCTION

The New Face of Snapshot Photography

JONAS LARSEN AND METTE SANDBYE

Maybe what's happening now for photography was always its destiny and fate. But it's not the end of photography. It's rather the end of photography as we know it. To understand this change, we need a new media ecology.

Martin Lister at the 'Private Eyes' conference,
University of Copenhagen, 2009

Photography, once again, is changing dramatically. Over the last decades, analogue snapshot photography has more or less died out as digital photography has become commonplace. Analogue cameras have quickly lost value. Many experience a humiliating trip to a garbage dump or cause clutter and dust in households and at flea markets. They belong to a family of technologies (such as the cassette player and the Walkman) devalued by digitization (Gregson, Metcalfe and Crewe 2007; Cobley and Haeffner 2009). Few amateurs now take pictures with analogue cameras. In 2004 Kodak stopped selling traditional cameras in North America and Western Europe, and in January 2012 Kodak filed for bankruptcy. Digital technology has not only changed the way the images are produced, but also the way they are used, circulated and communicated. This book sets out to highlight these new social forms and uses of photography.

Photographs are now very widely produced, consumed and circulated on computers, mobile phones and via the internet, especially through social-networking sites. The digitization of images thus implies media convergence and new performances of sociality reflecting broader shifts towards real-time, collaborative, networked 'sociality at a distance'. In 2001 the first camera phone was put on the market, but they only really began to sell in high volumes in 2004, the same year that the Web platform Flickr was invented. At that time, 68 million digital cameras and 246 million camera phones (mobile phones with inbuilt digital cameras) were sold worldwide (Larsen 2008). Many mobile phones now produce high-quality photographs and mobile-phone commercials (such as those for Nokia and iPhone) increasingly highlight the functionality of their cameras. In the United Kingdom, '448,962,359 MMS picture messages were sent in 2007, the equivalent of 19 million traditional (24 exposure) rolls of camera film' (MDA 2008). So photography is indeed converging with the internet and mobile phones.

Whereas 'analogue photography' was directed at a *future* audience, pictures taken with camera phones can be seen immediately by people at a distance, using mobile phones with MMS service or uploading them to social-networking sites. Using Snapchat, the photo is meant to be seen by the recipient for only a few seconds; with this app millions of photos are being shared instantly every day. The affordances of digital photography potentially make photographic images instantaneous and mobile. And so we have a sheer explosion of photographs circulating on the internet. As Francesco Lapenta (2011: 1) reports:

> According to the 1993 Wolfman Report, 17.2 billion analogue images were taken in the United States between 1992 and 1993. Today we can easily imagine the latter to be representative of the number of digital images taken in a fortnight by all the electronic eyes distributed around the globe. About 5 million pictures are uploaded to Flickr every day, around 2.5 billion photographs to Facebook each month,

and YouTube alone serves 2 billion videos a day to millions of view-
ers around the world.

This quote not only highlights the seemingly ever increasing number of
private snaps that are taken daily, but also some of the new technologies
and applications in which personal snaps are now embedded. The spread
of all these new digital technologies, social-networking sites and photo
communities with user-generated content exploded in the era that was
recently named 'Web 2.0 – the Age of the Amateur', when the internet
became much more open, collaborative and participatory. Web 2.0 affords
an open online participatory culture in which connected individuals not only
surf but make many 'products' through editing, updating, blogging, remix-
ing, posting, responding, sharing, exhibiting, tagging, and so on (Beer and
Burrows 2007). The sincerity of user-generated material is also recognized
by many businesses such as tourist organizations. For instance, VisitBritain,
the official website for travel and tourism in the UK, asks tourists to upload
comments, photos and videos: 'This is your chance to share what you love
about Britain with the world! Browse the reviews to see what other travel-
lers remember about their holiday in England, London, Scotland or Wales
and check out photos, videos and comments' (Urry and Larsen 2011). A
site such as TripAdvisor invites tourists to share their private photos with
other tourists in order to review hotels, implying that this kind of imagery
is more 'honest' than the hotels' own photographs.

Snapshot photographs fuse our everyday lives as never before: on the
internet, in mass media, within the art world and in everyday communica-
tion culture. They have revitalized the private photo album that so often
collected dust on the living-room shelf, 'despite being the most mass pro-
duced photographic product, the snapshot has remained highly private,
concealed from public eye, and quite often an invisible image' (Rubinstein
and Sluis 2008: 12). Today, the private snapshot has indeed left its hidden
home shelter. Now, personal narratives, represented by private snaps, are
omnipresent and widely accessible by the general public.

This is also seen in the news media, where private snaps are shown as an alternative to traditional press photography. In response to the production and distribution of digital images becoming cheap and accessible enough for anybody to assume the role of a photojournalist, amateur recordings, often in the form of mobile-phone images, frequently turn into representations of 'breaking news' in the international media (Mortensen 2009). This is seen with the Abu Ghraib scandal (2004), Saddam Hussein's hanging (2006), the terrorist attacks in London (2005) and Mumbai (2008), the riots in Iran (2009) and the recent uprisings in the Middle East and North Africa, where mobile camera phones arguably have played a key role in organizing and communicating the revolts. As argued in the British newspaper the *Guardian* (Beaumont 2011):

> Think of the defining image of the uprisings in the Middle East and North Africa – the idea that unites Egypt with Tunisia, Bahrain and Libya. It has not been, in itself, the celebrations of Hosni Mubarak's fall nor the battles in Tahrir Square in Cairo. Nor even the fact of Mohammed Bouazizi's self-immolation in the central Tunisian town of Sidi Bouzid, which acted as a trigger for all the events that have unfolded.
>
> Instead, that defining image is this: a young woman or a young man with a smartphone. She's in the Medina in Tunis with a BlackBerry held aloft, taking a picture of a demonstration outside the prime minister's house. He is an angry Egyptian doctor in an aid station stooping to capture the image of a man with a head injury from missiles thrown by Mubarak's supporters. Or it is a Libyan in Benghazi running with his phone switched to a jerky video mode, surprised when the youth in front of him is shot through the head.

On the one hand, amateur recordings may grant us insight into situations the media have no access to otherwise. On the other hand, amateur footage challenges the ethical standards of journalism with its unedited format, let

alone the difficulties involved in tracking a clip's author, origin and routes through the global communication systems. The photographs of triumphant American soldiers staging and carrying out the brutal humiliation and torture of Iraqi prisoners at the Abu Ghraib prison, which circulated in the global media in 2004, highlight another ethical problem. It is telling that one of the first reactions from the US Department of State was to regret not the violence, torture and humiliation committed, but the behaviour of the soldiers, that they behaved like ordinary tourists by circulating their personal snapshots on the internet and through their camera phones (Haldrup and Larsen 2010). Their photographic practices reflect, as Sontag (2004: 26) observes:

> A recent shift in the use made of pictures – less objects to be saved than messages to be disseminated, circulated. A digital camera is a common possession among soldiers. Where once photographing war was the province of photojournalists, now the soldiers themselves are all photographers, recording their war, their fun, their observations of what they find picturesque, their atrocities – and swapping images among themselves and emailing them around the globe.

Personal mobile-phone images of fun and conquest intended for friends and family members back home took wrong turns on their journey and became public images of disgrace on a global stage. As Nancy Van House (2011: 128) says more generally: 'Whereas printed images and negatives are under the control of the owner, digital photographs have slipped the bounds of materiality and may have a life of their own outside the control of their makers.' It is this new life of digital photography that this book is about.

Within the last decade, the material base of photography has been revolutionized to the extent that we can talk about 'old photography', the analogue, and 'new photography', the digital. All this indicates that digital photography is a constantly evolving complex of networks, technologies, practices and meanings embedded in people's daily lives. This digital

evolution is twofold, based partly on new digital technologies and image-based software applications and partly on new practices, social functions and meanings (Larsen 2008; Van House 2008; Lapenta 2011).

Rethinking Photography: Convergence

We need to rethink photography, and now is the moment to do it. The newness of digital photography relates not only to the digitization of images, but to media convergence and new performances of sociality, memory, history and identity. The future of the medium is inextricably linked to mobile phones and the internet, and, to a much lesser degree, paper images, albums and traditional cameras. Computer technologies, social-networking sites and camera phones are part of the sociotechnical system of snapshot photography, and so photographers need to have access to, interest in and some competence in using such systems (Van House 2011: 132). Increasingly, everyday amateur photography is a performative practice connected to presence, immediate communication and social networking, as opposed to the storing of memories for eternity, which is how it has hitherto been conceptualized. As José van Dijck says with regard to mobile-phone snaps:

> When pictures become a visual language conveyed through the channel of a communication medium, the value of individual pictures decreases while the general significance of visual communication increases. A thousand pictures sent over the phone may now be worth a single word: 'see!' Taking, sending and receiving photographs is a real-time experience and, like spoken words, image exchanges are not meant to be archived [...] Because of their abundance, these photographs gain value as 'moments', while losing value as mementoes. (2008: 62)

Although 'old photography' – as described by the early phenomenological photography theories by André Bazin and Roland Barthes – confirmed 'what has been' (Barthes 1981) and fulfilled a 'mummification desire' to embalm time (Bazin 1980), the new digital practices show to a greater extent 'what is going on': the present (Sandbye 2012). Whereas scholars used to theorize about photography as a distinct technology with a 'life of its own', photography's convergence with the omnipresent technologies of the internet and mobile phones means we cannot theorize about or conduct research on amateur photography without including such media. This means that disciplines related to photography must be informed about technologies, practices and academic disciplines (e.g. informatics, human–computer interaction, internet studies, mobile-phone studies). Traditionally, these areas have had little to do with the study of photography. Traditional photography theory and historians of photography are not well equipped to talk about the new use and spread of amateur photography and have not yet been able to realize fully the immense implications for our understanding of the photographic medium. Photography studies have mostly focused on photographs as images and, to a much lesser degree, on the everyday cultural production and *use* of photography. There is not much emphasis on the important agent in family and amateur photography: the person behind the camera and this person's use of photography as a performative, social construction of personal and collective identity. Moreover, in academic research the everyday use of photography – analogue as well as digital – is underexposed.

The Aims of this Book

In this book, we argue that to study digital photography as an everyday practice requires an interdisciplinary approach; the list of contributors, therefore, consists of researchers from photography studies, media geography, visual studies, art history, film and media studies as well as cultural studies.

Our thesis is that this new media convergence and the proliferation of private snaps do not mean the end of photography – as proclaimed with the advent of digital photography around 1990 – but rather a new, radical moment in the long history of photography that will change aspects of photography 'as we know it'. This new face of photography requires a novel paradigm or media ecology. This book thus develops 'a new photographic media ecology'[1] in a series of studies on the specific practices and uses of digital snapshot photography. While the chapters highlight many new technologies, meanings, circulations and practices, they simultaneously demonstrate overlaps and continuities between old and new photography. So despite the fact that we speak of the new faces of snapshot photography, our approach is informed by writers such as W.J.T Mitchell, Gillian Rose, Geoffrey Batchen and Sarah Pink, who warn against neglecting the old realities of new photography. As Pink (2011: 93) says:

New amateur photographic practices are undoubtedly emerging. I caution against a focus on the 'new' so much as on how more subtle shifts are taking place as 'new' and 'old' meet. New digital amateur photographic practices are better understood as emergent in relation to both older photographic media and technologies and practitioners' understandings of their potential.

This point is also stressed in Van House's research, where she argues that: 'One reason for the ready acceptance of digital technologies [...] is that they do not undermine the prior meanings of personal photography; but neither are these meanings left unaltered' (2011: 132).

The contributors demonstrate that the new face of snapshot photography is a peculiar mix of old *and* new technologies, and not least old and new social and cultural practices of taking, viewing, storing and circulating photographs. In various ways, the authors detect major changes and continuities, as well as complex overlaps between the past, present and future.

While much (earlier) writing on digital photography either focused on the dualism of truth/analogue versus construction/digital, or else resembled technical determinism by considering only technical affordances, we argue that technologies cannot be separated from embodied practices, from *doings*. The specific affordances of technologies shape but do not determine if and how they can be used and understood in practice. This also means that digital photographs can be many different things, according to how they are made meaningful and performed in specific contexts.

The book examines in detail how the affordances of digital photography are enacted in practice – how people produce, consume and distribute digital photographs and how vernacular photography changes nature with the transition from analogue to digital photography. While digital photography affords new possibilities (because it performs differently from analogue photography), it is less clear if and how these affordances are used in *everyday* practice, which we set out to explore in this book. We destabilize the idea that photography is a uniform practice with a fixed cultural meaning: photography is a complex and diverse practice across time and space, and it would be naive to assume that all photographers confer the same meaning on photography or even that they are following the same practice. Photographs need to be understood, everywhere and always, in relation to the societies in which they are embedded.

Thus the central thesis of this book's new media ecology – which ties the chapters together – is that photography must be understood simultaneously as a social practice, a networked technology, a material object and an image. This book investigates and conceptualizes the changes of photography 'as we know it' from a perspective of everyday photography and media convergence, and it examines these changes by researching how and to what extent the traditional social practices, technologies and images of analogue photography are transformed in the transition to digital photography. The chapters zoom in on typical, vernacular, everyday practices: the development of the family photo album from a physical object in the living room to a digital practice on the internet; the use of mobile phones in everyday life; photo communities

on the internet; photo-booth photography; studio photography; and fine art's appropriation of amateur photography. The overall aim of *Digital Snaps* is to explore how this media convergence transforms the media ecology – the networks, objects, performances, meanings and circulations – of vernacular photography, as we research it through ordinary people's use of such new cameras and interactive internet spaces as part of their everyday lives.

The Structure of the Book

The chapters work with a broad definition of digital photography that comprises camera *technologies*, discursive and aesthetic *practices* of doing photography, and photographs as circulating (digital and material) physical *objects*. Since the invention of photography, of course, there have been many types of analogue cameras, but they were all, so to speak, independent technologies with the sole function of *making* photographs. This was also the case with the initial phase of digital photography, where digital cameras set the scene. Yet camera phones are now taking the lead, and the quality of camera phones is improving rapidly. Samsung has launched a 10-megapixel camera phone, while the new iPhone 5 has an 8-megapixel camera. The problem with the digital camera is that it is just a camera, whereas the camera phone is a networked multimedia device that is always at hand as part of one's everyday life. Pictures taken on smartphones (and on digital cameras with Wi-Fi technology) can be seen instantly by people at a distance. While digital cameras generally make better photographs than mobile phones, however, they appear to be dying due to their lack of connectivity.

The following chapters examine how ordinary people 'do' photography and what the photographic practice implies in their daily lives. It is most remarkable that the international, extremely widespread *The Photography Reader* opens with the question 'What is a photograph?' (Wells 2003: 1) and that methodology books and readers on visual culture almost exclusively discuss methods to analyse photographs as texts. Photography as a *practice*

has been discussed relatively rarely, which is problematic, as technology cannot be separated from issues associated with performative practices of taking, editing, distributing, uploading and exhibiting photographs. Today, many people regard the camera as a part of their daily lives, almost as an extension of their bodies. When photographing their daily surroundings, you often see people holding the camera at arm's length, as if not seeing the world but touching it. The chapters explore how ordinary people take, store and upload digital photographs, and how photographs travel, create communities and identities, and function as social tools as well as material objects in people's lives. By analysing exemplary practices and cases, the authors also examine the afterlife of digital photographs and their placing within and beyond networked households and various social-networking sites (e.g. Facebook) and photo communities (e.g. Flickr and Photosynth). The chapters discuss how snapshot photographs are increasingly having short-lived, ephemeral lives on the one hand, and more mobile and public lives on the other.

The first section of the book is called 'Images on Web 2.0 and the camera phone'. Martin Lister's introductory article 'Overlooking, rarely looking and not looking' sets the scene for many of the ideas and concepts discussed not only in this section, but also in the rest of the book. Lister asks how we are to think about the unprecedented number of photographs being produced and circulated in our digital Web 2.0 culture, where cameras and computers are complexly interlinked. He addresses the various ways in which new kinds of everyday photographic practice and new relations between photographic and digital technology and the body are emerging in the new media ecology. Lister does so by discussing the politics of popular snapshot photography, the ideology of the Web 2.0, the sheer quantity of photography that we now (fail to) deal with, historical problems in the management and use of photographic data, and our recurring utopian or hopeful investments in information technology. He finally argues that new ways of seeing and new modes of doing and valuing photography are evolving in the ubiquitous use of small mobile screens and the pervasion of everyday life by mobile-networked technology.

In 'The (im)mobile life of digital photographs: the case of tourist photography', Jonas Larsen examines how tourist photography is being transformed in the face of digital cameras, mobile phones and social-networking sites. He employs the metaphors of life and death, mobility and immobility, as well as ethnographic research. In doing so, he discusses how the practice of tourist photography has sped up, how many tourist photographs are short-lived because of deletion or how they live indiscriminate lives on overcrowded personal computers. The few lucky ones are those that travel long distances to connect with faraway ties or live publicly on Facebook and Flickr.

In the chapter 'Distance as the new punctum', Mikko Villi also concerns himself with the mobility of photographs. His chapter focuses on the influence of the practices of mobile-phone communication on personal photography. The chapter discusses how a snap sent forward directly from the phone (by using, for example, MMS or email) can offer an almost synchronous photographic connection between the photographer and the recipient audiences. Drawing on Roland Barthes's and his own ideas of 'what has been' and of punctum as a source of the passing of time, Villi introduces the idea of distance as the new source of punctum, as mobile-phone photography communication is typified by absence in space and not in time.

The second section, 'Family albums in transition', discusses what has happened to family photography, the major institution of analogue photography and the focus of most academic writing on snapshot photography.

In her chapter 'How digital technologies do family snaps, only better', Gillian Rose argues that digital technologies intensify rather than transform family photography. Rose is critical of the idea that family photography is fundamentally changing because of the transition from analogue (prints and albums) to digital photography (files and file sharing). While not denying that the material basis of family photography has changed a great deal, her argument is that the social practice of family photography has not changed much. Rose begins with outlining the concept of seeing family photographs as a kind of visual object that people handle as a material object, within specific places and governed by specific traditions and social norms. She

goes on to critique conventional studies for reducing the significance of family snaps to signs. To understand what family photography is, it is also necessary to look at what family photographers do and how photographs circulate. She ends her chapter by arguing that digital photography allows families 'to do what they want to do with family snaps more easily, more often and more extensively'.

In her chapter 'Friendship photography: memory, mobility and social networking', Joanne Garde-Hansen makes the argument that networked digital photography and especially camera phones make friendships rather than families central to snapshot photography. This is in part because young people (without children) today are equipped with cameras and they tend to photograph friends rather than family members. For them, photography is a way of performing friendship. In this chapter, Garde-Hansen examines the production and movement of camera-phone images created by young people for public consumption. She finds that they use their camera phones to document and share the places, locations and communities *they* inhabit as part of their everyday lives.

Directly following Garde-Hansen's chapter is 'Play, process and materiality in Japanese purikura photography'. In this chapter, Mette Sandbye writes about the use of photo-booth photography among Japanese teenagers. Seen on a global scale, the Japanese are the most frequent users of mobile camera phones. Nevertheless, the use of photo-booth print stickers – so-called 'purikura' photography – is extremely widespread in Japan. Although digitally manufactured, the material aspect of this kind of photography is very important: purikura photography is at the same time a highly digital, convergent technology, a very material and indeed performative practice and a technological object used as a social and communicative tool. Here the aspect of friendship, adaptation to group identity, exchange of images, and performance when staging and producing the images are more important denominators than the actual freezing of the past in the photograph. The chapter shows how the digital technology keeps enhancing the idea of purikura, while the very material fundament behind this digital technology

is kept alive. Thus, this kind of digital photography underlines the need to look at photographs not just as images but as material and social objects; objects that mould and create identity and social relations between people. This specific Japanese phenomenon thus points towards important aspects of photography as such, whether in family albums or on internet-based social sites.

Sigrid Lien turns to another aspect of family photography: the professional family portrait. In '"Buying an instrument does not necessarily make you a musician": studio photography and the digital revolution', she analyses the consequences of digital technology in the work of the studio photographer. Through a specific Norwegian case study, she shows how digital technology, although so widespread today, has not 'killed' professional studio photography, as many predicted. Rather, it has realigned both the post-production phase and the aesthetics of the posed portrait towards uses of seriality and the mimicry of snapshot aesthetics, at the same time involving new ways of communication between photographer and clients via social media. Lien also shows, like other authors in the book, that digitization has paradoxically led to a stronger, materially based image culture than ever before.

The third section 'New public forms' begins with a chapter by Anne Jerslev and Mette Mortensen: 'Paparazzi photography, seriality and the digital photo archive'. Here, the two authors address the issues of archival practices and everyday consumption of digital images on social media in relation to online paparazzi photography shown in so-called 'galleries' on internet entertainment sites. This rapidly growing phenomenon constitutes a fascinating example of how the emergence of digital modes of production and distribution has changed established genres – here celebrity photography – profoundly. They suggest that these immense volumes of snapshots, compiled into large series of everyday life in an amateurish snapshot style, where celebrities are caught as 'ordinary people', construct a sense of flux, of time as continuously unfolding, and of immediacy and presence. At the same time, the unguarded and the private are turned into an almost deliberately constructed pose, which is what creates the user's fascination with this kind of imagery.

In 'Retouch yourself: the pleasures and politics of digital cosmetic surgery', Tanya Sheehan addresses the phenomenon of 'digital doctoring', where ordinary people with basic cameras and personal computers can manipulate their own portraits, taking part in a widespread mass-media 'makeover culture', which is also a commercial practice. Retouching has always been a possibility in photography, but with the advent of cheap digital technology, this practice is no longer only in the hands of professionals. This poses new and much more subtle ways of regarding questions of truth and realism in relation to photography: 'Doctored photographs of bodies can speak the truth at the same time as they can offer fleeting illusions of agency to those who produce and consume them,' she writes. Going back into history, Sheehan traces a cultural history of photography 'as medicine', bearing wide implications for both the pleasure and the politics of photography.

In her chapter 'Virtual selves: art and digital autobiography', Louise Wolthers turns to contemporary art's use of digitally transformed snapshots in works that take personal autobiography as their starting point, seeing them as part of a larger phenomenon that has been termed 'the archival turn' in contemporary art. Analysing works by Lorie Novak and by Kristoffer Ørum and Anders Bojen, she demonstrates how artists have turned to vernacular, visual, ephemeral and fictional archives in order to construct alternative biographies of self and others, opening up new potentials for reinterpreting historical sources and narratives. Their works refer to the current everyday use and abuse of digitized imagery, but establish alternative archives that evoke the performative power of photography. Wolthers argues that whereas the current tendencies constantly to upload, alter and expand self-imagery in everyday digital culture might be seen as a symptom of an individualistic society of free-floating consumers, the virtuality of digital archives also offers productive encounters and can likewise raise political and ethical discussions.

With the last chapter, by Michael Shanks and Connie Svabo, 'Mobile media photography: new modes of engagement', we return to the

pervasiveness of private, digitally produced and disseminated phone photography on social photo-sharing sites. Following up on some of the key points in this book's introduction, Shanks and Svabo argue that digital photography must be seen as processual, conversational and in constant flux. 'Mobile media photography marks a shift in orientation from the image towards photography as a mode of engagement,' they argue, describing two central aspects of photography: a temporal, archaeological engagement with the world, and a spatial, geographical engagement. But like Sheehan and Wolthers, also in this section, they end their article by pointing critically towards some of the more disturbing political aspects of this flourishing wealth of 'digital snaps' in contemporary visual culture. A downside of the spread of amateur images on social internet sites is that companies can use them as trading stock. As one new-media blogger said, 'If it is free, *you* are the product.'

Having used most of the book to describe the 'new face of photography' in largely positive terms – such as communication, sharing, performance and presence – we deliberately end with a few essays that remind us we should never lose our critical awareness regarding new media phenomena. Today, we often experience the world through photography, and it is no longer possible to go back to some kind of 'photo-free' society. The photographs are sometimes all we have to understand ourselves and the world around us, as Susan Sontag argued in her latest book on photography, *Regarding the Pain of Others* (2004). Thus, the new face of photography might be regarded as the face of Janus: smiling and crying at the same time.

NOTES

1 In using the term 'ecology', we refer to its scientific definition: ecology is the science of the relationships between living creatures, their social interactions and the interactions between them and their surroundings. Thus, we want to emphasize photography as a social tool connecting people with other people and their surroundings.

BIBLIOGRAPHY

Barthes, R. (1981; originally published 1980), *Camera Lucida: Reflections on Photography*, New York: Hill and Wang.

Bazin, A. (1980; originally published 1945), 'The ontology of the photographic image', in Trachtenberg, A. (ed.), *Classic Essays on Photography*, New Haven: Leete's Island Books.

Beaumont, P. (2011), 'The truth about Twitter, Facebook and the uprisings in the Arab world', *Guardian*, [online], <http://www.guardian.co.uk/world/2011/feb/25/twitter-facebook-uprisings-arab-libya>, accessed on 20 May 2011.

Beer, D., and Burrows, R. (2007), 'Sociology and, of and in Web 2.0: some initial considerations', *Sociological Research Online*, 12(5), <http://www.socresonline.org.uk/12/5/17.html>, accessed on 4 August 2013.

Cobley, P., and Haeffner, N. (2009), 'Digital cameras and domestic photography: communication, agency and structure', *Visual Communication*, 8: 123–46.

Couldry, N. (2004), 'Theorising media as practice', *Social Semiotics*, 14(2): 115–32.

Edwards, E., and Hart, J. (2004) (eds), *Photographs. Objects. Histories*, London: Routledge.

Gregson, N., Metcalfe, A., and Crewe, L. (2007), 'Identity, mobility, and the throwaway society', *Environment and Planning D: Society and Space*, 25(4): 682–700.

Haldrup, M., and Larsen, J. (2010), *Tourism, Performance and the Everyday: Consuming the Orient*, London: Routledge.

Holland, P. (2000; originally published 1996), '"Sweet it is to scan": personal photographs and popular photography', in Wells, L. (ed.), *Photography: A Critical Introduction*, London: Routledge.

Jenkins, H. (2006), *Convergence Culture: Where Old and New Media Collide*, New York: New York University Press.

Langford, M. (2001), *Suspended Conversations: The Afterlife of Memory in Photographic Albums*, Montreal: McGill-Queen's University Press.

Lapenta, F. (2011), 'Locative media and the digital visualisation of space, place and information', *Visual Studies*, 26(1): 1–3.

Larsen, J. (2005), 'Families seen sightseeing: the performativity of tourist photography', *Space and Culture*, 8(4): 416–34.

—— (2008), 'Practices and flows of digital photography: an ethnographic framework', *Mobilities*, 3(1): 117–40.

MDA (2008): Mobile Data Association (MDA), 'The Q1 2008 UK mobile trends report', n.d., [online], <http://www.themda.org/mda-press-releases/the-q1-2008-uk-mobile-trends-report.php>, accessed on 1 April 2010.

Mortensen, M. (2009), 'The camera at war: when soldiers become war photographers', in Schubart, R., Virchow, F., White-Stanley, D., and Thomas, T. (eds), *War Isn't Hell, It's Entertainment*, Jefferson: McFarland.

Pink, S. (2011), 'Amateur photographic practice, collective representation and the constitution of place', *Visual Studies*, 26(2): 92–101.

Rose, G. (2010), *Doing Family Photography*, Aldershot: Ashgate.

Rubinstein, D., and Sluis, K. (2008), 'A life more photographic: mapping the networked image', *Photographies*, 1(1): 9–28.

Sandbye, M. (2012), 'It has not been—it *is*. The signaletic transformation of photography', *Journal of Aesthetics & Culture*, 4.

Sontag, S. (2004), *Regarding the Pain of Others*, New York: Picador.

van Dijck, J. (2008), 'Digital photography: communication, identity, memory', *Visual Communication*, 7(1): 57–76.

Van House, N. (2009), 'Collocated photosharing, storytelling, and the performance of self', *International Journal of Human–Computer Studies*, 67: 1073–86.

—— (2011), 'Personal photography, digital technologies and the uses of the visual', *Visual Studies*, 26(2): 125–34.

Urry, J., and Larsen, J. (2011), *The Tourist Gaze 3.0*, London: Sage.

Wells, L. (2003), *Photography: A Critical Introduction*, London: Routledge.

IMAGES ON
WEB 2.0 AND THE
CAMERA PHONE

1

Overlooking, Rarely Looking and Not Looking[1]

MARTIN LISTER

How are we to think about the incalculable number of photographic images being produced and circulated in digital culture? How are we to understand the convergence of the camera with the telephone and the birth of a hybrid device that we virtually wear, a small device that lives in the pockets of millions of people and is literally 'to hand' as they go about their daily lives? Photographs are now taken very lightly indeed and, in all probability, deleted as readily. They are frequently stored as code, with their visibility being a potential rather than a fixed state. Many, I suspect, remain as code, lost as images, lingering in the invisible interiors of servers and hard drives. If viewed at all, it is frequently as temporary emissions of light from the plethora of mobile screens that we use for a multitude of other purposes. They continuously enter and exit the data streams of telecommunications networks.[2]

Overlooked and Rarely Looked-At Photographs

The effort to conceive of photography in this condition is not well served by the bodies of knowledge about photography that we have inherited from

the analogue age. We are not, however, entirely without precedents. Sitting awkwardly at the margins of the history and theory of photography, there are at least two kinds of photography that may help us approach these questions in ways that are sensitive to some of the characteristics of the newly fugitive networked image: the commercial stock photograph and the domestic snapshot.

There is a vast body of work-a-day and mundane commercial images residing in image banks, the stock photographs of the 'visual content' industry. There is also the ubiquitous personal or domestic snapshot, found in the proverbial shoeboxes and albums of more or less formal kinds, across much of the world. The importance of both these kinds of photography, with respect to the questions I posed above, lies in the way that they yield little to discourses that dominate the analysis of photographs and assume that its objects of study are skilfully crafted artefacts attended to by viewers who scrutinize them with a schooled and concentrated interest.

In a powerful challenge to such models of analysis, Paul Frosh (2002, 2003; see also Machin 2004) has explored the production and use of stock photographs. He describes such images, produced speculatively on an industrial scale for use in unknown future contexts, as the 'wallpaper of popular culture' (2002: 172). These are images that are 'deliberately unremarkable and inconspicuous' and 'designed not to attract attention or detain the eye'; they are images that we 'overlook' (2002: 172). Across the twentieth century, such bland and repetitious images increased in volume, undergoing their own digital revolution in the twenty-first century, to form a kind of 'ocular "white noise"' within visual culture (Rubinstein and Sluis 2008: 23).

The ubiquitous snapshot photograph is also an image that the majority of us, for most of the time, overlook. Indeed, Geoffrey Batchen observes that they are a kind of photograph that we look at only rarely (2008: 136). Snapshots, too, are boring and repetitive pictures (2008: 133) unless they are the few, however similar they are to the vast numbers of others, to which we each have some kind of biographical connection – when they

are famously able to cut to the emotional quick (2008: 133). In short, the wallpaper of visual culture constituted by the visual-content industry and stock photography is matched here by the 'sprawling cultural phenomena' (2008: 125), that 'endless torrent of similar kinds of pictures' (2008: 123) that is snapshot photography.

Both theorists issue a methodological challenge. Frosh challenges the premises of transmission models of visual communication and semiotic analysis (2002: 173) and Batchen argues that snapshot photography confounds the very concepts and judgements of 'the art history of photography' (2008: 125), arguably still the dominant discourse about photography.

It is quite recently that this vast and already existing body of commercial and domestic images, together with the challenge they pose for cultural analysis, has met the explosion of (networked) photographic activity, which raises the questions I posed at the outset of this chapter. As this happens, it may be that problems that have stalked the margins of photographic theory (such as Frosh and Batchen address) begin to move to centre stage. We can date this as occurring around 2004, a year in which a key technology in this connection, the camera phone, gained real market saturation and social significance (BBC 2004) and a key institution, Flickr, was launched. In terms of the pace of academic research, this was not a long time ago. After all, it takes a couple of years for people to notice emergent things, a couple more for scholars and researchers to engage thought, to fund and initiate research, a couple more before that research might be published, and probably yet another year before it starts to be read. That pretty much takes care of those eight years. Understandably, then, research literature and thought about digital online photography remains relatively sparse.

However, I do not think that this sparsity can be explained entirely by the timescale of academic response to rapid change. I have a sense that, of all the disciplines that addressed and were once securely attached to a discrete medium, the study of photography stands out as resisting engagement with recent developments in its field. It has been defensive

and inward-looking, whereas media disciplines – such as film and cinema studies, television, music, journalism and museum studies – have all engaged with the conceptions and insights of 'new media studies' (or the study of 'old media' and old institutions in new times) and contributed to its ever growing literature. It was, for instance, already in 2004 that insightful work on the meaning of the digital MP3 file for the production and consumption of music was published (Katz 2004). Yet, it was not until 2011 that I first heard similar questions being asked about the meaning of the JPEG for photography.[3]

On the other hand, social scientists (scholars of communications, of human–computer interaction and cultural anthropology) were swift in attending to the use of camera phones and social-network sites (see, for example, Kindberg et al. 2005; Okabe 2004, 2005; Tatsuno 2006; Van House 2005). But, in my view, they tend to deliver rather unilluminating conclusions from their empirical studies. This is due, I believe, to their too ready adoption (I am tempted to say their 'uncritical acceptance') of well-worn concepts borrowed from other disciplines: from art history, media studies and the study of visual culture. And yet, these are the very concepts whose purchase on current developments is now under question.

For example, in 2005, researchers tracked the behaviour and production of 60 camera-phone users over a period of ten months. On the basis of this research it was concluded that the four social uses of camera phones are: to preserve memories, to sustain relationships, for self-presentation and for self-expression (Van House 2005). Such a statement, it seems to me, is rather hard to argue with in its generality. Yet, at the same time, it is hard to feel that much has been learnt. Camera-phone photography may well serve mnemonic, social and expressive purposes, but so did the snapshots of the Kodak era, home videos in the 1980s and, indeed, albeit for far smaller social groups, miniature portrait painting in the early nineteenth century. Indeed, as early adopters of a new technology seek to apply it within known practices, even as new and unlooked-for uses emerge, this degree of historical continuity should not be surprising. The question surely is not whether

photography continues to support such practices, but whether these apparent continuities capture the emergent practices, uses and experiences that arise with the convergence of the camera, the computer and the phone.

This is more than a quibble about the respective methodological strengths and weaknesses of the social sciences and the humanities. There is a bigger challenge here. Whether 'we' own or borrow the old ones, we surely need fresh conceptual frameworks to enable us to begin to get to grips with the current condition and nature of photography. Empirical surveys whose data is interpreted using concepts formulated in the analysis and judgement of photography and art in the earlier twentieth century do not serve us well. Indeed, they may actually hinder us in thinking productively about these fugitive networked images as a form of cultural production. This is why Batchen's and Frosh's audacious and unorthodox thinking about the snapshot and the stock photograph are relevant in the present context. They have attended seriously to kinds of photography that have sat uncomfortably outside the canon for several decades. We should take our lead from their willingness to reframe conceptually and give sustained thought to the boring, mundane, repetitive and incommensurate in image culture, without resort to received concepts such as 'self-expression' or 'representation'.

In what follows, I offer a contribution to such a project. The reader will not find here a seamless narrative or developing account of digital networked photography. Rather, through a number of sections operating as a series of frames, I seek to establish a context for thinking about current developments, and I have avoided imposing a false coherence on the text overall. I consider, in the process: the politics of popular snapshot photography; the ideology of Web 2.0; the sheer quantity of photography that we now (fail to) deal with; historical problems in the management and use of photographic data; our recurring utopian or hopeful investments in 'information' technology; and, finally, arguments that new ways of seeing, as well as new modes of doing and valuing photography, are evolving in the ubiquitous use of small mobile screens and the pervasion of everyday life by mobile networked technology.

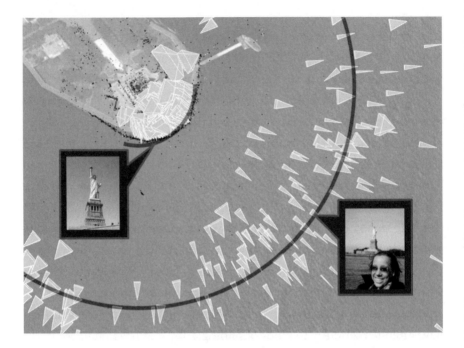

1.1 Paths through photo collections. The reconstructed camera viewpoints from hundreds of Flickr photos of the Statue of Liberty.

Photography: The Original User-Generated Content?

In a 2007 conference presentation, which can be viewed online,[4] the software-developer Blaise Agüera y Arcas demonstrated Microsoft's new Photosynth software. His presentation amounted to a software-developer's mission for photography: a glimpse of photography in the era of Web 2.0 (Agüera y Arcas 2007). In his presentation Agüera y Arcas pulls hundreds of tourists' and publicity images taken of the cathedral of Notre-Dame in Paris from the Web, to be projected simultaneously alongside one another on a large screen. For each image the software calculates the position that would have been occupied by the camera that made it. By choosing one image, many others, each having a different viewpoint, frame or focus on the

building, are brought together to produce a composite three-dimensional image of the cathedral.

The presentation reminds us that photographs, existing and new, have found a vast new realm to inhabit on the World Wide Web. Photographs now saturate the virtual world in a way that bears comparison with the ubiquity they accrued in the actual world across the nineteenth and twentieth centuries. The majority of photographs, from camera-phone snapshots to professional portfolios and historical collections, are now stored on the Web, in commercial databases, the digitized archives of museums and other public bodies, and on social-networking sites. Each image has identifying metadata attached, via which they can be searched, navigated and ordered according to the user's interests and priorities.

Agüera y Arcas describes his software and the algorithms that process the data it searches out as producing a 'classic network effect' and a 'social environment' drawn from the image data contained in the 'collective memory' of the internet. Something emerges, he says, that is greater than its parts and that grows in complexity as it is used. This activity of the users of software, their input, choices, decisions, even their modifications, are key characteristics of what has been dubbed 'Web 2.0'. The key characteristic of Web 2.0 – that which is seen to distinguish it from earlier manifestations of the Web – is 'user-generated content'.

We might think that the content of the images that Blaise Agüera shows is rather trivial. It does have its origins in a kind of virtual tourism and, as is usual with the emergence of new technologies, it is the sheer technological wizardry that is foregrounded; we need only think of the history of early photography itself or, even more, of early cinematography, or of media technologies that, even when technically viable, lacked a cultural purpose and form, as was the case with radio or television. Photosynth, then, is a powerful hybrid technology looking for uses, and this is not the first such instance in the history of media.

However, the thought occurs that, from another perspective, we can see photography itself as the original 'user-generated content'. From around

the 1890s, photography was the media technology that put the means of image-making into people's hands within the conditions of their everyday lives. This is something that was not possible for film or television until the 1980s with video camcorders for the consumer market. Real developments over the last 15 years (together with a good deal of overstatement) tell us that we can now all be media producers and distributors of many kinds. What was once unique to photography is now true of music, the moving image, journalism, animation, and so on. In this light, photography, far from being overhauled in some way by new media developments, can be seen as having been in the vanguard of such developments by more than a hundred years.

The idea of Web 2.0 and 'user-generated content' has, of course, been much contested. There are parallels between the current contestation of the value of 'user-generated content' and much earlier debates about whether photography offered some kind of democratic access to the means of production and emancipatory practices of self-representation. Critics of Web 2.0 argue that it is a form of unregulated self-publishing accompanied by a new wave of techno-utopianist hype, which serves to hide the fact that it is merely the old Web with better business plans and intelligence-collecting facilities. As 'creative users' we contribute to Web 2.0 at the expense of the surveillance of our habits, choices, predispositions and patterns of consumption. And, far from fostering a democratic, inclusive 'creativity', Web 2.0 has created a cult of amateurism, 'an endless digital forest of mediocrity' (Keen 2007: 2).

There are strong echoes here of the way in which the personal snapshot photography of the Kodak era was seen to be constrained and led down narrow ideological paths to sell more film, to celebrate the nuclear family, to encourage the consumption of commodities, to turn away from the worlds of work and the politics of everyday life to frame instead small compensatory moments of leisure and recreation (Slater 1991).

Photographs That Nobody Looks At

By a strange route then, the 'user-generated content' of Web 2.0 takes us to one of the recurring divides in photographic theory and the politics of representation, a divide that preoccupied Walter Benjamin in the 1930s (see Benjamin 1973) and that we saw again in the late 1970s and the 1980s (in the UK and other parts of Europe). In the latter case, the argument was between activists of the 'independent photography movement', who saw photography as a force for democracy and a voice for the marginal and the invisible (see, for example, Bezencenet and Corrigan 1986; Braden 1983; Dennett and Spence 1979), and the kind of historical analysis that John Tagg made at the same time, in the *Burden of Representation* (1988). Tagg, while at least recognizing the potential democratizing power of photography (1988: 16), nevertheless concludes that what in fact was produced was a 'new consumer body for photography' (1988: 17), one that 'solidified' rather than challenged the power relations around cultural practice, due largely to the limited and codified kinds of images that could be produced and the restricted knowledge that was made available alongside the mass-market snapshot cameras (1988: 17).

In his 2009 essay 'Mindless photography' (surely a play upon the title of Burgin's seminal 1982 text *Thinking Photography*), Tagg revisits this earlier work in which he had seen a 'striking rendezvous' in the nineteenth century between the State and the new technology of photography. In 'Mindless photography' he discusses the system used to photograph car number plates by the London (traffic) congestion-charging scheme and cautiously recognizes a kind of post-human vision at work. Here, in the new networked environment within which photography finds itself, we again find ourselves led back to the computer. Tagg (2009: 19) notes that:

The incorporation of record photography in nineteenth-century policing, medicine, psychiatry, engineering, social welfare and geographical surveys always depended on the deployment of a composite

machine – a computer – in which the camera with its inefficient chemical information storage system was hooked up to the file cabinet [...] constituting for the late nineteenth century a new information technology.

However, within this continuity there is something new. In the London transport system, cameras take pictures, they are stored, computers inspect them and appropriate action is taken (the levying of fines, etc.), but this is a circuit of visualization in which no human subject or, indeed, as Tagg puts it, not 'even a bodily organ' (2009: 21) plays a part. Far from a fascinated gaze at photographs, or even an 'overlooking' of photographs, in this case nobody even looks at the photographs that are produced.

Research into 'pattern recognition', a form of machine vision, has been heavily invested in since the 1960s (Gates 2005: 42). It is a technology used both by Photosynth (in order to seek and match images in processes of 'user-generated creativity') and for the surveillance of drivers within the London transport system. The aim is (in the latter case, at least) to get the human being 'out of the loop' (Gates 2005: 42). To overcome the fallibility and subjectivity of human vision on the one hand and to solve a problem as old as photography itself on the other, teetering, disorderly and finally unmanageable piles of photographs began to build up from the earliest uses of police photographs in the nineteenth century. This is a problem that has persisted, especially since 9/11, as a problem in our own times.

A Surfeit of Photographs?

It is no wonder that (while we wait to learn what their quality or meaning may be) the changes to photography that have been unfolding over the last decade are typically presented in sweeping, large-scale terms; they are met on a scale of almost unimaginable quantity, a kind of digital sublime. We need only to think about the Flickr home page announcing,

in near real time, in a kind of self-consciously mind-boggled way, that 6,000 images and counting were uploaded in the last minute to join the billions already on its servers. Or the tens of thousands of private images that billions of people now store on hard drives and servers; or the massive peer-to-peer traffic of photographs on the internet and wireless networks, as, immediately after a picture is taken, the default state of many camera phones is to ask us to whom we want to send it; or the sheer numbers of digital cameras and camera phones sold year on year and the increase in the number of free (filmless) pictures that people take; or the enormous investments in time that large archival digitization projects take. However, the question is what does all this mean and, as I am pressing here with my call for conceptualization, how would we know? Behind these glimpses of histories, of the snapshot, of the State and surveillance, of surfeit and overload, of machine vision, of sheer quantity, there may be something else. This is that the convergence of the camera with the computer, and of photography with the internet, might have only deepened a malaise that has attended photography throughout its history and may herald a kind of endgame for photography as we know it. We may call this 'the malaise of photography as information'.

This is not to talk about the end of photography again, in a rerun of the discourses that preoccupied us in the 1990s. We have now, I believe, got beyond that earlier preoccupation with the splitting of ontological analogue and digital hairs to realize that photography has been continually reinvented and has converged with other media technologies throughout its history. As Maynard (1997: 3) points out: 'the importance of photography has depended not only upon its social uses but also upon a series of remarkable technological innovations, a series still showing no limit.' On this view the cameraphone is simply the latest of very many innovations, including 'the latent image, the negative–positive process, dry plates, roll film, miniature cameras with fast lenses, "tripack" color film, motion pictures, television, […]' A list to which we might add the telegraph. Narrowing his field of view, Maynard then offers a second list, confined

only to innovations of the 1970s, which includes: 'electronic shutters, LED displays, microchip processors, miniature format films, lightweight materials, the single lens reflex, and automatic focus' (1997: 4). Both lists precede 'the highly technical innovations of our time' (1997: 3). Thus, far from photography being dealt a death blow by new technology, it was always intimate with it and there is now, by one means or another, more photography than ever. As we will go on to see, there are grounds for thinking that there is too much.

The Camera and the Computer: Reducing the Distance

There exist elements of a hidden history of photography and information (Batchen 2002; Lister 2007; Maynard 1997). This is a history that reduces the distance between the camera and the computer, or, rather, the way in which they have been insulated from one another in the hard-walled histories we have received, as if for two centuries they existed in separate worlds. When thinking about the contemporary convergence of photography and digital technologies it is helpful to reduce this (apparent) historical distance and by getting a longer historical run-up to where we now find ourselves, perhaps we will be less surprised or less foxed by contemporary developments.

This hidden history of photography and computing (where the two technologies and associated practices are considered in the same frame) arises from the pressures and urgencies of producing, managing and reproducing information within nineteenth- and twentieth-century imperialism and industrialization. As an example, we may take the work of the information scientist Vannevar Bush, which is outlined in his 1945 essay 'As we may think' (reproduced in Mayer 1997). Amid the stirrings of cybernetics, Bush was concerned about an approaching surfeit of information. His project was to tackle a fear of information overload in the period immediately after World War II by seeking to design a human–machine interface that

was in tune with the associative nature of human cognition. In his article he imagines a machine called the Memex: an electro-mechanical machine that anticipates the databases, hypertextual systems, search engines and the networks we now access from our PCs. He speculates on the role that photography would play in the Memex assemblage:

> Certainly progress in photography is not going to stop. Faster material and lenses, more automatic cameras, finer-grained sensitive compounds to allow an extension of the minicamera idea, are all imminent. Let us project this trend ahead [...] The camera hound of the future wears on his forehead a lump a little larger than a walnut. It takes pictures 3 millimeters square, later to be projected or enlarged [...] it will have automatic exposure. (Mayer 1997: 25)

He then asks, 'Will there be dry photography?' And he expresses the view that 'often it would be advantageous to be able to snap the camera and to look at the picture immediately' (Mayer 1997: 26). Bush conceives of Memex machines being networked by telephone lines, and their users would share, order and reorder their materials in a dynamic fashion, making their own trails of association among information, including the information contained in photographs. Practically, the available technologies could not deliver his idea, but the convergence of the camera and the computer was, and not for the first time, envisioned.

Some ten years ago, in an era where technology had delivered what Vannevar Bush dreamt of, the art historian and computer scientist Lev Manovich published *The Language of New Media*. In a chapter on the database, he points out that digital storage media (he particularly has in mind storage on networked servers), 'have proved to be particularly receptive to traditional genres that already had a database-like structure' in their analogue form (2001: 220). He picks out the photo album as his prime example, observing that these, in turn, 'inspire new database genres, like database

biography' (2001: 220). This is the two-way dynamic of 'remediation' that Bolter and Grusin (1999) explain in their book of that title, whereby new media refashion older media just as, simultaneously, old media refashion themselves to answer the challenges of the new.

A Digital Dark Age?

During the 1990s computerized societies entered a 'digitising craze' or a 'storage mania' (Manovich 2001: 224). Books, videos, photographs and audio recordings were fed into computers at an ever increasing rate. Manovich himself (2001: 224) cites Spielberg's Shoah Foundation, which videotaped and digitized interviews with Holocaust survivors, and he estimates that it would take 40 years for someone to watch the resulting material. In terms of photography, the much-referenced cause célèbre is the Bettmann Archive: 11 million photographs collected over the twentieth century and acquired by Microsoft in 1996 when they began digitizing the contents. They stopped after scanning 225,000 photographs out of 11 million. It was estimated that it would take 25 years to finish the task (Boxer 2001; Puglia 2003). The issue here not only being the self-defeating nature of the exercise, but the radical editing of the historical resource that is involved. In this connection, I recall an unpublished report of an initiative to digitize the photographic collection of Birmingham City Library in the UK, one of the largest collections of documentary photographs in Europe (Morris 2001). What the project encountered was chaos. The slow accumulation of photographs that had taken place over some 100 years or more, from multiple sources – individuals, families, foundations, companies, trade unions, craft guilds, amateurs and enthusiasts, community organizations and civic authorities – had themselves never been organized or systematically archived. The 'digitizers' found themselves facing a daunting, bewildering and remedial task of doing what had not been done to the analogue sources.

Hence, alongside Web 2.0, which sees an increase in and a widening of access, maybe a democratization of data generation of all kinds, we were already haunted by the despair of the dysfunctional and disorderly piles of photographs that have been growing in State, civic, cultural and personal archives and collections since the 1850s. Arguably, this is a time when already existing problems are compounded by our new technology rather than resolved by them, such that we now hear about a digital dark age (see, among many such references, SMH 2005).

The creaking shelves, institutions and warehouses, where paper and other artefacts were threatened by humidity and fire, having reached their physical limits, have been joined by the threat of rapid technological obsolescence and extreme fragility in computer hardware and storage media. These are problems that flow from a furious 'upgrade' culture, a rapid supersession and obsolescence of electronic and digital software, hardware and storage media over only 20 years.

We appear to live in an information age in which there is, paradoxically, a historically unprecedented loss of information while we anxiously weigh it in gigabytes and worry as it quite literally heats up our computers and has us digging ever bigger cables into the ground (so much for the immateriality of information).

It is in this context that I think there are grounds to argue that we are drowning in images, documents and artefacts, that we have too much stuff. The sheer mind-boggling quantity means that the game is up. Media theorists are likely to be familiar with the Borges story (1998), famously relayed by Baudrillard (1998), about the map that was so detailed, so perfect, that it covered and obscured the territory it mapped. Baudrillard used the metaphor to envisage a stage in the practices and technologies of signification whereby representation finally obscures the real. In the computer age, an age of indices and databases, Manovich (2001: 225) suggests that the map now comes to exceed the territory. As each of us at our personal networked computers 'mines information' and 'drills deep into data', we can imagine ourselves depositing further large amounts of information on top of the

already obscured surface of reality; the map thickens like a crust as well as extending beyond the territory.

Vaster and Closer

The tsunami of images and information that we now face is an issue of sheer scale and incommensurability, but alongside it there are other, more intimate developments to note. The manner in which photography has come to pervade the local sites and small moments of everyday life increases, and new kinds of practice evolve as ever lighter and mobile apparatuses become connected, even attached, to the human body. So, in this final section, I return to my earlier call for fresh conceptualization in the effort to grasp the nature of current developments in photography by discussing two remarkable accounts of the apparatuses and the practices of networked imaging that actively resist the mapping of older concepts onto their findings.

· In the first example, an article by Heidi Rae Cooley (2004), Walter Benjamin's notion of tactile vision is brought to bear, as well as concepts drawn from outside the usual field of photo-theory: design and biomechanics. While, in the second, Kris Cohen reflects on the practices of photobloggers. In doing so, he measures their distance from the traditional discourses about photography that centre relentlessly upon the photograph as the meaningful endpoint of a practice of 'representation' in pursuit of 'the Real' (Cohen 2005: 884–5).

In both of these accounts I suggest that we are watching photography enter a new media ecology. Ecology is a useful word here, with its roots in a concern for understanding the pattern of relations between organisms and their environment. It draws our attention not only to changes in an environment, but also to the adaptations and mutations undergone by an organism or species as it lives on in changed circumstances. It captures something of the complex interplay between emerging media and communication systems and behaviours, the convergence and recombination of old and new media

forms, and the remediation of the old by the new. Hence, we might usefully try to think of photography in these terms at this time.

In her paper 'It's all about the fit: the hand, the mobile screenic device and tactile vision', Cooley recalls Walter Benjamin's theory of 'tactile vision'. In doing so, she begins to offer an account of what must surely be a suggestive historical event – a new kind of human bodily posture, a new way in which our bodies are in the world. In his 'Work of art' essay, Benjamin comments on how we come to know or experience architecture, buildings, our built environment, 'in a twofold manner' (1973: 242); that is, by use as well as by perception – by which he has in mind touch as well as sight. We feel our way into a building by use and habit, not concentrated 'optical' contemplation. Sight is, of course, involved, but in a distracted manner. He generalizes from this to think about how human beings come to find new ways of seeing when presented with changed and challenging conditions. Tasks, he says, that face human perception at turning points in history cannot be solved by 'optical means' – that is, by visual contemplation – alone. The process of adjusting how we see is achieved 'gradually by habit', by slow acquaintance, and we come to new ways of perceiving with the help of touch, or, in Benjamin's phrase, by 'tactile appropriation' (1973: 242).

Cooley suggests that now 'a new kind of seeing' is encouraged by the way in which the everyday world is coming to be imaged via screens (rather than viewfinders) that are carried as a part of small devices cradled in the hand as we move through our environments. To do this, she draws upon biomechanics and ergonomics, as well as visual cultural theory. We might note how, in the design of cameras and the way they are reviewed by consumer magazines and websites, there is now a marked emphasis on their tactility. Cooley presents us with a twenty-first-century example of an intense kind of materiality – indeed a somatics of photography. This is not a materiality of the photograph as an anthropological object (that has dissolved in this scenario), but of the intimate, tactile acquaintance of body and technology that our times especially provide. She considers images that are made as people move through their everyday worlds and by the movement of the

thumb, the hand, the shoulder, the rotation and inclination of the neck, the scrolling jog wheel, the feel of the buttons, the sculpted form of the device. Here, we witness an instinctual, but also practiced and extraordinarily dexterous, coordination of the eye and the hand, and a continual oscillation of the eyes between the screen and the world that the screen slides across and obscures at every turn (unlike the viewfinder). In short, the human hand, mobile imaging device, screen and eye come into a new relationship.

Writing in 'What does the photoblog want?', Kris Cohen (2005) draws on his ethnographic research to ponder the question of what it is that photobloggers do and why. In a photoblog, people post photographs taken by them to a website, usually daily and continually. Many now extend over several years. It follows that the pictures they take and post are normally photographs of things that appear or occur within their everyday lives, on their way to work, during their lunch break, over the weekend. It is a rolling, continual and fast-moving cross between an album and a journal, pegged to everyday sights. As Cohen (2005: 887) observes:

> photobloggers like […] to make photographs of what they call 'the everyday', 'the banal' or 'the mundane'. These descriptors are a way of emphasizing what their photographs are not about; they are not your conventional holiday or Big Occasion snaps, not just about weddings or birthdays. They're not that kind of mundane.

In contrast to our preoccupation throughout the 1990s with the digital threat to the photographic 'real', for the photoblogger it is digital technology that affords an 'on the hoof' kind of access to this everyday 'real' and the freedom to 'shoot outside of traditional photographic categories' (2005: 888–9).

Cohen describes photobloggers as engaging in a kind of photographic supervernacular (my phrase). This is a kind of photography in which photography itself dissolves in the circuit of using a camera within everyday life and posting the images online. Within this circuit, photographs themselves are not the endpoint, the *raison d'être* of photography. Throughout his account,

Cohen can find no linear chain of causality running through (i) the choice of subject, (ii) capturing an image of the subject or (iii) viewing the subject as an image, or (in other words) between intention, technology and action, and display and exhibition (2005: 884–5, 894).

If any point in the photographic process is privileged it is the act of 'taking', or, better, the sheer doing of photography: 'The photoblog gives photos something to do' (Cohen 2005: 893). In photoblogging, photographs matter not so much as finite products (and neither does the blog), but because they provide the occasion for taking photographs: for walking, for wandering, for being alert to opportunities, for being 'in the moment'. Having the small digital camera at the ready, having the internet connection and the server space waiting for uploads all require that photographs be taken. If we think about Rubinstein and Sluis's suggestion (2008: 18) that the rapid and continuous exchange of online photography becomes like a kind of speech, then this speech would be one composed of little exclamations, 'oohs' and 'ahs', nods, chuckles, pointings in several directions, silent mutterings to the self.

Cohen's analysis of photoblogging points towards the drive we find in much new media discourse: to dissolve the interface, to render it invisible, to connect directly, to arrive at an unmediated experience of the world. To pursue the end of media! Cohen reports an exchange with one of 30 photobloggers he studied. Having listened to Ed talk about the practice that feeds his photoblog, Cohen jokes, 'You need a camera implanted in your eyes,' to which Ed replies:

That's what I want: camera on the glasses, mobile phone around ear, Bluetooth to a pack down here and a computer [on waist], and heads-up display on glasses. So, completely wired but with none of these objects [gesturing at his L'espion digital camera, mobile phone, Handspring PDA plus portable keyboard, and MP3 player]. So I can go around recording, taking pictures by [pause] blinking. (Cohen 2005: 891)

However near-instantaneous the digital capture and transmission of photographs has become, Ed the photoblogger is still frustrated. Cohen remarks, 'Blinking, as a trigger, would significantly reduce the barriers that exist between seeing the image and fixing it photographically.'

The speed and ease that is conventionally associated with digital photography is not the experience here, it is inverted as the several small physical tasks that face the photoblogger loom newly and strangely large ('retrieving the camera, turning it on, waiting for the camera to ready itself, lining up the shot, pressing the button, and then waiting for the camera to focus, process and record' [Cohen 2005: 892]).

Ed, then, prior to Cohen's joke about bionic eyes, had already invented a fantasized blogging machine (Cohen 2005: 892). Or had he seen Vannevar Bush's 'camera hound' with his walnut-sized camera strapped to his head? Whatever the case, it would be a vision of a machine, like the Memex in its time, which would again go beyond the available technologies. However, if available, it would collapse 'the living of life' into 'the making of photographs' even further than Ed has already managed. Ed, observes Cohen, has a desire 'to live as he photographs: to photograph as he lives' (2005: 892). If achieved, this expansion of photography would also entail an 'infinite regression' because, 'being everywhere, photography would also be nowhere' (2005: 892). Photography would have no edges, no limits. Might this be a corollary of the 'too much photography' that I proposed earlier?

NOTES

1 This chapter is based on a paper given at the conference 'Private Eyes – Amateur Photography and Collective History' held at the University of Copenhagen in 2009.
2 A version of this paper has been published in Spanish; see Lister, M. (2011), '¿Demasiadas fotografías? La fotografía como contenido generado por el usuario', adComunica: Revista científica de estrategias, tendencias e innovación en comunicación, 2: 25–41.

3 Daniel Palmer delivered his paper 'The rhetoric of the JPEG' during the Versatile Image Conference at the University of Sunderland in 2011.

4 This was a 2007 TED conference. 'TED stands for Technology, Entertainment, Design – three broad subject areas that are, collectively, shaping our future' (from the TED website <http://www.ted.com/pages/about>).

BIBLIOGRAPHY

Agüera y Arcas, B. (2007), 'Blaise Agüera y Arcas demos Photosynth', TED conference, [online video presentation], <http://www.ted.com/talks/blaise_aguera_y_arcas_demos_photosynth.html>, accessed on 15 July 2013.

Batchen, G. (2002), 'Obedient numbers, soft delight', in id. *Each Wild Idea*, Cambridge, MA: MIT Press.

—— (2008), 'Snapshots: art history and the ethnographic turn', *Photographies*, 1(2): 121–42.

Baudrillard, J. (1998), 'Simulation and simulacra', in Poster, M. (ed.), *Selected Writings*, Oxford: Polity Press.

BBC (2004), 'Mobile phone sales dial up a record', BBC News, 3 February 2004, [online], <http://news.bbc.co.uk/1/hi/business/3454811.stm>, accessed on 15 July 2013.

Benjamin, W. (1973; originally published 1936), 'The work of art in the age of mechanical reproduction', in Arendt, H. (ed.), *Illuminations*, Glasgow: Fontana Press.

Bezencenet, S., and Corrigan, P. (1986), *Photographic Practices: Towards a Different Image*, London: Comedia Publishing Group.

Bolter, J.D., and Grusin, R. (1999), *Remediation: Understanding New Media*, Cambridge, MA, and London: MIT Press.

Borges, J.L. (1998), *Collected Fictions*, Harmondsworth: Penguin Books.

Boxer, S. (2001), 'A century's photo history destined for life in a mine', *New York Times*, 15 April 2001, [online], <http://www.nytimes.com/2001/04/15/us/a-century-s-photo-history-destined-for-life-in-a-mine.htmlt>, accessed on 26 April 2012.

Braden, S. (1983), *Committing Photography*, London: Pluto Press.

Burgin, V. (1982), *Thinking Photography*, London: Macmillan.

Bush, V. (1999; originally published 1945), 'As we may think', in Mayer, P. (ed.), *Computer Media and Communication*, Oxford: Oxford University Press.

Cohen, C.K. (2005), 'What does the photoblog want?', *Media, Culture, Society*, 27: 883–901.

Cooley, H.R. (2004), 'It's all about the fit: the hand, the mobile screenic device and tactile vision', *Journal of Visual Culture*, 3: 133–52.

Dennet, T., and Spence, J. (1979), *Photography Politics One*, London: Photography Workshop.

Frosh, P. (2002), 'Rhetorics of the overlooked: on the communicative modes of stock advertising images', *Journal of Consumer Culture*, 2(2): 171–96.

—— (2003), *The Image Factory: Consumer Culture, Photography and the Visual Content Industry*, Oxford: Berg.

Gates, K. (2005), 'Biometrics and post-9/11 technostalgia', *Social Text*, 23: 35–53.

Katz, M. (2004), *Capturing Sound: How Technology Has Changed Music*, Ewing, NJ: University of California Press.

Keen, A. (2007), *The Cult of the Amateur: How Today's Internet Is Killing Our Culture*, New York: Currency/Doubleday.

Kindberg T., Spasojevic, M., Fleck, R., and Sellen, A. (2005), 'The ubiquitous camera: an in-depth study of camera phone use', *Pervasive Computing*, [online], <www.computer.org/pervasive>, accessed on 26 April 2012.

Lister, M. (2007), 'A sack in the sand: photography in the age of information', *Convergence: The International Journal of Research into New Media Technologies*, 13(3): 251–74.

——, Dovey, J., Giddings, S., Grant, I., and Kelly, K. (2009), *New Media: A Critical Introduction*, London: Routledge.

Machin, D. (2004), 'Building the World's Visual Language: The Increasing Global Importance of Image Banks in Corporate Media', *Visual Communication*, 3(3): 316–36.

Manovich, L. (2001), *The Language of New Media*, Cambridge, MA, and London: MIT Press.

Mayer, P. (1997) (ed.), *Computer Media and Communication*, Oxford: Oxford University Press.

Maynard, P. (1997), *The Engine of Visualisation: Thinking through Photography*, Ithaca and London: Cornell University Press.

Morris, A. (2001), *Digital Technologies and Photographic Archives*, PhD thesis, University of Wolverhampton.

Murray, S. (2008), 'Digital images, photo-sharing, and our shifting notions of everyday aesthetics', *Journal of Visual Culture*, 7(2): 147–63.

Okabe, D. (2004), 'Emergent social practices, situations and relations through everyday camera phone use', paper presented at Mobile Communication and Social Change, the 2004 International Conference on Mobile Communication in Seoul, Korea, 18–19 October 2004, [online], <http://www.itofisher.com/mito/archives/okabe_seoul.pdf>, accessed on 26 April 2012.

—— (2005), 'Social practice of camera phone in Japan', in *Ubicomp 2005 Workshop on Pervasive Image Capture and Sharing: New Social Practices and Implications for Technology*, Tokyo, Japan, 11 September 2005.

Puglia, S. (2003), US National Archives and Records Administration, 18th Annual Preservation Conference, Preservation Reformatting: Digital Technology vs. Analog Technology, Overview: Analog vs. Digital for Preservation Reformatting, [online], <http://www.archives.gov/preservation/conferences/papers-2003/puglia.html>, accessed on 26 April 2012.

Rubinstein, D., and Sluis, K. (2008), 'A life more photographic: mapping the networked image', *Photographies*, 1(1): 9–28.

Slater, D. (1991), 'Consuming Kodak', in Spence, J., and Holland, P. (eds), *Family Snaps: The Meaning of Domestic Photography*, London: Virago.

SMH (2005), 'The digital Dark Age', *Sydney Morning Herald*, 23 September 2005, [online], <http://www.smh.com.au/articles/2005/09/22/1126982184206.html>, accessed on 15 July 2013.

Sturken, M., and Cartright, L. (2001), *Practices of Looking: an Introduction to Visual Culture*, Oxford: Oxford University Press.

Tagg, J. (1988), *The Burden of Representation: Essays on Photographies and Histories*, Basingstoke, Hampshire and New York: Palgrave Macmillan.

—— (2009), 'Mindless photography', in Long, J., Noble, A., and Welch, E. (eds), *Photography: Theoretical Snapshots*, London and New York: Routledge.

Tatsuno, K. (2006), 'Current trends in digital cameras and camera-phones', *Quarterly Review*, 18, January.

Van House, N., and Davis, M. (2005), 'The social life of cameraphone images', in *Ubicomp 2005 Workshop on Pervasive Image Capture and Sharing: New Social Practices and Implications for Technology*, Tokyo, Japan, 11 September 2005.

2

The (Im)mobile Life of Digital Photographs: The Case of Tourist Photography

JONAS LARSEN

Introduction

This chapter is concerned with examining how the turn to 'digital snaps' has changed the media ecology of tourist snapshots with regard to technology, production, storage, distribution, viewing and valuing. Photography has always been an emblematic tourism practice and middle-class family albums are packed with tourist snaps. Don Slater (1995) once discussed statistics demonstrating that half of all analogue snappers were buying one or two films each year and they presumably shot one of them during their holiday. Most families would only use their analogue camera on holidays and during important family rituals. Tourist photography and snapshot photography are inseparable modern twins with many parallel tracks, and they have largely constituted the nature of snapshot photography more generally (Urry and Larsen 2011: Chapter 7). While much tourist photography is about 'consuming' significant places, it is also a genre of emotional geographies attentive to co-travelling 'significant others', and our 'happy moments' decorate households and social-networking sites (Haldrup and Larsen 2003,

2010). Any account of the 'new face of snapshot photography' needs to account for how tourist photography is being transformed with the transition to digital photography.

In the introduction we argue that the newness, generally speaking, of digital photography relates to the digitization of images, media convergence and networked sociality at a distance. This potentially makes photographs instantaneous on the one hand and mobile on the other (for further details, see Larsen 2008). The materiality and destination of private tourist photographs have never been more unpredictable and undetermined. The present chapter is inspired by ideas within anthropology and sociology that things are not fixed, but rather have mobile lives and are always in a state of becoming (Appadurai 1986; Jackson 1999; Hannam, Sheller and Urry 2006; Cook and Harrison 2007). In this sense, the chapter explores the spatio-temporal lives of tourist photographs. It explores how (well) they travel and to what destinations. What is the 'home' of tourist snaps in our contemporary mobile, networked societies? And in what material form do photographs travel and populate our everyday spaces? The chapter contributes to and partly moves beyond culture studies concerned with photographs as material *objects* (Edwards 1999, 2002; Edwards and Hart 2004) by discussing the materiality and *im*materiality of digital photography. Will any given tourist snap travel half the world in a nanosecond, straight after bursting into life, or will it be aborted immediately? Will it be a much-liked photograph on Facebook or live a forgotten life in an overcrowded folder? I consider the transformations of tourist photography through the metaphors of life and death, of mobility and stillness. This means thinking of photographs as corporeal, travelling, ageing and affective, rather than as bodiless, timeless, fixed and passive images (for further details, see Urry and Larsen 2011: Chapter 6). So I will engage in a form of 'humanism of the inhuman' (Lash and Lury 2007). This is done from a *historical* perspective, seeing the new in the light of the old, so that both breaks and co-existences between older and newer forms of photography are reported. Carolyn Marvin (1988: 5) notes in her early history of electrical communication that 'new practices

do not so much flow directly from technologies that inspire them as they are improvised out of old practices'.

I begin by discussing some theoretical inspirations; then follows a brief theoretical discussion of how writers have understood the life of analogue photographs. I end by discussing various studies that can help us to understand the mobile and immobile life of tourist snaps.

Theories

This chapter is influenced by practice and non-representational approaches to photography that take the materiality of snaps seriously (Rose 2003; Couldry 2004; Larsen 2005; Pink 2011). They explore how ordinary people do photography and what photographs do to us. With regard to the former, the geographers Alan Latham and Derek P. McCormack state that 'the force of images is not just representational. Images are also blocks of sensation with an affective intensity: they make sense not just because we take time to figure out what they signify, but also because their pre-signifying affective materiality is *felt* in bodies' (2009: 2). So photographs are more than just representations, and while photographic *images* are caught up in the moment, photographic *objects* have temporal and spatial duration; they are performative objects and their affective sensations are felt bodily. This way of reasoning is also stressed by the geographer Veronica della Dora (2009: 340) in her recent article 'Travelling landscape-objects':

> Considering graphic landscape representations as three-dimensional material objects (rather than two-dimensional visual texts) means returning to them their more-than-representational, more-than-textual, more-than-human qualities [...] It means acknowledging materiality's own agency – a move initiated in anthropology, but now involving an increasing number of cultural geographers.

Thus, more-than-representational theories of photographs are concerned with the performative agency of photographs as well as their emotional and affective qualities, something poignantly captured in Roland Barthes's *Camera Lucida*. In that piece, Barthes theorizes photography with, and through, his own body and a few private photos, including one of his mother.

Rose's research on family photography is also concerned with doings and objects of photography – not so much with the birth of photographs, but rather with their afterlife, as photographic objects in time and space. In contrast to Latham and Derek, she is concerned with how people 'do' photographs. Rose partly wants 'to think of family photographs as objects because things are done to objects' and also because, 'while objects may be acted upon, they are far from inert' and in part are constituted through their use and circulation (2003: 8). She examines qualitatively what middle-class mothers *do* – physically, emotionally and socially – with their photographs, causing them to prompt memories, to be exhibitable and to reach absent others (see Chapter 4 in this book).

Studies of tourist photography used to be dominated by a representational paradigm. But in the late 1990s, the geographer Mike Crang (1997: 244) urged tourist scholars to explore the eventful, corporeal practices that produce – or give birth to – tourist photographs:

> Rather than thus seeing pictures as symbols of some hidden meaning, we can think about the practices involved in producing them. Restoring some sense of eventfulness to the pictures can then be achieved without being seduced by the amnesiac geographies of flows, where the experience of the actual tourist seems all too easily erased.

I have adopted such a framework (Larsen 2005; Haldrup and Larsen 2010) in a series of non-representational ethnographies of tourists picturing at attractions and uploading photographs at internet cafés and hotels. They took place at the Danish castle ruin Hammershus (northern Europe's largest medieval ruined castle) in 2001–2 and at various attractions and internet

cafés in Turkey in 2006–7 (for further details, see Haldrup and Larsen 2010). The second ethnography examines in detail how the affordances of digital cameras are enacted in practice – producing, consuming and distributing photographs – and how the nature of tourist photography changes with the transition to digital photography. It also includes home ethnographies where in 2007 and 2008 I visited 18 tourists in their own homes after a recent trip to Egypt and Turkey to explore the afterlife of their photographs.[1]

Throughout this chapter, I will draw upon these studies as well as more recent studies by other scholars, as much has changed with regard to the digitization of photography since 2007 and 2008. Indeed, I will suggest that we need to speak of 'digital photography 1.0' and 'digital photography 2.0' – with my ethnographic studies belonging to the first phase. Now, however, we shall turn our attention to the prominence of life-related metaphors among photography scholars in order to understand how we may conceptualize the life of photographs.

The Life of Analogue Photographs

As Roland Barthes illuminates in *Camera Lucida* (2000), private snaps are not mere images but objects that are 'full of life': a corporeal extension of a dear moment or person. In all their funereal immobility, they can stay alive. They not only freeze but also produce nearness. People do not see a photograph of a loved one; they only see the person. The photograph is a corporeal extension of the pictured person (Barthes 2000: 7). As Rose reports about this illusory co-presence of the represented and its referent: 'That family photos carry a material trace of the person photographed was taken absolutely for granted in my interviews' (2004: 555). My interviewees at Hammershus in 2001–2 emphasized strongly that tourist photos are precious belongings, definitely not throwaway images, 'no matter how hideous the image may be'. Analogue tourist snaps were destined for a long life as material objects (Larsen 2005). This in part explains why tourists took

great care in making good photographs. My observations revealed how analogue-shooting tourists often tended to spend much time on composing and choreographing each photograph. They were rarely the outcome of a quick shutter release: 'I always spend like 15 minutes waiting so that there are fewer people [...] so I don't have all these horrible tourists in my pictures' (Danish female, 40s). The practice of analogue tourist photography was also one of deferral. The camera was just a camera, and the real reward of photographing would first materialize in the future. There was no instant gratification except the pleasures of 'clicking around'. All analogue tourist snaps began their life as invisible, as a negative, and their real social lives first began as prints once tourists had returned home, delivered them by hand to the chemist and later picked them up. Part of the tourist experience was standing outside the chemist, nervously flicking through a couple of newly developed films, sincerely hoping that one's happy moments had turned out well this year. Even with the best of efforts, one was bound to walk home with many blurred and unfocused photographs and perhaps only a handful of pleasing ones.

Barthes and Susan Sontag stress how the other side of photography is 'death'. Sontag notes how 'photographs state the innocence, the vulnerability of lives heading toward their own destruction, and this link between photography and death haunts all photographs of people' (1977: 70). Photography is a murderous act, transforming living subjects into dead images of funereal immobility. One of the causes of a punctum is the fact that we do not see a *picture* of a loved one, but only the *person*. And that person might have died or deserted us. While a young face reminds us that that person is destined to die. To cite Barthes: 'whether or not the subject is already dead, every photograph is this catastrophe' (2000: 96). Death haunts photographs because they are not throwaway objects. They tend to have a long afterlife. The charm of looking at ageing photos is potentially mixed with terror. Even while a joyful and rosy life is celebrated in snapshots, death haunts our loving family tourist photographs. Our dead relatives and our once youthful bodies stare at us. Or our former partner, whom we perhaps

still love! The dark side of family tourist photography is that of loss, absence and death. While photographs are intended to bring back happy memories, they can also strike back and haunt us with unpleasant emotions and effects over time (Kuhn 1995).

Another way of approaching the life of photographs is through the fact that they are three-dimensional objects. Photographs are something more than just representations: they are always both images *and* objects. It is not only the content but also the 'body' of the photograph that reveals its age. Recall Barthes's account of the photograph of his diseased mother:

> The photograph was very old, the corners were blunted from having been pasted in an album, the sepia print had faded, and the picture just managed to show two children standing together at the end of a little wooden bridge in a glassed-in conservatory, what was called a Winter Garden in those days. (Cited in Edwards and Hart 2004: 1)

According to Edwards and Hart, what Barthes describes here is not so much what the photograph shows but how the passing of time has physically aged it as an object. The same goes for photo albums, as enduring material objects that 'have weight, tactility, they often smell, often of damp, rotten card – the scent of "the past"' (Edwards and Hart 2004: 11). Whereas the sensuous quality of the photographic *image* is purely visual, the photographic *object* is a richer and more tactile thing: it is touchable and perhaps odorous. It has been noted that some express an 'almost inseparable desire to touch the image' of a loved one when they consume and talk about it (Edwards 1999: 228; Pink 2011). This 'aura of thing-ness' and sensuous richness has assured analogue photographs a long afterlife.

Acknowledging photographs as objects sets them in motion – in space and time. Photographs are 'blocks of space–time' that have effects beyond the place or people or events to which they refer (Ash 2009; Urry and Larsen 2011: 155). Private photographs are often set in motion to bridge distance, emotionally reaching out to close ones living in other places. Rose

speculates that: 'the more distant people are, the more important photographing becomes [...] A major reason for sending family photographs to relations and friends is that they do not see the children of the family frequently enough' (2003: 11). Rose continues: 'family snaps are seen as a trace of a person's presence; but they are also taken, displayed and circulated in awareness of the pervasiveness of absence and distance. Hence the spatial stretching of domestic space beyond the home. Photos bring near those far away' (2003: 13). The afterlife of photographs is thus not confined within the household. Photographs have long connected remote places and produced emotional attachment with those not living close by. Yet it took considerable time to develop and send them to some distant recipient. Having discussed the life of various analogue snaps, I will now discuss the new life of tourist snaps as they turn digital.

Digital Photography

Let us begin with, so to say, the birth of photographs: that is, how they are produced, something not much discussed within photography studies. Here I will draw on my ethnographic studies of photographic practices at tourist attractions (for more details, see Bærenholdt et al. 2004; Haldrup and Larsen 2010). Equipped with *digital* cameras, tourists tend to photograph faster, spending less time on each photograph. This is because each picture is cost free and erasable. The interviewees praise this freedom to 'shoot around', and they inscribe it with creative and playful qualities: 'We would never have taken 700 photos with a[n analogue] camera. And this, I think, is the cool thing about it [the digital camera], that you can play with it [...] It is a great toy' (Danish man, early 20s). Other respondents also stress the enjoyment of photographing with digital cameras: 'I love them. I think it is great that you can actually snap, snap, delete, delete if [you] need to, rather than carrying film and not knowing how they turn out' (Australian woman, late 20s). Digital cameras push photography in a more playful and

experimental direction, and this is causing a profound multiplication of photographs. While the fact that it is free and fun to photograph digitally partly explains this boom, the immediate delivery, instant viewing and the possibilities for termination (deletion) also underpin it.

This also highlights the new temporality of photographs. While analogue cameras depend upon developing to make their photographs 'come to life', digital cameras make and store them by themselves and display them instantly on the screen. Photography is no longer an art of deferral or what Barthes (2000) called the 'that has been'. Digital cameras' screens can also show ongoing events right here, as the spaces of picturing, posing and consuming come together. The camera screen is where most photographs are inspected immediately after springing into life as well as during their first days (before uploading). The digital camera is not just designed as a picturing device (a camera), but also as an archive of thousands of snaps and an album or projector where the archived snaps can be examined and shown (see also Rubinstein and Sluis 2008; Van House 2009). As my ethnographic study in Istanbul showed, as early as 2007–8, where my tourists were novel digital snappers, it had become a ritual to examine the digital camera screen right after a single shot or a longer series, at the very scene or somewhere with some shade, so that the image may be seen properly. 'Here you just take five [photos of everything] and then you can sit in the shadow and say: "this is crap, this is crap", and then there are two left [...] there is so much *freedom* involved in this' (Danish female, mid-20s). It had also become common to delete and retake photographs that did not instantly charm. This affords experimentation and greater control over how people and places are represented. Strikingly, few tourists expressed any emotional difficulties about deleting photographs, even of loved ones. This deleteability represents something radically new. In a short span of time, tourists have learnt to consume photographs instantly and digitally upon screens and to delete those deemed unappealing. Consuming and deleting photographs have become part of producing photographs, which makes it easier (yet more time-consuming because of retaking) to produce the

anticipated images. Tourists are less likely to be haunted by poor images in the future as we have seen was the case with analogue tourist photography. The flexibility of the digital camera represents a further twist to consumer society where 'the presentation of the self' takes a renewed importance (for details on this research, see Haldrup and Larsen 2010). We have seen that analogue snaps were ageing material objects too, but this is not the case with digital snaps – unless they are printed. While camera screens have a material tactility, the photographs they display are images, not physical objects. Their lack of material aura perhaps explains why they are so easy to delete.

When I conducted my study in Turkey, few Western tourists used mobiles for 'serious' tourist photography. The vast majority used digital cameras. As a consequence, hardly any newborn photos travelled as 'live postcards' (communicating: 'we are here right now') by MMS messages. The interviewees argued that this was due to the lack of critical mass, poor picture quality and the high price of sending MMS messages. As Rubinstein (2005: 1) reports more generally about the first generation of not-so-smart mobile phones, what we might call 'mobile phone 1.0':

> Most of them prove to be of limited use, as they tend to interfere with the main purpose of the phone, either by shortening the battery life, or by becoming ergonomically cumbersome. The phone that can take digital photographs did not seem to be principally different from these other crossbreed implements whose main attraction is the manifestation of technology at a stage when it is capable of producing hybrids and mutations. The images obtained from these cameras were only good to 'muck about', in the words of the first advertising campaign for these phones.

But there is also the non-technical explanation that the interviewees did not regard their camera phone as a camera (it is just a phone!). Others again ‸‸d that they desired a holiday where they could unplug and a mobile ‸d potentially disrupt that. Other mobile-phone research at that

time likewise showed that 'camera phones 1.0' primarily captured every-day life and not tourist life (Goggin 2006: 145; Villo 2007). The everyday became an object of photography because suddenly one had a camera that was always at hand (rather that something that one needed to remember to bring along and carry in a bag or around the neck) (Lee 2010). The mobile phone made photography mobile and connected with the body and everyday practices, but this had little impact on tourist photography. So, interestingly, camera phones did not initially connect with tourist photography as analogue photography has done since the invention of the Kodak Brownie Camera in the 1890s (Urry and Larsen 2011: Chapter 7).

Yet this has changed within the last couple of years in which mobiles have become 'smart' and able to take much better photographs. Not many 'magic moments' are missed and the everyday has become much more 'photographic'. This is the era of what I term 'mobile phones 2.0'. Smartphones seem to be everywhere these days and not least iPhones have become 'hot'. In Europe the penetration rate (the number of active users or owners within a specific population) is 50 per cent, and constantly rising. In great numbers camera phones are replacing digital cameras as *the* camera these days (see the introduction of this book). The problem with digital cameras and 'mobile phones 1.0' is that they are monofunctional, whereas the 'mobile phone 2.0' is a multimedia device that connects the camera to the outside world.

We may even talk of a subgenre of snapshot photography called 'iPhone-ography', as the photographer Stephanie C. Roberts does in her photography guide to the iPhone. She writes 'that iPhoneography is the art of shooting and processing (editing and enhancing) digital images using an iPhone' (2011: 1). It involves various digital photography applications, or 'apps', and social-networking services such as Twitter, Flickr and Facebook. Hipstamatic is one of the most popular iPhone apps. Ironically, it represents a retro trend in digital photography in the sense that the photographer can use the square format (similar to Kodak Instamatic and Polaroid images) of the iPhone camera and digital flashes, lenses and films to simulate the look of old analogue photographs. With Instagram, a user can apply various

retro filters to his or her photographs and then share them on a variety of social-networking services, including Instagram's own. There is also another conventionality built into the affordances of the iPhone. This is in relation to the tactility of the screen. The iPhone comes with a wide screen where a user can leaf from one photo to another by swiping a finger across the display. Now it is once again possible to touch a photograph and flick through an album. All this makes photographs resemble the look and feel of old analogue photographs, while making them in the same movement much more mobile than the original.

In the era of 'mobile phone 2.0', many tourists shoot with smartphones even when visiting the supposed highlights of their tour. Why bring along an additional camera if one has a camera of roughly similar quality built into a mobile phone (one that might also contain a guidebook in the form of an app)? Another advantage is that it is discreet and does not shout out loudly its user's identity as a tourist. So often tourists are resisted and mocked because tourism, and not least tourist photography, represents commercialism, superficiality and a distinct lack of coolness. Shooting with a smartphone, one is less likely to be positioned as yet another 'insipid tourist' with a clunky camera around his neck (and a heavy, brightly coloured guidebook). On a recent trip to Vietnam with my son, I delighted in the anonymity and lightness that my smartphone afforded. Having downloaded a cheap guidebook app, I had no cause to worry about carrying and looking after a book and camera since my guidebook–map–watch–camera phone fitted nicely into my discreet money belt. And I also escaped the burden of sending postcards by texting a few photographs.

Yet there is also something oddly frustrating and worrying about travelling with a camera phone in a foreign country. While it can be nice to receive a text from a friend at home, a call from work or an unknown number can cause stress. In this sense, we may say the camera phone becomes too much of a phone and therefore disrupts the 'tourist escape'. Yet it is also an annoying factor that international calls and roaming charges are exorbitantly high, and this will largely restrict most tourists' use of their mobiles. This is particularly

annoying for those with a mobile-phone deal that otherwise includes the free use of texts, photo-messages and the internet. They are used to sending messages freely and without considering issues of cost. How very different it is abroad. While photo-messages are not particularly expensive, the price will almost inevitably restrict tourists from sending many. What is more of an issue is the exorbitant roaming charges of accessing the internet from one's mobile abroad. Everyone, it seems, knows somebody who, unaware of those charges and how to avoid them, returned home to find a massive telephone bill. Therefore, international tourists as a matter of routine turn the data roaming off. Yet once this is done the smartphone is not 'smart' any more. It does not connect to the internet and so one cannot upload photographs in the same breath as one takes them. This is somewhat overlooked in otherwise brilliant writing on the digitization of tourist photography where it is stressed that tourists often share images immediately after taking them. As the sociologist Jennie Germann Molz (2012: 66) writes:

> Now more than ever, leisure travellers are likely to use mobile digital devices to stay in touch with a geographically dispersed group of friends and family members while they are on the road. Thanks to the 'digital immediacy' of camera phones and the Internet, snapshots and travel stories that would have been shared after the journey can now be shared in interactive formats *while* the traveller is experiencing them. Travel mottos like 'I was here!' or 'Wish you were here!' seem obsolete in an age of 'I am here right now and you are (virtually) here with me!'

Domestic tourists will have a higher propensity to upload photographs instantly to, say, their Facebook account than foreign ones. At the present time, there are some strong economic barriers to achieving real-time connected presence with people back home when travelling abroad. Once they locate a place with free Wi-Fi connection, the best they can hope for is a slightly delayed 'connected presence' or 'synchronous gaze'. Nonetheless, the

tourist gaze is increasingly connected with 'a synchronous gaze' at home. This means that the function of the photograph is not only to document an event for the future, but to act here and now, to *prick* the receiver: 'We are separated but I'm thinking about you right now and I'm alive.' This is the new punctum of digital photography, according to Villi (see Chapter 3 in this book). Digital tourist snaps are consumed in fundamentally different ways than used to be the case with analogue snaps. Tourist snaps on blogs and social-networking sites elicit a sense of actively 'travelling with' rather than listening to stories or looking at photos after the journey (Molz 2012).

Post-Travel Photography

While tourist photography is increasingly consumed on the move, there is still photo work going on at home. My ethnographies include studies of what people do to their photographs when they return home and where their photographs travel (similar to Van House 2009; Rose 2010). They may travel to desktops, folders, printers, photo paper, frames, social-networking sites – or trash bins.

Most photographs that survive deletion on tour are uploaded to computers and viewed on yet another screen, the computer screen or sometimes the TV screen. The latter was particularly the case in households with a stationary computer placed in a smaller home office where it was not convenient to watch photographs together (see similar findings in Nunes, Greenberg and Neustaedter 2009). Many uploaded their digital photographs to their computers and filed them in special folders. But in some homes, they seemed forever imprisoned in the camera that gave birth to them. They do not even make it to the computer.

Few did much editing, the majority make little more editing work than 'filing'; so, based on this study, there is little evidence that 'image doctoring' is an integral element to autobiographical remembering (van Dijck 2008: 67). Not many photographs receive much of a 'facelift' or 'body makeover' (see also

Rose 2010). This limited post-production care may be down to the sheer fact that tourists now return with way too many photographs. They were exciting to make but boring to organize and polish off. As Lister (2007) says, we are in process of being drowned in photographs (see also Chapter 1 in this book).

From here, a small selection are mobilized and distributed, emailed to friends and family members or uploaded to social-networking sites where they will (hopefully) be consumed upon further computer screens around the world. My respondents explained how they mobilized photographs through practices of attaching them to emails.

The vast majority of the photographs are thus 'immobilized' by the computer where they also are denied a material existence (see Chapter 1). Most digital tourist photographs are as immobile and fixed as the traditional analogue photograph, which so often lived silently in an album on the bookshelf. But at least analogue photographs were 'real' photographs whereas digital photographs are only 'half-human', a code. And this is the reason why it is much easier to delete digital photographs than it is to dispose of paper photographs. While several of the respondents expressed a longing for paper photographs and physical albums, few actually printed their digital images, and the computer screen is where most viewings take place. Many photographic images are now destined to live, for longer or shorter periods, virtual, digital lives without any material substance – in cameras and computers as well as on the internet, as I will now discuss.

Indeed, some digital snaps are travelling. As discussed, family snaps have always been posted to faraway family members. The desire or need to send photographs to significant others is nothing new. What is new is that the digitization and internetization of photographs have made this cheaper and easier, as emails and 'messages' travel as fast and as cheaply to multiple far-off destinations as they do to singular nearby ones. All you have to do is press the button and the 'internet' does the rest (Rubinstein and Sluis 2008).

However, as some of my respondents said, this was not always the case in the early days of the internet. They told anecdotes about photo emails

that did not travel light and instead blocked email boxes (as was even more the case in the past, see Rubinstein and Sluis 2008: 12). But photographs are travelling much lighter and email boxes have improved storage capacity these days, so photographs travel more smoothly and regularly, and they are less likely to be promptly deleted. Millions and millions of private snaps live forgotten and invisible lives in email boxes.

But at the same time billions of other photographs live semi-public and visible lives on blogs and especially on social-networking sites where they are more or less open to a public audience or extended networks. Overwhelming numbers of tourist photographs are exhibited on user-generated travel sites such as www.virtualtourist.com, www.tripadvisor.co.uk, www.trekearth.com and amateur photography sites such as www.flickr.com. About 5 million photos are uploaded to the last of these on a daily basis and 80 per cent have open exhibitions (profiles) (Davies 2006; Cox, Clough and Marlow 2008). The 'sincerity' of user-generated material is also recognized by tourist organizations that ask tourists to upload comments, photos and videos (see the introduction of this book).

Yet Facebook is where most tourist snaps live virtual lives these days. Three million Danes (out of a total population of 5.5 million) now have a Facebook account, compared with only a few hundred thousand (mainly youngish people), or fewer, when I conducted the bulk of our home ethnographies during 2008. Although only a few of the interviewees had a Facebook profile at the time of my visit, many more of them have one today, and, like most other Facebookers, they exhibit single images and albums there. Tourist photographs have found a new home in the semi-public world of Facebook friends, and much activity on Facebook relates to seeing and perhaps 'liking' and commenting upon other people's private snaps. There is an interesting element of voyeurism from below at play here. This illustrates how we may consume holiday photographs without necessarily being face to face with the photographer; the lives of photographs become much distributed, noticed and semi-public. Given that the average Facebooker has around 200 friends, that Facebooking, for many, is

an everyday practice, and that Facebook photographs are much seen and commented upon, photographs now reach a far wider audience (including 'weak' and 'old' ties) and have become part of the everyday life of the networked household and its face-to-screen sociality. (Tourist) photographs have never been so visible, distributed and semi-public before (Rubinstein and Sluis 2008).

It has been argued that, unlike the traditional photo album, exhibitions of photographs on Flickr and Facebook are tied into the flow of the everyday and tend to reflect 'instantaneous time', a 'culture of instantaneity' where people expect 'rapid delivery, ubiquitous availability and the instant gratification of desires' (Tomlinson 2007: 74). We are told that on Flickr and Facebook snapshot photographers do not so much share memories (as was the case with analogue photography) as ongoing or recent experiences. So photographs on Facebook and Flickr are said to be short-lived, a stream of 'transitory, ephemeral, "throwaway"' images (Van House 2007: 2719). This is only partly the case now. First, there would not be billions and billions of photographs on various social-networking sites if all digital photographs were in any simple sense 'throwaway images'. While most digital photographs were sent and uploaded to communicate something 'ongoing' or very recent, it seems that few delete such photographs, so as time passes by they change meaning and become memories of a distant event. This is also recognized by the fact that Facebook has introduced a timeline that archives a user's photographs according to the year in which they were uploaded. So old photographs as much as new photographs make up the identity of the snapshot world of Facebook. Broken hearts, ageing and 'death' will also haunt the user's Facebook albums in the future. Moreover, once the photographer lets loose a photograph on the internet, he or she loses control over its destiny, as friends or strangers may use it in unforeseen contexts or distribute it even further. As copyable and timeless travelling bites of information, internet-residing photographs face very unpredictable lives with multiple possible paths, and some of these are potentially harmful and unpleasant:

> While the Internet allows for quick and easy sharing of private snap-shots, that same tool also renders them vulnerable to unauthorized distribution. Ironically, the picture taken by the roommate as a token of instant and ephemeral communication may have an extended life on the Internet, turning up in unexpected contexts many years from now. (van Dijck 2008: 59)

They are also out of control and in danger due to extreme fragility in computer hardware and storage media (Lister 2007). We know that computers crash, and yet so often we forget to store our holiday photographs elsewhere.

Conclusion

This chapter has discussed the ways in which digital cameras and images are changing the nature of tourist photography. I have described how photography has changed dramatically in recent years, during which time photography has become digital and networked, converging with mobile phones, computers, the internet, blogs and social-networking sites. I have argued that the newness of digital photography compared with analogue photography relates to connectivity and mobility on the one hand (uploading and posting images) and immediate consumption and what we might call 'screen-ness' on the other.

I have suggested that the digitization of tourist snapshot photography has gone through at least two phases. The first phase was dominated by digital cameras while few used their mobiles for 'serious' tourist photography (they might have take an odd mobile picture now and then) and even fewer used the internet to send and upload photographs while on holiday. At that time, tourist photography involved little 'connectivity' and 'mobility'. Yet I have shown the huge significance of the screen. The pleasurable 'magic' of digital cameras is that they make photographs and they do so instantly, so that photographs may be widely consumed on the screen and erased on the spot.

A significant part of this pleasure is the co-performances of much digital photography. Tourist photography has become a communal game where people consume and inspect the newborn image in unison straight after its release and during the holiday. This is a source of much playful face-to-face talk and sociality. This screen-ness separates digital photography from analogue photography and yet it also highlights their common history. Both the photographic album and the digital camera screen are material objects that function by virtue of presence and co-performances of talk and showing. Yet where tourists used to come together to relive memories, photographic consumption has now become part of tourists' co-performative experiences.

The second phase refers to the situation where tourists begin to take pictures with mobiles (what I have termed 'mobile phone 2.0') and upload tourist snaps in vast numbers to various social-networking sites. This is also the period in which more and more photographs will have potentially mobile lives. Whereas tourist photographs used to be fixed material objects with a secure, stable home in the bookshelf-residing photo album, most are today variable digital objects facing unpredictable afterlives in computer trash bins, folders, email boxes, blogs and, increasingly, on social-networking sites. Their life is not determined and it is a hard job to track their paths and predict their future whereabouts and characteristics, which is to say nothing of their life expectancy, although many do have short lives. More generally, our photographs no longer have their own designated storing and viewing space (e.g. shoebox or album) as they now share it with our downloaded games, music, films, books, articles and much more. Tourist photographs have become more visible, mobile and tied up with everyday socializing on various networked screens. Lack of an 'aura of thingness' partly explains why so many digital photographs are short-lived, but also why they are valued as a fast, mobile form of pictorial communication in mobile, networked societies, where social ties are often at a distance and much socializing is mediated by and conducted through distantiated screens.

NOTES

1 The interviews lasted between 1 and 2.5 hours and included observations on how photographs are used, worked upon, filed, discarded and distributed.

BIBLIOGRAPHY

Appadurai, A. (1986) (ed.), *The Social Life of Things: Commodities in Cultural Perspective*, Cambridge: Cambridge University Press.

Ash, J. (2009), 'Emerging spatialities of the screen: video games and the reconfiguration of spatial awareness', *Environment and Planning A*, 41(9): 2105–24.

Bærenholdt, J.O., Haldrup, M., Larsen, J., and Urry, J. (2004), *Performing Tourist Places*, Aldershot: Ashgate.

Barthes, R. (2000), *Camera Lucida*, London: Vintage.

Cobley, P., and Haeffner, N. (2009), 'Digital cameras and domestic photography: communication, agency and structure', *Visual Communication*, 8: 123–46.

Cook, I., and Harrison, M. (2007), 'Follow the thing', *Space and Culture*, 10(1): 40–63.

Couldry, N. (2004), 'Theorising media as practice', *Social Semiotics*, 14(2): 115–32.

Cox, A.M., Clough, P.D., and Marlow, J. (2008), 'Flickr: a first look at user behaviour in the context of photography as serious leisure', *Information Research*, 13(1), paper 336, [online], <http://informationr.net/ir/13-1/paper336.html>, accessed on 15 July 2013.

Crang, M. (1999), 'Knowing, tourism and practices of vision', in Crouch, D. (ed.), *Leisure/Tourism Geographies: Practices and Geographical Knowledge*, London: Routledge: 238–56.

Davies, J. (2006), 'Affinities and beyond! Developing ways of seeing in online spaces', *E-Learning*, 3(2): 217–34.

della Dora, V. (2009). 'Travelling landscape-objects', *Progress in Human Geography*, 33: 334–54.

Edwards, E. (1999), 'Photographs as objects of memory', in Kwint, M., Breward, C., and Aynsley, J. (eds), *Material Memories: Design and Evocation*, Oxford: Berg.

—— (2002), 'Material beings: objecthood and ethnographic photographs', *Visual Studies*, 17(1): 67–75.

Edwards, E. and Hart, J. (2004), 'Introduction: photographs as objects', in Edwards, E. (ed.), *Photographs Objects Histories: On the Materiality of Images*, London: Routledge.

Goffman, E. (1969; originally published 1959), *The Presentation of the Self in Everyday Life*, New York: Doubleday.

Goggin, G. (2006), *Cell Phone Culture: Mobile Technology in Everyday Life*, London: Routledge.

Gregson, N., Metcalfe, A., and Crewe, L. (2007), 'Moving things along: the conduits and practices of divestment in consumption', *Transactions of the Institute of British Geographers*, 32(2): 187–200.

Haldrup, M., and Larsen, J. (2003), 'The family gaze', *Tourist Studies*, 3(1): 23–46.

—— (2010), *Tourism, Performance and the Everyday: Consuming the Orient*, London: Routledge.

Hannam, K., Sheller, M., and Urry, J. (2006), 'Mobilities, immobilities and moorings', *Mobilities*, 1(1): 1–22.

Jackson, P. (1999), 'Commodity cultures: the traffic in things', *Transactions of the Institute of British Geographers*, 24(1): 95–108.

Kuhn, A. (1995), *Family Secrets: Acts of Memory and Imagination*, London: Verso.

Larsen, J. (2005), 'Families seen photographing: the performativity of tourist photography', *Space and Culture*, 8(3): 416–34.

—— (2008), 'Practices and flows of digital photography: an ethnographic framework', *Mobilities*, 3(1): 141–60.

Lash, S., and Lury, C. (2007), *Global Culture Industry*, London: Polity.

Lash, S., and Urry, J. (1994), *Economies of Signs and Space*, London: Sage.

Latham, A., and McCormack, D.P. (2009), 'Thinking with images in non-representational cities: vignettes from Berlin', *Area*, 41(3): 252–62.

Lee, D.-H. (2010), 'Digital cameras, personal photography and the reconfiguration of spatial experiences', *Information Society*, 26(4): 266–75.

Lister, M. (2007), 'A sack in the sand: photography in the age of information', *Convergence*, 13: 251–87.

Marvin, C. (1988), *When Old Technologies Were New: Thinking about Electric Communication in the Late Nineteenth Century*, Oxford: Oxford University Press.

Molz, J.G. (2012), *Travel Connections: Tourism, Technology and Togetherness in a Mobile World*, London: Routledge.

Nunes, M., Greenberg, S., and Neustaedter, C. (2009), 'Using physical memorabilia as opportunities to move into collocated digital photo-sharing', *International Journal of Human-Computer Studies*, 67: 1087–111.

Pink, S. (2011), 'Sensory digital photography: re-thinking "moving" and the image', *Visual Studies* 26(1): 4–13.

Roberts, C.S. (2011), *The Art of iPhoneography: A Guide to Mobile Creativity*, Lewes: ILEX.

Rose, G. (2003), 'Family photographs and domestic spacings: a case study', *Transactions of the Institute of British Geographers*, 28(1): 5–18.

—— (2004), 'Everyone's cuddled up and it just looks really nice: an emotional geography of some mums and their family photos', *Social and Cultural Geography* 5(4): 549–64.

—— (2010), *Doing Family Photography: The Domestic, the Public and the Politics of Sentiment*, Aldershot: Ashgate.

Rubinstein, D. (2005), 'Cellphone photography. The death of the camera and the arrival of visible speech', [online], <http://lsbu.academia.edu/DanielRubinstein/Papers/98273/Cellphone_photography_The_death_of_the_camera_and_the_arrival_of_visible_speech>, accessed on 7 May 2012.

Rubinstein, D., and Sluis, K. (2008), 'A life more photographic', *Photographies*, 1(1): 9–28.

Slater, D. (1995), 'Domestic photography and digital culture', in Lister, M. (ed.), *The Photographic Image in Digital Culture*, London: Routledge: 129–46.

Sontag, S. (1978), *On Photography*, New York: Farrar, Straus & Giroux.

Tomlinson, J. (2007), *The Culture of Speed: The Coming of Immediacy*, London: Sage.

Urry, J., and Larsen, J. (2011), *The Tourist Gaze 3.0*, London: Sage.

van Dijck, J. (2008), 'Digital photography: communication, identity, memory', *Visual Communication* 7(1): 57–76.

Van House, N. (2007), 'Flickr and public image-sharing: distant closeness and photo exhibition', *CHI*, 3(2): 2717–22.

—— (2009), 'Collocated photosharing, storytelling, and the performance of self', *International Journal of Human-Computer Studies*, 67: 1073–86.

—— (2011), 'Personal photography, digital technologies and the uses of the visual', *Visual Studies*, 26(2): 125–34

Villi, M. (2007), 'Mobile visual communication: photo messages and camera phone photography', *Nordicom Review*, 28(1): 49–62.

3

Distance as the New Punctum

MIKKO VILLI

The camera phone is used to capture, like, instant things. For example, I see a really hot girl, and I want to take a picture and send to a friend – 'look who's at the party' – so it's, like, quick things with the phone.

This quote from Kasper, a Finnish camera-phone user, demonstrates the momentary and real-time character apparent in the communication of camera-phone photographs. A photograph captured with a camera phone and forwarded directly from the phone can offer an almost synchronous photographic connection between the sender and the receiver(s). Photographic communication can thus be about communicating the *now*. The photograph is valuable for the purposes of interpersonal interaction and engagement at a specific moment, like words during a phone call. After all, the photograph was captured with a camera *phone*.

The use of camera phones in photographic communication does not rely only on telephone networks, but it increasingly takes advantage of the connection to the internet provided by mobile broadband. These extremely connected cameras further diversify the modes of sharing and communicating photographs. Nowadays, social-media services such as Facebook and Twitter are integral in communicating photographs. In addition to the content-sharing platforms on the Web, mobile photo applications ('apps') are expanding

photo circulation on the internet. Thus, as Francesco Lapenta (2011: 1–2) notes, 'what is really changing has little to do with the increasing numbers of images taken every day and more to do with the increasingly differentiated forms of photographic image production, aggregation and distribution.' Much of the traffic in photographs now circulates through information networks and is facilitated by new platforms (Dovey and Lister 2009: 136–7).

This chapter focuses on the influence of mobile-phone communication and digital networks on vernacular photography, more specifically on the *communication* of vernacular photographs. In particular, I study how the meaning of time and distance is changing in relation to photography. I do not focus on the implications of time *in the image*, but rather on the time that passes between the original exposure and the remote viewing of the photograph. In reference to the theory of photography, I adapt ideas from Roland Barthes, especially his discussion on spatial immediacy and temporal anteriority, and the concept of punctum. For Barthes, it was not possible to consider photography as a part of telephone communication, but I intend to extend his thoughts into the era of camera phones and digital communication networks.

In the first part of the chapter, I discuss the elements of time and distance in camera-phone photography. In the following section, I introduce the idea of distance being the 'new punctum'. In the concluding section, I complement the more theoretical insights with actual examples of camera-phone communication from a study of Finnish camera-phone users.

Time and Distance

It can be argued that in the process of developing communication technology over the last few centuries the greatest emphasis has been placed on advancing telecommunication media (Villi 2010: 84). Since the late nineteenth century, development has been particularly rapid in technologies that allow communication over distance, that is, everything with the prefix 'tele-':

telegraph, telephone, telex, television (Manovich 2001: 162; Harper and Hodges 2006: 256). In addition to the crossing of distance, the possibility of communicating in real time is a vital aspect of telecommunication; 'tele-' is defined by both the simultaneity and the crossing-of-space of communication. Paul Virilio (1998: 51) even insists that, due to new communication technology, *here* ceases to exist and everything is only *now*, meaning that we can be present in multiple spaces simultaneously. John Urry (2000: 126) uses the expression 'instantaneous time' in describing how communicational changes allow information to become instantaneously and simultaneously available more or less anywhere. Mobile phones and the internet manifest perfectly this instantaneous time.

What is specifically of interest to me is how the condition of instantaneous time affects the communication of photographs. Real-time communication over distance has always been the essence of telephone communication. By contrast, the most prominent use of photographs has been recording and documenting events for viewing at a later time. Before the advent of digital photography, it took considerable time just to develop the photographs,[1] not to mention transmitting them instantly from the camera to some distant recipient (Villi 2010: 84–5).

As a consequence, the conceptions of photography have generally regarded the essence of photography as the 'that has been', subject to the passing of time. According to Barthes (1991: 44), a photograph does not establish a consciousness of the 'being there' of the object in the photograph, but an awareness of its 'having been there'. In his essay 'Rhetoric of the image', Barthes (1991) presents a specific space–time category for photographs: 'spatial immediacy' and 'temporal anteriority', 'the photograph being an illogical conjunction between the here–now and the there–then'. Photographs are like time machines, as they shuttle us back and forth between past and present (Batchen 2004: 97).

The concept of spatial immediacy can be read as the ability of a photograph to provide in itself a presence in space by being in front of the viewer as a material artefact, the 'here–now' of an event photographed in some

other place, some time ago. The 'there–then' of the photograph is present here and now. The photograph provides an after-image of the moment, place or person photographed, through a temporal transition – in a way, the photograph is a re-enactment of that situation. Photography is then about presence in space and absence in time; (Villi 2010: 85) it is communication *over* time, not communication *in* time.

A camera-phone photograph can offer the same type of spatial immediacy as any photograph, as it can mediate an event from there–then to here–now. However, a photograph transmitted immediately after capture by using the network connection provided by the mobile phone can also provide *temporal* immediacy. It can form a connection between 'there–now' and 'here–now' and thus be more about communicating over space than communicating over time (Villi 2010: 86, 98).

The available research on camera-phone communication (e.g. Kato et al. 2005; Rivière 2005; Koskinen 2007) directs us to the assumption that the communicative relationship of a camera-phone photograph to time is potentially different from that of a photograph taken with a camera lacking any capabilities for telecommunication. As the camera-phone photograph can be used to link remote individuals visually in real time, the photograph can then be more of a 'tele-machine' than a time machine (Villi 2010: 133). The photograph can shuttle the individuals between two physically separated 'presents'.

Camera-phone communication is not only about the present, but also *presence* or, more specifically, mediating one's presence (Villi 2010). 'Mediated presence' describes the use of telecommunication technology in being in contact over physical distance (Licoppe 2004: 147). This presence is not direct physical co-presence, but instead communicated through a medium, mediated. Users of telecommunication technology are not present in other places by any physical means, but merely present in the space of the communicative connection. Mediated presence represents an 'as if' presence: people can be connected to a remote location as if they were there themselves; they can talk on the phone as if they were sitting next to the other

person (Huhtamo 1995: 95). A photograph also enables mediated presence by conveying the presence of the absent, the object or person captured in the photograph. Photography exemplifies the epistemological dialectic of presence and absence (Lister 2007: 353). Actually, as Göran Sonesson (1989: 73) writes: 'the whole point of photography is to offer us vicarious perceptual experience, that is, the illusion of having seen something without having been present at the scene.'

In the context of telecommunication, the idea of mediating presence visually can be extended through the idea of a 'synchronous gaze' (Villi 2010: 139–41). A photograph communicated from a camera phone in a concurrent manner offers both an interpersonal, shared experience and a common view (for the sender and the receiver) through the photograph. The act of seeing together as a practical possibility was in the past available only to individuals sharing the same space at the same time (Villi and Stocchetti 2011: 108). Ilpo Koskinen (2007: 132) illustrates the phenomenon by describing how, when a person observes something interesting and communicates it visually to distant others, the communicators for a brief moment 'share a point of reference'. Camera phones make ubiquitous visual access to others possible, and thus the gaze of others is always present as a potentiality (Okabe 2005).

Distance as a Source of Punctum

Following the discussion on time and distance in relation to camera-phone photography, I will extend the insights of Roland Barthes into networked photographic communication. Specifically, I want to introduce the idea of distance as a source of punctum, exemplified in photographic communication between people separated by distance. Instead of a strong argument, I present here rather a notion regarding the need to update the theory of photography in order to reflect photography in the age of camera phones and digital communication networks.

Barthes introduced the concept of 'punctum' in his classic work, *La Chambre claire: note sur la photographie/Camera Lucida: Reflections on Photography* (Barthes 2000). The 'punctum' is the detail in a photograph that attracts the viewer; it comes in contrast to the 'studium', the cultural coding or cultural context of the photograph, the general knowledge in the photograph (2000: 42, 94–6). The studium is the whole context of meaning and references (Baudrillard 1999: 139); it is the shared cultural information of average interest. By contrast, the punctum is, in a way, cultureless and totally personal (Barthes 2000: 90). The detail in the photograph that 'stings' the viewer is too personal to generalize for all viewers. However, this personal relation does not have to be personal in the sense that the viewer knows the person in the photograph or that there is some kind of intimate relation between them, but that there is something in the photograph that is personally relevant to the viewer, a subjective meaning. According to Barthes (2000: 55), '[it] is what I add to the photograph and what is nonetheless already there.'

In addition to a detail in the photograph, time can also be the source of punctum (Villi 2010: 95). Or, more accurately, the passing of time, the fact that the person or object in the photograph existed and does not necessarily exist anymore, implying the future death of the viewer as well. It is not just the abrupt and unforeseen detail, but also a detail overrun by time. A photograph is a pure representation of the passage of time and therefore also connotes death (Olin 2002: 108; Fried 2005: 560–1). The feeling of loss is important; the inevitable aura of a lost past attached to all photographs causes a trauma or pain (Jay 1993: 444). That feeling is often permanent, as the loss itself is permanent. The past is lost, but also the person in the photograph can be lost for ever. The spiritual sufferance is associated with the absence in time (which, at the extreme, is death) (Villi and Stocchetti 2011: 108), as when Barthes is looking at the Winter Garden photograph, experiencing grief for his recently deceased mother.

A camera-phone photograph communicated immediately after its capture, too, manifests a future death – death is latent in the image. Yet due to its

immediate and transient communicative nature, it can have a different rela-
tion to death and the passage of time from, for example, album photographs.
It would be exceptional to receive a photograph that depicts a dead person
(not dead in the image, but dead now). By contrast, family photo albums are
full of people that have already passed away. There is not necessarily a defeat
of time in the camera-phone photograph, as the 'that has been' (Barthes 2000:
96), the essence of a photograph, is subsumed to the image. But importantly,
the 'has been' is not very far temporally from the 'is', the present; the past is
not very past in the photograph. In this sense, it is hard to feel a sensation
of loss when receiving a camera-phone photograph taken only a minute
ago – at least a loss related to the passing of time (Villi 2010: 96).

However, there is another kind of loss built into a photograph captured,
communicated and viewed in the space of an instant. Imagine a situation
where a person is travelling far away from home, when he or she receives a
photograph to the phone sent by his or her spouse, portraying their children,
mediating their present presence at home. They are alive, but they are not
there, with the traveller. They are absent, and this absence – not absence in
time, but absence in space – can be a source of punctum. The picture of the
children can wound the receiver due to the sensation of yearning. This loss,
often temporary, represents the same type of absence as with all telephone
communication: the photograph wounds over distance. What the notion
of punctum does, in practice, is to express the subjective awareness of the
absence produced – somewhat paradoxically – by the visual activation of
a feeling of presence (Villi and Stocchetti 2011: 108). In this sense, the
camera-phone photograph is similar to a picture of a loved one that has
been placed in the wallet or a pendant. However, the camera-phone pho-
tograph is not just a reminder of the other, but is often also an expression
of the sender's feelings in that exact moment.

Distance as a source of punctum is affiliated with the potential transience
of camera-phone photographs (Villi 2010: 91–3). When distant individuals
strive to establish and maintain a connection by communicating through
photographs, the feeling of loss associated with the photographs is often

not permanent, and the motivation for sending photographs is high only during the phase of absence. The fading of distance (i.e. when the absent party has returned) leads to a situation where the distance is no longer a source of punctum. And if the punctum acts as an important motive for cherishing and saving photographs, then there is necessarily no reason to save the photograph once the distance has been reduced to zero, when the traveller is back home again. By contrast, the punctum of time never ceases. It is not possible to abolish time in the same sense as distance; the dead cannot return. Time as a source of punctum in a photograph is universal (Batchen 2007: 285–6) and, we might add, permanent.

Naturally, camera-phone photographs can also be viewed, like any photographs, after years have passed. This aspect of camera-phone photography can be expected to become more prominent along with the evolution of the technology and software in camera phones. The picture quality and storage capacity of a camera phone can nowadays be on a par with a mid-priced compact camera and thus good enough for people to consider using the camera phone as a 'real camera', replacing the stand-alone camera when photographing for the album or the archive.

The previously lesser quality of the cameras in camera phones is manifested in earlier research, dating to the midpoint of the last decade. A general anticipation towards camera-phone photographs was that they are best when fresh, they can live vigorously for a while, be shared with friends and then be soon forgotten. According to Van House and Davis (2005), camera-phone photographs have little expectation of future value and a short useful life. Dong-Hoo Lee (2005) underlined the transience of these photographs by stating that 'to photograph with a camera phone is to assume that the event is easily forgettable'. Camera phones embrace a photographic culture where photographs are intended more for momentary consumption than for providing a lasting value (Lee 2005: 58–9).

This inherent transience of camera-phone photography follows (or followed) from the technological shortcomings in camera-phone technology. However, importantly, it also expresses the conventions and the transitory

nature of telephone communication. In many regards, photographs sent from camera phones are closer to text messages than they are to printed photographs: they are photographs whose purpose is primarily to act here and now. The affiliation of camera phones with internet communication also promotes, for its part, the transience of photographs. Heli Rantavuo (2007) points out that when used in Web communication, the snapshot photograph becomes a disposable tool; it is a 'transitory tool for transitory communication'. The participants in a study on Flickr (Van House 2007) described the photographs published on the Web as 'transitory, ephemeral, throwaway; a stream, not an archive'. There exists a new category of photography, called 'ephemera'; the websites oriented to the social use of digital photography have much more to do with transience than with loss (Murray 2008: 154–5). In all, photographs might become less objects to be saved than messages to be circulated (Sontag 2004).

Thus, as part of mobile internet *communication*, a photograph can possibly be more of a disposable posting, a fleeting act of communication. The lasting value of a photograph sent, posted or shared can be quite trivial. The transient photograph comes and goes, fulfilling its task in communication by connecting individuals, without necessarily establishing a place in the photographic collection. It is hard to imagine that, for example, a conventional family photograph could similarly become outdated or lose its value. Photographs can be removed from family albums in times of dispute or divorce, but less frequently because the photograph is no longer *relevant*. The contents of a photographic document might become undesirable, but not outdated. In fact, the value of a 'documentary' photograph rather increases as time passes from the moment of photography (Villi 2010: 156).

Modern camera phones have gigabytes of memory, so there is no evident need to erase photographs from the phone. However, at the same time, users are offered smartphone applications that take the transience of photographs to the extreme. For example, the Snapchat app allows a person to take and send a photograph and control how long it is visible to the one who receives it. After that, normally in less than ten seconds, the picture

disappears for ever. This type of mobile app can be useful, for example, in instances of 'sexting', the practice of using a camera phone to take and send nude or semi-nude photographs to others' mobile phones (Chalfen 2009: 258). The nudity can be momentarily shared but not saved.

In conclusion, the camera phone is a device oriented to communicating with photographs over time and distance. The dual role of camera-phone photographs is evidenced in how they are useful in both interpersonal communication and individual reminiscing. They can be communication in the moment, but, at the same time, building blocks of memory (Villi 2010: 94). The latter aspect is emphasized by the ongoing evolution of camera phones, which enables the phone to produce such photographs that do not carry the stigma of having been captured with a 'toy camera' (see Oksman 2006: 113). Thus, nowhere near all camera-phone photographs fall into telecommunicative oblivion.

Communicating Presence in the Moment of Absence

I will now present examples of camera-phone communication in action. In this, I utilize a qualitative in-depth interview study focusing on how a group of Finnish camera-phone users describe their practices of using camera-phone photographs in photographic communication. The sampling procedure for the interviewees was purposive and consisted of searching for exemplary informants – people who have actually shared photographs from their mobile phones. I interviewed eight subjects individually, the interviews lasting on average 1.5 hours.

I used a semi-structured model for the interviews. The dialogue during the interviews was staged according to a thematic, topic-centred structure, which also allowed unexpected themes to develop (Mason 2002: 62–3). The interviewees could continue their thoughts along new lines, and they were asked to elaborate on certain themes that seemed interesting and to express reflective and critical views. The main interest was in the perceptions and

interpretations of the interviewees. The study proceeded from analysis and coding of parts of the data-set to developing a holistic understanding of the practices and views expressed by the interviewees.

The accumulation of the empirical data and its analysis were systematic and grounded on a firm theoretical foundation. By applying thematic analysis, I classified the interview material based on a study of previous literature on mobile communication and camera phones, including Koskinen, Kurvinen and Lehtonen (2002); Kindberg, Spasojevic, Fleck and Sellen (2005); Rivière (2005); Scifo (2005); Goggin (2006); Koskinen (2007); and Ling (2008).

During the interviews, six of the eight subjects agreed to show me their camera-phone photographs, either from the screen of their mobile phone or from the screen of a laptop (in the case of photographs that had been transferred from the phone to the computer). I obtained permission from them to include their camera-phone photographs in the study. In the following section, I present two photographs, both from 'Mikael'.[2] Based on his descriptions, I explain how each photograph was used in communication. I also make brief readings of their contents.

The practices described by the other interviewees are consistent with the examples that I provide. The study shows clearly how photographs sent directly from the camera phone are used to communicate what one is experiencing at the moment. Most of the photographs the interviewees communicated were strongly linked to sharing a certain instant and, according to them, would have had less value if communicated the following week, or even the following day. Also, the distance between the communicators had significance in how they communicated with photographs. This was exemplified by how two of the interviewees – Mikael and Kasper – used to send photographs to their girlfriends regularly during their time in the army, when there was a forced distance between the lovers, but cut down on the photographic communication after their military service was over. During their time in the army, Mikael and Kasper also sent more SMS messages and made more phone calls than they normally would. Kasper explained: '[w]hen I was in the army it [sending photographs] was quite a

3.1 *The same blue seats every Sunday night.*

3.2 *I miss you and a sad face.*

big communicational help, because she [his girlfriend] didn't know what I was doing and I didn't know what she was doing.' Conscripts were already sending photographs to their loved ones in the time before camera phones (Hoath 2009), but with a camera-phone photograph, the longing can be mediated in that exact moment of melancholy.

The photograph representing empty seats in a train (figure 3.1) was sent by Mikael to his girlfriend when returning to the army base from a furlough. As he described it, '[t]he mood is blue when you're in the army [...] the same blue seats every Sunday night [...] I wanted to share that feeling with my girlfriend.' The photograph in itself was used to establish a connection, a sense of sharing and loving fellowship, and to share the mood with the girlfriend. Mikael's longing for her presence is subsumed in the photograph. The seats are empty, devoid of any human presence. The blue mood of the journey away condenses in the blue seats. In this sense, the photograph depicts the emotions of that (recurring) Sunday night very well. The seat in the train is not evidence of Mikael's presence. Rather, it represents a 'double absence'. He is not with his girlfriend and he is not in

the photograph. Yet there is an awareness that he is present in the train, the train that is taking him farther away from his girlfriend. To us outsiders, this might be an indifferent picture, but not for those two individuals, in that moment of absence when distance as punctum was at work.

During his time in the army, Mikael also sent other photographs to his girlfriend in order 'to tell her I miss her'. He sent pictures of himself, which he described as 'I miss you and a sad face' photographs. In figure 3.2, the facial expression is used as a message to convey the negative mood. It can be noted that Mikael is sitting once again in the train, in the familiar blue seat. However, this time the emptiness of the emotional atmosphere – as in the picture of the empty seats – is replaced by the equal sadness represented by the gloomy expression on his face. For Mikael, the 'I miss you and a sad face' photograph was about communicating his presence in a moment of absence. Importantly, for both Mikael and his girlfriend, at the time of communication, these two photographs from the train did not express grief over somebody lost for ever, but a longing for the distant other. The heartache was accompanied by buoyancy, as they knew that they would meet soon again; it was just then that they were not with each other. The emotional sting was only temporary.

Based on the study interviews, it is apparent that the practice of communicating camera-phone photographs is, to a large extent, determined by the will to overcome absence in space. Upon arrival in Spain, Lotta had sent a photograph of herself and her boyfriend to her parents in Finland 'to let the people back home know that we had just arrived and that we're OK, and this is how it looks, and it's warm and sunny'. According to Lotta, the photograph 'gave them [her parents] an understanding of what we're experiencing'. The physical distance between them was accentuated by the fact that in Spain it was a glorious day and in Finland it was raining.

By contrast, Lotta did not usually see a big need to send photographs to her boyfriend as 'we just spend so much time together'. Following a similar logic, Mikael had no great urge for communicating with his girlfriend through photographs, explaining that 'we live together, I see her face enough' (the study interview was done several years after Mikael's army service).

Kasper reported sending photographs 'mainly to people who live maybe a bit farther away or who I see more rarely' and to 'those who I see [meet in person] I can show the picture [on the screen of the camera phone]'. He offered an example of communicating pictorially with a good friend who lives in another city about 160 kilometres away, and therefore they can only seldom meet: 'I don't see him as often, so we send each other [visual] jokes and fun things we see in the city […] it's mainly like hello and how's your day […] to cheer the other one up.'

Conclusion

The camera phone is a device that enables real-time photographic communication. It is the first telecommunicative camera that is within reach of ordinary people.[3] Until this millennium, the camera was a device with just one purpose: to take photographs. Communication of photographs was left for other media (paper, envelope, facsimile and lately the computer) to accomplish. There was an apparent physical difference between the device that took the photograph and the medium that communicated it (Villi 2010: 51).

But now, the camera phone attached to a communication network enables the effortless communication of photographs over distances without delay. The sender of the photograph can communicate his or her contemporaneous presence in a certain location, the 'I am here now'. The camera-phone photograph potentially offers a visual connection between there–now and here–now. In a conventional photograph, this connection is different, as it is one between there–then and here–now. A photographic print is here in front of my eyes (present), but at the same time, the person or situation depicted in the photograph is already gone (in time). The person photographed might even be dead (Villi 2010: 142).

The effect of mobile and networked communication on photographic practices is that the uses of personal photographs can partly take a more transient and momentary role. Photographs can become disposable single-use

images, which are of importance only in the passing moment of communication, and do not necessarily have importance in the long run – as do documents to be placed in a photo album or a digital archive in order to be looked at during the coming years and decades. These photographs function as communicative objects through which distant people engage with each other, helping them to form a connection in the present, as opposed to a connection between the past and present. Photographs gain value as 'momentos' while losing value as mementos (van Dijck 2007: 115). The integration of internet connectivity into camera phones further enables a perpetual photographic connection to other people; the users are *visually online* all the time. The 'power of now' (Wilhelm et al. 2004: 1406) that is so characteristic of camera-phone communication is firmly linked to the real-time Web represented by the continuous flow of tweets and status updates.

Punctum, a concept developed by Roland Barthes, refers to something in a photograph that stings, that personally touches the viewer. A detail in the photograph, the passing of time or, in the case of camera-phone communication, the distance between the communicators, can all be a source of punctum (Villi 2010: 99). Importantly, punctum is about the interplay between presence and absence (Villi and Stocchetti 2011: 108), which is an essential theme for both photography and telecommunication. Photography is traditionally about presence in space and absence in time. In telecommunication, presence is about being in contact with one another over physical distance – being socially present while being physically absent. This interplay between presence and absence is encapsulated in the quotation from Kjell, one of the interviewees. For him, a strong motive for sending a photograph with his camera phone is 'to touch people'.

Acknowledgements

I would like to thank the interviewees and Matteo Stocchetti, who helped in realizing the empirical study.

NOTES

1 It should be noted that 'instant photography' has been a possibility since the late 1940s with the invention of the Polaroid camera by Edwin Land.
2 I refer to the interviewees by using pseudonyms.
3 It should be noted that the camera itself is becoming a telecommunications device, as many stand-alone cameras now have built-in 3G, 4G or Wi-Fi connectivity, and older digital cameras can be equipped with memory cards that enable the transmission of photographs directly from the camera.

BIBLIOGRAPHY

Barthes, R. (1991; originally published 1977), *Image, Music, Text*, essays selected and translated by Stephen Heath, New York: The Noonday Press.

—— (2000; originally published 1980), *Camera Lucida: Reflections on Photography*, trans. Richard Howard, London: Vintage.

Batchen, G. (2004), *Forget Me Not: Photography & Remembrance*, New York: Princeton Architectural Press.

—— (2007), 'This haunting', in Elkins, J. (ed.), *Photography Theory*, New York: Routledge: 284–6.

Baudrillard, J. (1999), *Photographs 1985–1998*, Ostfildern-Ruit: Hatje Cantz Publishers.

Chalfen, R. (2009), '"It's only a picture": sexting, "smutty" snapshots and felony charges', *Visual Studies*, 24(3): 258–68.

Dovey, J., and Lister, M. (2009), 'Straw men or cyborgs?', *Interactions: Studies in Communication and Culture*, 1(1): 129–45.

Fried, M. (2005), 'Barthes's punctum', *Critical Inquiry*, 31: 539–74.

Goggin, G. (2006), *Cell Phone Culture: Mobile Technology in Everyday Life*, London: Routledge.

Harper, R., and Hodges, S. (2006), 'Beyond talk, beyond sound: emotional expression and the future of mobile connectivity', in Höflich, J.R., and Hartmann, M. (eds), *Mobile Communications in Everyday Life: Ethnographic Views, Observations and Relections*, Berlin: Frank & Timme: 255–72.

Hoath, P.A. (2009), 'A young soldier's account', in *Private Eyes: Amateur Photography and Collective History*, University of Copenhagen, 12–13 November 2009.

Huhtamo, E. (1995), 'Ruumiiton matkustaja "ikään kuin"-maassa [The disembodied passenger in the "as if" land]', in id. (ed.), *Virtuaalisuuden arkeologia: Virtuaalimatkailijan uusi käsikirja*, Rovaniemi: University of Lapland: 88–125.

Jay, M. (1993), *Downcast Eyes: The Denigration of Vision in Twentieth-Century French Thought*, Berkeley: University of California Press.

Kato, F., Okabe, D., Ito, M., and Uemoto, R. (2005), 'Uses and possibilities of the keitai camera', in Ito, M., Okabe, D., and Matsuda, M. (eds), *Personal, Portable, Pedestrian: Mobile Phones in Japanese Life*, Cambridge, MA: MIT Press: 300–10.

Kindberg, T., Spasojevic, M., Fleck, R., and Sellen, A. (2005), 'The ubiquitous camera: an in-depth study of camera phone use', *IEEE Pervasive Computing*, April–June 2005: 42–50.

Koskinen, I. (2007), *Mobile Multimedia in Action*, New Brunswick, NJ: Transaction Publishers.

Koskinen, I., Kurvinen, E., and Lehtonen, T.-K. (2002), *Mobile Image*, Helsinki: Edita.

Lapenta, F. (2011), 'Locative media and the digital visualisation of space, place and information', *Visual Studies*, 26(1): 1–3.

Lee, D.-H. (2005), 'Women's creation of camera phone culture', *Fibreculture Journal, issue 6: Mobilities, New Social Intensities and the Coordinates of Digital Networks*, [online], <http://journal.fibreculture.org/issue6/>, accessed on 12 October 2008.

Licoppe, C. (2004), '"Connected" presence: the emergence of a new repertoire for managing social relationships in a changing communication technoscape', *Environment and Planning D: Society and Space*, 22: 135–56.

Ling, R. (2008), *New Tech, New Ties: How Mobile Communication Is Reshaping Social Cohesion*, Cambridge, MA: MIT Press.

Lister, M. (2007), 'Photography, presence, and pattern', in Elkins, J. (ed.), *Photography Theory*, New York: Routledge: 350–8.

Manovich, L. (1995), *The Language of New Media*, Cambridge, MA: MIT Press.

Mason, J. (2002), *Qualitative Researching*, 2nd ed., London: Sage.

Murray, S. (2008), 'Digital images, photo-sharing, and our shifting notions of everyday aesthetics', *Journal of Visual Culture*, 7(2): 147–63.

Okabe, D. (2005), 'Social practice of camera phone in Japan', in *Ubicomp 2005 Workshop on Pervasive Image Capture and Sharing: New Social Practices and Implications for Technology*, Tokyo, Japan, 11 September 2005.

Olin, M. (2002), 'Touching photographs: Roland Barthes's "mistaken" identification', *Representations*, 80: 99–118.

Oksman, V. (2006), 'Mobile visuality and everyday life in Finland: an ethnographic approach to social uses of mobile image', in Höflich, J.R., and Hartmann, M. (eds), *Mobile Communications in Everyday Life: Ethnographic Views, Observations and Relections*, Berlin: Frank & Timme: 103–22.

Rantavuo, H. (2007), 'Transitory tools: cameraphone photos and the Internet', in *Towards a Philosophy of Telecommunications Convergence*, Budapest, Hungary, 27–29 September 2007.

Rivière, C. (2005), 'Mobile camera phones: a new form of "being together" in daily interpersonal communication', in Ling, R., and Pedersen, P.E. (eds), *Mobile Communications: Re-Negotiation of the Social Sphere*, London: Springer Verlag: 167–86.

Scifo, B. (2005), 'The domestication of camera-phone and MMS communication: the early experiences of young Italians', in Nyíri, K. (ed.), *A Sense of Place: The Global and the Local in Mobile Communication*, Vienna: Passagen Verlag: 363–74.

Sonesson, G. (1989), *Semiotics of Photography: On Tracing the Index*, report 4 from the project Pictorial Meanings in the Society of Information, Lund: Lund University.

Sontag, S. (2004), 'Regarding the torture of others', *New York Times Magazine*, 23 May 2004.

Urry, J. (2000), *Sociology beyond Societies: Mobilities for the Twenty-First Century*, London: Routledge.

van Dijck, J. (2007), *Mediated Memories in the Digital Age*, Stanford, CA: Stanford University Press.

Van House, N. (2007), 'Flickr and public image-sharing: distant closeness and photo exhibition', in *Conference on Human Factors in Computing Systems CHI '07*, San Jose, 28 April–3 May 2007.

—— and Davis, M. (2005), 'The social life of cameraphone images', in *Ubicomp 2005 Workshop on Pervasive Image Capture and Sharing: New Social Practices and Implications for Technology*, Tokyo, Japan, 11 September 2005.

Villi, M. (2010), 'Visual mobile communication: camera phone photo messages as ritual communication and mediated presence', PhD thesis, Helsinki: Aalto University School of Art and Design.

Villi, M., and Stocchetti, M. (2011), 'Visual mobile communication, mediated presence and the politics of space', *Visual Studies*, 26(2): 102–12.

Virilio, P. (1998), *Pakonopeus*, trans. Mika Määttänen, Tampere: Gaudeamus.

Wilhelm, A., Takhteyev, Yu., Sarvas, R., Van House, N., and Davis, M. (2004), 'Photo annotation on a camera phone' in *Human Factors in Computing Systems CHI '04*, Vienna, Austria, 24–29 April 2004.

FAMILY ALBUMS IN TRANSITION

4

How Digital Technologies Do Family Snaps, Only Better

GILLIAN ROSE

Introduction

For most of the twentieth century, family photography consisted of collections of printed photographic images. Critics writing about family photography paid a great deal of attention to those collections and to how their prints pictured families and family members. From Chambers (2002) looking at the sorts of photographs created by ordinary families in their back gardens and on their holidays, to Bourdieu (1990) and his colleagues studying the photos sitting on mantelpieces in houses in rural France; from Barthes (1982) searching for a photograph to remind himself of his mother after she had died, to Hirsch (1997: 8) reflecting on 'composite imagetexts'; from Williams (1991) looking at Vanessa Bell's family snaps taken in the decades leading up to World War II, to Hall (1991) writing about the studio portraits migrants to London in the 1950s sent back to their families in the Caribbean: all these very different kinds of critics built their arguments on photographic prints in albums and shoeboxes, on mantelpieces and in archives.

From this work, a particular definition of family photography emerged. Family photographs are photos that are taken by family members (usually,

although a few professional studio portraits often slipped into collections of family snaps too), and they picture family members. They could be posed or informal. However, they were very rarely impressive aesthetically: often out of focus, missing heads or feet and showing children in particular with lurid red eyes. Most importantly, though, they show family members happily together at leisure. This has led many feminist critics not only to complain about the quality of family snaps – Evans (2000: 112), for example, writing in *Feminist Visual Culture*, claims that it is in family photography that 'the most stultified and stereotyped repertoire of composition, subject-matter and style resides' – but also to argue that family photo collections contain distorted and misleading visions of family life. 'They will be shared, they will be happy,' says Kuhn (1991: 25), 'the tone of seduction is quite imperious.' The fragility of contemporary family relationships is obscured, they say, in their relentless picturing of happy times and leisure spaces.

Over the past decade, the technologies used to produce family snaps have changed significantly. Digital cameras, files on computer hard drives and photo-sharing websites have replaced analogue cameras, the photographic print and the album or shoebox. And in much of the scholarly work reflecting on this change, it is assumed that because of these technological shifts the nature of family photography has also altered. Thus, Rubinstein and Sluis (2008: 9) note that 'recent changes in the production, distribution, consumption and storage of images caused by the merging of photography with the internet have had a notable effect on varied and diverse social and cultural processes and institutions'. This claim generally develops in one of two ways (Buse 2007): either close attention is paid to the material qualities of digital family snaps, leading Di Bello (2007) to lament that digital photos can no longer be held in the palm of your hand; or else critics interrogate the hardware and software that create and transmit them digitally (Rubinstein and Sluis 2008), in order to diagnose large-scale cultural change. That is, for many critics, the significance of family snaps rests in large part on the material qualities of photographs, whether analogue (prints and albums) or digital (files and file-sharing).

Indeed, it could be argued that this focus on the photograph itself remains typical of a great deal of scholarship on photography which, driven by a broadly semiological approach, emphasizes the photographic image and its meaning (Rose 2012). Hence the careful sifting-through of photographic prints and the detailed analysis of the album, the reproduction of individual prints or single album pages. While this often produces intense and charged reflections on the family snap – readings which frequently depend on Barthes's account of looking for a photograph of his mother after her death – they seem to stumble when faced with photographs that are less amenable to this reflective approach. They have never paid much attention to Polaroid photographs, for example (Buse 2007, 2010). Nor do they seem comfortable with the apparently new practices of production, circulation and display that are enabled by digital practices (Sarvas and Frohlich 2011).

This chapter takes a different approach to family photography, as do several others in this collection (see also Larsen 2008). Rather than focus on family photography as a collection of photographs, this chapter examines family photography as a social practice. In so doing, it suggests two things: first, that we need to be clearer on exactly what we mean by 'family photography' – what it is and what it does; secondly, that photography critics need to take great care when assuming that a photograph's effects happen when it is scrutinized carefully. I want to suggest that the implicit methodology of many studies of photographs (which is to pay close attention to photographic images) occludes other aspects of photographic practice, aspects which, while always present in family photography, seem to be gaining prominence in digital family snaps.

The chapter will make this argument in three steps. First, it will argue that if we are to understand family photography (or indeed photography of any kind), we need to look beyond the photographs and to pay much closer attention to what is done with the snaps by their creators. Family photography produces certain kinds of images, sure; but it is also much more than just the photos. To understand what family photography is, it is also necessary to look at what family photographers do. Secondly, I want

to clarify what it is that family photographers achieve when they do what they do with their snaps. Thirdly, I also want to suggest that in many ways digital photography allows people to do what they want to do with family snaps more easily, more often and more extensively. And finally, the chapter reflects briefly on the methodological implications of family photography. I want to suggest that giving photographs – whether analogue or digital – 'attention' is in some ways quite an unusual thing to do, and just because photography critics have tended to approach photographs in this way does not mean that it is the only way that photographs can be interpreted.

Family Photography as a Practice

Between 2000 and 2009, I carried out a series of interviews with women with young children about their family photographs (Rose 2010). I interviewed these mothers in their homes, sitting on sofas and at kitchen tables and desks, looking through hundreds of their photographs with them, in handcrafted albums, on computer screens, in cardboard boxes, in photo-developer envelopes, in plastic flip-over albums, as well as in frames in every room of their house.

A key moment in that project was when I started to think about why I was shown several photos by one mum that were almost unrecognizable as pictures but were nevertheless kept in the family photo collection because they had been taken by a child and were precious because of that. Those photos that didn't show anything very clearly, but were nonetheless kept because of who took them, eventually suggested to me the crucial point about family photography. Family photographs cannot be identified solely on the basis of what they show – families at leisure, photographed in a particular way – as so much of the critical literature assumes. It is certainly the case that family photos only picture a certain range of subject matter, in a certain way: they are indeed a specific kind of image. But their content is only part of what defines them as family photographs. Equally important

is what is done with them. Family photos are particular sorts of images embedded in specific practices, and it is the specificity of those *practices* that define a photograph as a family photo as much as, if not more than, what it pictures. What is important in a family photograph is: who took it; who it shows; where and how it is kept; who made copies of it and sent them to other people; who those other people are; and how it gets looked at by all those people. Family photos are photos that get taken by a member of a family, that show members of that family, and that are viewed mostly by other members of that same family, and often by a few close friends. So a photo that is a blur of flesh and shadow is kept by a mother because it was the first time her daughter wanted to use the camera, not because it actually shows anything much at all; it is the taking and the keeping as much as the referential content that makes it a family photo.

What I want to argue, then, is that family photography does not consist just in a certain kind of photograph. Rather, it is a social practice. 'Practice' is now a heavily theorized term, of course. A succinct definition is offered by Schatzki (1996: 83), who describes a social practice as a cluster of 'doings and sayings'. Reckwitz (2002: 249) elaborates:

> A 'practice' [...] is a routinised type of behaviour which consists of several elements, interconnected to one another: forms of bodily activities, forms of mental activities, 'things' and their use, a background knowledge in the form of understanding, know-how, states of emotion and motivational knowledge.

A practice is a fairly consistent way of doing something, deploying certain objects, knowledges, bodily gestures and emotions. It is through practices that social relations and institutions happen, and through practices that subject positions and identities are performed. This chapter understands family photography as a practice in this sense (and there are of course many other kinds of practices in which photographs participate [Maynard 2007]). In Schatzki's terminology, the practices that constitute family photography

are 'integrative practices': that is, they are one of 'the more complex prac-
tices found in and constitutive of particular domains of social life' (Schatzki
1996: 98). Schatzki (1996: 98–9) usefully suggests that integrative practices
have three aspects. The first of these is what he calls 'understanding'. This
is the usually unreflective capacity to do and say appropriate things: that
is, knowing how to identify, undertake and respond to specific practices.
Secondly, integrative practices draw on 'explicit rules, principles, precepts,
and instructions' (Schatzki 1996: 99). And thirdly, integrative practices
happen through what Schatzki (1996: 89) calls 'teleoaffective structures'.
Teleoaffective structures have two components: first, senses of project, goals,
purposes and beliefs (hence 'teleo'); secondly, feelings, moods and emotions
(hence 'affective').

Photographs are made and looked at as part of specific social practices.
And this is not a relation that leaves the photo untouched. Certain constel-
lations of practice utilize some of the affordances of an object but not others.
An image has a specific range of qualities as an object, but it is only when
someone uses the image in some way that certain of those qualities become
activated, as it were, and significant. When that use changes, the photograph
also alters, as it is seen and done differently. Some scholars have taken this
argument about the importance of context to the significance of objects
to an extreme; Thomas, for example, goes so far as to claim that 'objects
are not what they were made to be but what they have become' (1991: 4),
although in later work he emphasized that the material qualities of an object
are never entirely irrelevant to the ways in which it is used (Thomas 1999).
The material qualities of photographs may be subject to the 'mutability of
things in recontextualisation' (Thomas 1991: 28), but the affordances of an
object still make specific doings possible and others impossible.

The practices that define family photography are quite particular, and
have been given some attention by a range of writers (for example, Titus
1976; Bourdieu et al. 1990; Rose 2012). The visual content of family snaps
is certainly important: all my interviewees agreed that family photographs
were photographs of members of their family looking happy, and that they

should have a certain style (they must not look 'arty'). But so, too, are a wide range of other things. They also all agreed that photos needed dating at the very least, for example. Photographs taken with a film camera were always printed, and sometimes kept in the envelopes or boxes they arrived in from the developers, and then stored in cupboards or boxes devoted to them. Albums were also used for storage, especially the 'flip-over' kind. One interviewee had a fireproof metal box for especially precious photos. Digital photos were downloaded onto computers and put into labelled folders, and some had prints made of them. Some printed photos were selected to go into special albums (all my interviewees had an album of their babies' first year); others may be chosen to be framed or propped up somewhere unframed. Some were made into collages, or pinned onto a noticeboard; some were put into purses or wallets; some were taken into workplaces. Very, very many – both analogue and digital – were sent off to family and close friends. This was a particularly important part of what was done with family photographs; all my interviewees felt obliged to send photographs of their children to their own parents at regular intervals. Most of Linda's family was in South Africa, 'so we email photographs fairly regularly [...] they're missing out on his growing up.' Tami, with family in Israel, said she sent photos to her father, sister and sister's mother 'because they don't see us. They see us twice a year or once a year and they want to see how the children look.' And some photos were looked at long after they'd been downloaded or printed.

This suggests something of the particularity of family photography. It suggests that family photography is a practised assemblage of technologies (including camera hardware and software, but also other sorts of objects like printers, books, frames and shelves) and social actors and relations. Certain sorts of cameras (whether analogue or digital, almost all the women had what they called 'point and shoot' cameras) are used to create certain sorts of images (not perfectly composed, spontaneous or posed) of particular scenes (happy families), and these are then displayed (in family homes) and circulated (with letters and Christmas cards, on websites and as email

attachments), all this being a combination of implicit know-how, more explicit rules, feelings and achievements. This further suggests that other kinds of photography will entail other probably fairly distinct assemblages of specific bits of technology with which quite specific integrative practices are done. Indeed, work appearing in this collection and elsewhere is starting to specify other more or less distinct assemblages, such as photoblogging (Cohen 2005), teens' use of photos in their bedrooms and on Facebook (Durrant et al. 2011), the use of photos in the development of romantic relationships (Schwarz 2010a, 2010b) and for the presentation of the self in social networks (van Dijck 2008; Van House 2011). We might note in passing here how this approach to photography makes the term 'vernacular photography' (Batchen 2000) rather a difficult one to work with, because it refers to a very diverse range of specific assemblages of photographic practice.

What Is Produced When Family Photography Is Practised?

Specific practices of production, circulation, display and viewing constitute family photographs as particular kinds of images, then: family photos cannot be defined simply by their visual content. But if thinking of photographs as objects is useful because it focuses both on the material qualities of a photograph and on how some of those qualities are emergent in specific social practices, it is also useful because those constellations of objects and practices are productive. They are productive both of certain sorts of images – since, as we have seen, specific practices valorize only certain of the material qualities of any visual object – and of subject positions and relations. 'The things that people make, make people' (Miller 2005: 38). Schatzki (1996) says as much, too. Practices are what allow subject positions to happen – a person becomes a 'cook', for example, while undertaking the practices associated with 'cooking' – and practices also induce relations between subjects. 'A practice establishes a tissue of co-existence among

its participants that arranges them vis-à-vis one another,' says Schatzki (1996: 172), and this can include relations with other people as well as with objects.

I would argue that it is the 'tissues of co-existence' enabled by the practices of family photography that make family photography so pervasive and such a compelling mix of the banal (images) and the profound (co-existences). In particular, family snaps are fundamental to how women make themselves, their homes and their families. Several historical accounts of women's photographic practices are relevant here. In contrast to the negative account of family snaps with which this chapter opened, these historians suggest that photographing family and friends and doing things with those photos (such as making albums) are highly complex practices which often negotiate dominant ideologies of domestic femininity with remarkable skill. This historical feminist work has paid most attention to the photographs and albums made by upper-class women in the mid-nineteenth century. While some critics examined the photographs made by women in the 1850s and 1860s and argued that they share a distinctive, feminine aesthetic, others, like Di Bello (2007) and Warner (1992), have paid more attention to the albums in which such photographs were displayed. These albums were often heavily worked by their creators, with photographs cut and pasted into watercolour scenes, surrounded by painted flowers, or made part of abstract and surreal geometric schemes. Di Bello's work is particularly rich, exploring not only the albums themselves, but how they would have been looked at in the drawing rooms of these women. She argues that, as Williams (1991: 198) describes the albums made by Vanessa Bell in the interwar period, these earlier albums were 'knowing'; these women were using photographs 'to give materiality to their own culturally and socially specific desires and pleasures' (Di Bello 2007: 5). An essay by Hof (2006) on the current hobby of scrapbooking suggests that little might have changed. 'On a small scale,' she says, in a scrapbook, 'life can be cropped, embellished and laid out according to available resources, aesthetic preferences and as contemplations on the past and dreams for the future' (Hof 2006: 381–2).

Following such work, and as I have explored in depth elsewhere (Rose 2010), the practice of family photography is embedded in three particular aspects of subjective relations for the women I spoke with: the familial, the domestic and the maternal.

Familiality is performed by several aspects of family-photography practice, all of which involve the 'togetherness' of family members. Family photographs *picture* family members together, and my interviewees very often identified their favourite family photograph as showing their family 'together'. Family snaps are also *displayed* together. Although some of my interviewees had misgivings about putting too many of their family snaps out on display in their houses, nine of my interviewees had whole walls devoted to family photos, which often included photos of their parents and even grandparents, their husband's family, and themselves when much younger, as well as pictures of their own children. Collages and multiframes were popular too, as were the slideshows generated by software. All members of a family need to be shown together through these multiple displays, and some mothers were annoyed at displays of photos that failed to show images of certain family members, for example. Crowded together in groups, photos as objects again register 'togetherness' as a central quality. *Looking* at family photographs is also central to the togetherness that they articulate: photographs in albums and on computer screens were frequently looked at by mums with their children, as I've noted, and children were taught to recognize family members through the photos.

Finally, *sending* photographs maintains familial affiliations and shows togetherness. Significant photographs are shared within families; indeed, such circulations can extend togetherness over long distances. Copies of many of the photos in a house also exist in other houses, sent there by the women I spoke with, and they own photos of other family members, which had been sent to them. Sending family photos to other family members is an important way of keeping this familial web together, just by 'keeping in touch'. This was particularly the case for some of my interviewees with digital photos and home computers. Photos were sent quite frequently, to

large numbers of family and friends, usually as attachments with emails, but also sometimes via photo-sharing websites.

Given this power both to signify and to enact familial togetherness, it is easy to see why family snaps are crucial objects in making a home. Various writers have commented on the way that certain objects are central to the production of domestic space, that is, to the transformation of a built space into an emotionally resonant home for a particular group of people affiliated to one another (Csikszentmihalyi and Rochberg-Halton 1981; Miller 2006). Family photographs are among the most powerful of these transformative objects: they are one of those objects 'critical to achieving the state of being at home' (Gregson 2007: 24). Several of my interviewees told me that photos were one of the first objects they unpacked after moving house (see also Chambers 2002). Family snaps are objects that, in this case, work to identify a particular family form with a specific living space. Such domestic objects produce homeliness because looking at them produces feelings of togetherness. It is important to emphasize here that this is not just about making a house look like a home, by decorating it with personal objects (although this is part of what is going on); it is also about making a house domestic by gathering together the family members in it via photos of them.

Finally, family snaps are important for mothers. (Which is not to say that they are not important to fathers, too, but my study focused on mothers because, among heterosexual couples, it is the case that family photographs are almost always the mother's responsibility, and I was interested to explore why this was the case, given all the other domestic labour that mothers are expected to perform.) This is not just about the family-wide relations that the taking, circulating and displaying of family snaps perform, but also about the relationship between a mother and her child – or at least, given whom I interviewed, between a white middle-class mother and her own able-bodied child. Although so many of the photos I was shown were of children, it did seem as we were talking that the active subject in relation to the photo was the mother (see also Gallop 1999). This struck me particularly when I considered how important it was to the women I spoke with that they had

photos that 'captured' their children as they 'really' were. (Their reluctance to use photo-editing software is relevant here.) 'I do like unposed ones', 'I like these ones that are natural', 'I love that one of her, it's really natural', 'nothing posed'. 'Natural' is contrasted, and preferred, to 'posed'. Posing is seen as artificial, while natural shows the real child. Now, it seems to me that to claim to know when your child is looking 'natural' – looking as they really are, without pose or pretence, revealing their true nature – is a way of seeing a photo that produces a mother as very powerful in relation to their child. For to claim to know when your child is looking 'natural' asserts an absolute knowledge of that child. Seeing the real implied by the term 'natural' produces a mother who knows the very essence of her children. It asserts her full knowledge of her child: her son's or daughter's history and character are recognized by her, but also made and claimed by her through her production and audiencing of these photos. This claim leaves little space for alternative interpretations of, or by, those children. There was very little discussion during the interviews about how children reacted to being photographed (I didn't ask – a mother's omission, perhaps – and very few comments were offered) and no discussion of children posing in family snaps (apart from the very obvious grimaces of one seven-year-old). Although the children were there as corporealized subjects in the photos, their embodiment and subjectivity was interpreted, in these conversations at least, entirely by mothers. So I want to suggest that the importance of these photos to the women I spoke with is not only caused by the way photographic practice is so powerful in producing feelings of familiality, but that it is also a way of asserting the mother's subjectivity against (the trace of) their child's.

This section has explored the way that apparently banal family snaps are intimately bound to the performance of very significant relations, subjectivities and spaces. This is not simply because of what they show: it is also because of what is done with them. So how can this account of family photographic practice help us to conceptualize the digitization of family snaps?

How Digital Photography Intensifies Family Photography

What I have argued so far is that family photography, as an integrative practice, achieves three important forms of co-existence: family, home and mothering. Its significance lies in these achievements, I would argue, at least as much, if not more, than it does in the technologies that enable those achievements. And those achievements are teleoaffective projects (to use Schatzki's [1996] term) that are not likely to be disappearing any time soon. Indeed, Finch (2007) argues that, given a range of changes in the composition of families in the West, the need to perform and display familial togetherness is increasing rather than decreasing.

I would argue, then, that in thinking about the change from analogue to digital means of making, displaying and circulating family photographs, we need to pay as much attention to the projects in which family snaps are embedded as we do to the technologies being used to achieve those projects. And in considering those projects and their practising, I want to suggest that digital family photography has not *altered* family photography, but rather *intensified* it. This section makes this argument in relation to three aspects of family photography – the sheer numbers of photographs taken, their organization and their sharing – all of which, I would argue, are enhanced by digital technologies.

All my interviewees took very large numbers of photographs. This was not because they had many different things to picture; on the contrary, they were often puzzled about why they took so many. All of my interviewees stressed how important it was to take photos of their family members and in particular of their children. They all felt compelled to take photographs of their kids, especially when those children were very young (Titus 1976). The mothers told me about the many, many photos they had taken of their children when they were newborn: 'tons and tons', 'masses', 'every time Cameron moved he got to have a photograph', 'we were clicking all the time', 'we've got pictures of Jenny breathing, sort of, smiling, breathing, eating', 'you know, everything he did – and they don't do anything! – I went, "Take

a photograph, take a photograph", so we've got, like, loads'. As their babies grew, all these mothers agreed with Tina when she said, 'you just have to make a conscious effort to keep snapping away, I think.' I was shown albums and albums and boxes and boxes and folders and folders of photographs, and photos were on display everywhere in almost all the houses I visited, even in the toilets; they were 'dotted about', 'all round' and 'anywhere'.

The practice of taking photographs was also trivialized. All the mothers laughed as they talked about just how many photographs they had taken of their babies. They were laughing at themselves for their desire to photograph repeatedly babies who, as Fiona said, aren't doing anything, ending up with hundreds of photos showing more or less the same thing. But if the sheer numbers of photos were funny, they were also a bit embarrassing when someone else was looking at them all. There were even suggestions that such a compulsion to photograph was a kind of pathology: Sam described herself as going 'mad' when she took lots of photos on a recent trip with her two-year-old daughter to Australia to see her brother, while Michal said she took photos of 'really stupid things' and Tina said she was 'getting better' now that her kids were older and she was taking fewer photos of them. However, some photographs at specific events continue to be taken: for example, the first day of every new school year, the birthday-morning photo, all the family at the Christmas table, which suggests that taking a photograph is as much about confirming the event as memorable as it is about creating an image of it.

Nor were photos always treated as particularly precious objects: I was told of photos 'shoved', 'bunged' and 'whammed' into storage boxes or albums, and the process of downloading digital photos from cameras onto home computers was never given any attention by my interviewees. However, it was very important that they were dated. As evidence of children growing up to send to other family members, and as records of rituals like birthdays and the first day of each school year, snaps had to have dates added to them; dating, in fact, is one of the rules of this integrative practice. As Emma said, 'I was so good and labelled the fronts of the... of the, erm...

wallet, you know sort of "Bonny first week", or "Bonny first month".' Most printed photographs were also put into some kind of organized storage, either in the envelopes or boxes they arrived in from the developer's and then in cupboards or boxes devoted to them, or else they were taken out and stored in albums, and, as I have already noted, one interviewee had a fireproof metal box for especially precious photos.

So, once again we can see that it is important to make family photographs, to archive them and to send them, almost regardless of their quality. And with digital photography, all these things are remarkably easy to do (Rubinstein and Sluis 2008). There is no extra cost involved in taking lots of digital photographs. Cameras are now on most mobile phones, too, and so one is always to hand; indeed, the only limit to the numbers of snaps that can be taken is the size of the camera's memory card or the computer's hard drive. Moreover, dating snaps is not only easy with digital cameras, it's done automatically for you. And that is a huge advantage of digital snaps over analogue ones, because, of course, the rule about dating each and every analogue photo was honoured mostly in its breaking. Almost every mother with an analogue camera whom I spoke with expressed guilt for not dating all the photographs in their family collection, and, as I noted above, my interviewees with analogue cameras described themselves as 'good' if they even approached this ideal by dating the envelopes and wallets that held their snaps.

But digital cameras automatically date your snaps. And not only that, they also organize your photos for you into folders that are dated albums; more recent software allows you to tag photos and enable face-recognition software so you can sort through all your photos more easily. And almost all this is done by the software itself, as you transfer your snaps from your camera's memory card to the computer's hard drive. So the storage process becomes even more carefree. And, finally, the sharing of family snaps is now much easier. Not only can you upload your files to printing services and order prints in whatever format you want, sent to whomever you want, you can also order mugs, mouse mats and canvases embellished with your

snaps. And of course you can upload your files to photo-sharing websites, too, and share the site's link with your online family members. All of these things allow mothers now to take more photographs and to organize, date and share them more easily, which means that the most important aspects of family snaps also become easier to achieve: creating pictures that you want to display, at significant and insignificant moments, in which the kids really look like themselves; recovering those snaps when you want to look at them, often with those same children; and sending those snaps to family and friends to maintain familial networks and affiliations, as well as receiving snaps from them.

What I am suggesting then is that family photography is an integrative social practice which allows certain subject relations and places to be achieved. Those achievements are what drive people's assembling of various combinations of technologies. They encouraged certain kinds of uses of analogue cameras and their prints, and they are now underpinning digital family photography. The ubiquity and ease of use of digital photography technologies are clearly allowing other social relations to incorporate digital photographs into their practising: teenage social networks, for example (Durrant et al. 2011), or romantic couples (Schwarz 2010b). But these distinct uses should not allow us to generalize about *the* digital, or indeed *the* vernacular, as if it was just one field. It is highly differentiated, and the continuing vitality of family photography is one significant part of it.

Conclusion

Claims that we now live 'a life more digital' thus need careful assessment. Clearly, in terms of the everyday technologies that surround us, those claims are true. But in terms of what we achieve with those technologies, the difference that digital technologies make is not so obvious. This chapter has argued that, in the case of family photography, digital technologies have not

so much altered family photography as enhanced it. The project of family photography – at least for the mothers I interviewed – was to achieve family, home and mothering. New technologies are allowing some of the practices through which those things are achieved to become more extensive: more photographs are taken, more are stored, more are shared more easily. But the teleoaffective projects themselves are not changing for these mothers, even if the technology they are assembling is.

What may need altering, though, with the enhancement of family photography, is the methodology needed to understand it. That close reading of photographic images, so important to photography studies, surely remains important for some kinds of cultural work, particularly if it is argued that 'appearances are not to be trusted' (Watney 1991: 30). But another question that photography scholars should now pose themselves is: do collections of thousands of photographs, whether analogue or digital, necessarily require close reading? Is it the content of these images that matters most? After all, they were not made to be looked at like that (although just a few in any family photo collection do seem to demand it). Instead, they were made to capture some individuals and as part of events, and their circulation among others remains key to their significance and effects. Indeed, the only significant development in the photographic practices of the two groups of mothers that I interviewed – the analogue group and the digital group – was a variation of family photography that had developed for several of the digital family snappers: sending photos of your children to friends, as digital image files attached to emails. In that situation, the snap seemed to enter a different visual economy. Instead of being a gift, sent in order to perform familial affiliation without expectation of a return, several of my interviewees described sending photos in email attachments to their friends as definitely entailing an expectation of an exchange of snaps (Rose 2010). In that situation, friendship seemed to involve a certain requirement that sending a photo was an act that should be reciprocated, but these were snaps that were also readily deleted by their recipients once they had been opened and glanced at. Here, in terms of the social relations enacted by this

practice, the visual content of the photo seems to be trivial in comparison to the importance of the act of sending it. Perhaps, then, as critics we should take the risk of paying as little attention to these images as was given to most of them when they were made and received, and instead we should be much more attentive to what is done with them, to their travels, and to the complex effects of those doings and their mobilities.

BIBLIOGRAPHY

Barthes, R. (1982), *Camera Lucida*, London: Jonathan Cape.

Batchen, G. (2000), 'Vernacular photographies', *History of Photography*, 24: 262–70.

Bourdieu, P. (1990) (ed.), *Photography: A Middle-Brow Art*, Cambridge: Cambridge Polity Press.

Buse, P. (2007), 'Photography degree zero: a cultural history of the Polaroid image', *New Formations*, 62: 29–44.

—— (2010), 'The Polaroid image as photo-object', *Journal of Visual Culture*, 9(2): 189–207.

Chalfen, R. (1987), *Snapshot Versions of Life*, Bowling Green, OH: Bowling Green State University Press.

Chambers, D. (2002), 'Family as place: family photograph albums and the domestication of public and private space', in Schwartz, J., and Ryan, J. (eds), *Picturing Place*, London: I.B.Tauris: 96–114.

Cohen, C.K. (2005), 'What does the photoblog want?', *Media, Culture and Society*, 27: 883–90.

Csikszentmihalyi, M., and Rochberg-Halton, E. (1981), *The Meaning of Things: Domestic Symbols and the Self*, Cambridge: Cambridge University Press.

Di Bello, P. (2007), *Women's Albums and Photography in Victorian England: Ladies, Mothers and Flirts*, Aldershot: Ashgate.

Durrant, A., et al. (2011), 'The secret life of teens: online versus offline photographic displays at home', *Visual Studies*, 26(2): 113–24.

Evans, J. (2000), 'Photography', in Carson, F., and Pajaczkowska, C. (eds), *Feminist Visual Culture*, Edinburgh: Edinburgh University Press: 105–20.

Finch, J. (2007), 'Displaying families', *Sociology*, 41: 65–81.

Gallop, J. (1999), 'Observations of a mother', in Hirsch, M. (ed.), *The Familial Gaze*, Hanover: University Press of New England: 67–84.

Gregson, N. (2007), *Living with Things: Ridding, Accommodation, Dwelling*, Wantage: Sean Kingston Publishing.

Hall, S. (1991), 'Reconstruction work: images of post-war black settlement', in Spence, J., and Holland, P. (eds), *Family Snaps: The Meaning of Domestic Photography*, London: Virago: 152–64.

Hirsch, M. (1997), *Family Frames: Photography, Narrative, and Post-Memory*, Harvard: Harvard University Press.

Hof, K. (2006), 'Something you can actually pick up: scrapbooking as a form and forum of cultural citizenship', *European Journal of Cultural Studies*, 9: 363–84.

Kuhn, A. (1995), *Family Secrets: Acts of Memory and Imagination*, London: Verso.

Larsen, J. (2008), 'Practices and flows of digital photography: an ethnographic framework', *Mobilities*, 3: 141–60.

Maynard, P. (2007), 'We can't, eh, professors? Photo aporia', in Elkins, J. (ed.), *Photography Theory*, New York: Routledge: 319–33.

Miller, D. (2005), 'Materiality: an introduction', in Miller, D. (ed.), *Materiality*, Durham, NC: Duke University Press: 1–50.

—— (2006), 'Things that bright up the place', *Home Cultures*, 3: 235–49.

Reckwitz, A. (2002), 'Toward a theory of social practices: a development in culturalist theorising', *European Journal of Social Theory*, 5: 243–63.

Rose, G. (2010), *Doing Family Photography: The Domestic, the Public and the Politics of Sentiment*, Aldershot: Ashgate.

—— (2012), 'The question of method: practice, reflexivity and critique in visual culture studies', in Heywood, I., and Sandywell, B. (eds), *The Handbook of Visual Culture*, Oxford: Berg: 542–58.

Rubinstein, D., and Sluis, K. (2008), 'A life more photographic: mapping the networked image', *Photographies*, 1(1): 9–28.

Sarvas, R., and Frohlich, D.M. (2011), *From Snapshots to Social Media: The Changing Picture of Domestic Photography*, London: Springer-Verlag.

Schatzki, T.R. (1996), *Social Practices: A Wittgensteinian Approach to Human Activity and the Social*, Cambridge, Cambridge University Press.

Schwarz, O. (2010a), 'Going to bed with a camera', *International Journal of Cultural Studies*, 13(6): 637–56.

—— (2010b), 'Negotiating romance in front of the lens', *Visual Communication*, 9(2): 151–69.

Thomas, N. (1991), *Entangled Objects: Exchange, Material Culture and Colonialism in the Pacific*, London: Harvard University Press.

—— (1999), *Possessions: Indigenous Art/Colonial Culture*, London: Thames and Hudson.

Titus, S.L. (1976), 'Family photographs and the transition to parenthood', *Journal of Marriage and the Family*, 38: 525–30.

van Dijck, J. (2008), 'Digital photography: communication, identity, memory', *Visual Communication*, 7(1): 57–76.

Van House, N. (2011), 'Personal photography, digital technologies and the uses of the visual', *Visual Studies*, 26(2): 125–34.

Warner, M. (1992), 'Parlour made: Victorian family albums', *Creative Camera*, 315: 29–32.

Watney, S. (1991), 'Ordinary boys', in Spence, J., and Holland, P. (eds), *Family Snaps: The Meaning of Domestic Photography*, London: Virago: 26–34.

Williams, V. (1991), 'Carefully creating an idyll: Vanessa Bell and snapshot photography 1907–46', in Spence, J., and Holland, P. (eds), *Family Snaps: The Meaning of Domestic Photography*, London: Virago: 186–98.

5

Friendship Photography: Memory, Mobility and Social Networking

JOANNE GARDE-HANSEN

Introduction

In his controversial book *The Social Conquest of Earth* (2012), Edward O. Wilson, Professor Emeritus at Harvard University, biologist and Darwinist, claims that it is not the *family* that has been fundamental to human evolution but *friendship*. He defines this as 'highly flexible alliances' between prehuman ancestors whose 'bonding is based on cooperation among individuals or groups who know one another and are capable of distributing ownership and status on a personal basis' (2012: 17). What is striking about Wilson's book is his emphasis upon multidirectional alliances between families, genders, classes and tribes whose 'memories had to travel far into the past to summon old scenarios and far into the future to imagine the consequences of every relationship' (2012: 17). Wilson's research (while clearly grounded in the biological sciences) resonates with our contemporary culture, which stresses the importance of friendship, collectives, tribes, networks and their memories, emotions and sociality.

This focus on friendship over family can be clearly located within the sphere of media and communication studies. It has shifted its attention from

the privacy of the family as the context of production and consumption to the public domain of networked intimacy. While the current focus on networked photography as social currency may be new in terms of ubiquitous computing, the idea of public intimacy produced through the snapshot is not. In Elizabeth Siegel's *Galleries of Friendship and Fame: A History of Nineteenth-Century American Photograph Albums* (2010), she explores the precedent for exchanging self-portraiture through a photo calling card (*carte-de-visite*) in the 1860s, thus already demonstrating the importance of affective branding among networks of elite persons and families that sought intimacy through photography. The intimacy explored in this chapter differs in that it is ordinary and technologically distributed. Again, this is not entirely new either. Gillian Rose has written extensively on the family photograph in terms of its movement into the public sphere and its mobility among networks of intimates in *Doing Family Photography: The Public and the Politics of Sentiment* (2010).

However, as with previous studies of family photography (see Hirsch 1997) the focus is on the domestic, the family and the importance of memory for shoring up familial relations. In terms of the emergence of a concept of friendship photography, this chapter argues that the pervasive ubiquity and ordinary affective mobility of mobile-phone camera photography has an impact on memory and forgetting. Particularly, if those images are made by networks of young people for whom friendship is more important than family. In this chapter, I shall consider the production and movement of camera-phone images created by young people. Their practices may complicate the notion that memory, archiving and gift-giving is defining the movement of domestic photography within our visual economy, largely dominated by women and mothers as producers of affect and intimacy (see Rose 2010).

I therefore reflect on the research I undertook regarding young people's mobile camera phones in the context of their use of social-networking sites towards their production of personal memories for public consumption. This research was conducted in 2009–10, with young people in the UK aged 15–18, through the completion of 94 questionnaires and five focus groups.

It found that their use of camera phones was fundamental to documenting the places, locations and communities *they* inhabited. Unlike some older mobile-phone camera users, their level of literacy and creativity suggests a desire to connect in placed, emotive and meaningful ways through everyday photography. They did not have a 'hostile worlds' view of the relationship between a sacred private sphere of the family and a dangerous public sphere of the internet. Nor did they have a scarcity approach to visual media. For these young people, managing everyday photography was fundamental to a constant and important process of 'becoming' rather than a more traditional identity-politics focus on 'being'.

I have detailed the methodology used in this research project in *Media and Memory* (2011). The focus there was on using the results to provide a framework for thinking through the practices of memory and forgetting by young people. I would like to expand upon the notion of 'connected memory' that I began to explore in that book. Here I aim to understand the affective uses of photographs of everyday life as a form of friendship photography that has a different relationship to memory as mobile and networked intimacy. While Susan Sontag has argued that the circulation and dissemination of photos becomes more important than their saving and archiving (2004: 26), José van Dijck has maintained that new forms of connectivity and sharing (particularly through photographs) are challenging pre-existing social and cultural theories of individuality and collectivity (2011, 2012).

Drawing upon Annette Kuhn's autobiographical memory work through her analysis of the family photograph album (2002) and Anna Reading's concept of 'memobilia' (Reading 2009), this chapter examines the emergence of the photograph as a shared, networked and thus connected reflection of the everyday lives of young people. No longer laid out in a hard-copy album, the photograph exists in personal archives, from the memory cards of mobile camera phones to computer hard drives and online digital vaults. Once shared online it becomes *networked friendship photography*. Thus, the generation that takes family photographs and lovingly sticks them in an album will soon be replaced by a generation that acknowledges the fruitless

preservation of a sacred, private sphere of families as opposed to an online public sphere of rapidly contracting and expanding visualized connections and alliances.

Family Photography, Memory, Media

An understanding of personal and public histories is structured through what José van Dijck has termed 'mediated memories' (2007). This term refers to the 'activities and objects we produce and appropriate by means of media technologies, for creating and re-creating a sense of past, present, and future of ourselves in relation to others' (van Dijck 2007: 21). Family photographs are an articulation of these mediated memories, such that 'the personal memory of an individual is perceived as enmeshed within a whole, ultimately indivisible from its contextual webwork, yet personally unique and situationally distinctive' (Booth 2008: 300). While this chapter does not produce memory work from young peoples' personal reminiscences around digital photography, it is important to note that generations of families have 'create[ed] themselves through memory practices like photography', such that 'by defining their memory, they define themselves' (Tebbe 2008: 201). While the same can be said for friends and couples, it is the domestic, intimate and affective power of a sacred familial space and experience that has held sway over lay photography. It has been the *ordinary family* that has required construction and remembering.

However, what I do not notice when researching my own social-networking pages is the 'loss' and 'longing' that Annette Kuhn (2002) isolated when analysing her own family photographs of her childhood. 'Why should a moment be recorded,' asks Kuhn, 'if not for its evanescence'? (Kuhn 2002: 49) If the way in which we view photographs is very much linked to our personal memories and our shared stories of being and becoming, then what difference do the photographs of my friends make to my life (story)? In fact, mobile-phone and digital-camera images are now so ubiquitous

that their multiple displays on my computer screen, taggable and shareable, no longer suggest loss. They immerse me in a default archive or montage of embodied, fragmentary and episodic lives that has more to do with the incompleteness of networked memory than the completeness of family narratives. The photographs we witness, scrutinize, surveil and forget on Facebook, for example, no longer seize a moment as if they have only that one chance to capture events. Rather, they are constantly 'metonymically transport[ing] you' (Tolia-Kelly 2004: 316) to times and places that you have never experienced and that belong to others yet into which you are extended. In the context of film studies, Alison Landsberg describes these prosthetic memories as 'not strictly derived from a person's experience', but 'experienced with a person's body as a result of an engagement with a wide range of cultural technologies' (2004: 26). Thus, the images are close to my body (prosthetic and supplement as both *needed* and *extra*) and I get to live my friends' lives just for a moment.

For Annette Kuhn (2002), the production of a family photograph album involved the careful and detailed presentation of well-chosen photographs from expensive cameras. These were carefully developed and selected, then lovingly and with great skill placed and preserved in beautifully presented bound albums or singly framed for display. Now, an album of everyday life is carried around in our pocket, instantly accessible any time, any place, anywhere. But is it even an album? Most significantly, the mobile phone has become a technological archive(r) of everyday life and narratives – visual, aural and textual – that can be 'messaged' as Gillian Rose defines it (2010: 68) and shared. Daniel Rubinstein and Katrina Sluis (2008) argue that our life has become more photographic because of the mobile camera phone: not in a traditional printed way, but in a screen-based and networked way, transformed from an individual to a communal activity (offline and online), with no lone photographer taking that singular image with its 'aura' of uniqueness. With this in mind, the tendency might be to enframe mobile-phone memories in discourses of globalization and technologization in order to recognize the rapid social shifts in production and consumption.

These shifts should not be seen to dominate our understanding of what we actually do with mobile camera phones and how we feel about them and the images they produce.

Thus, it is important to interrogate how and why mobile-phone users produce and consume their photo albums in the context of friendship photography so as to isolate continua from an old media economy to a new one, as well as to understand shifts in domestic/public practice. Kuhn says that memory work (and in this case with mobile-phone users) can make possible the exploration of the 'connections between "public" historical events, structures of feeling, family dramas, relations of class, national identity and gender and "personal" memory' (2002: 4). The movement of images from our phones to the internet represents the making public of a previously private gallery of images towards the 'collective nature of the activity of remembering' (Kuhn 2002: 4). However, the term 'collective' – in the context of the seminal work by Maurice Halbwachs (1992) – may no longer be useful for undertaking memory work with mobile-phone camera images because the group today is not simply defined in terms of family, kinship or geographically specific places. Rather the concept of 'joint memory' (Ashuri 2011) might explain the practices of sharing photographs of family and friends through media technologies because it does not assume a 'hostile worlds' view of a division between private/family and public/internet.

Within the context of war, conflict and remembering, Tamar Ashuri seeks to address the ethical question of what we should remember, considering the role of ICTs in witnessing and recording. In making 'their personal memories visible to the public domain', Ashuri posits that the term 'joint memory' aptly expresses 'an aggregation of memories of individuals which are accessible to members of a community who were absent from the occurrences in time, in space, or in both' (2011: 106). Thus, what we actually do with camera phones is to connect more deeply and emotionally to the physical places and spaces we do and do not inhabit and the times we experience, *jointing* ourselves to our cultural geographies as well as to those not geographically

proximate. Katz and Aakhus (2002) have written of mobile-phone culture as one of 'perpetual contact', while Srivastava (2005) has reiterated this idea of perpetual contact: as *being in the world* (or 'becoming') rather than as being contactable for giving and receiving information. Towards this end, academic theory has explored the mobile phone's situatedness (positioned near the human body, close to the user's personal sphere of belonging) as much as its mobility (see Richardson 2005).

Therefore, what people actually do with (and are able to do with) their mobile phone in terms of its mnemonic capabilities as a visual recorder of everyday life should be considered not as private or public but as a syncing of memories to lived life and a tagging of emotional connections within situated experiences. It is the younger generation who will negotiate the transition between the narrative-driven analogue family album and the wearable, mobile friendship album as their own lives develop within both platforms. They are literally the 'joints' who compile personal memories in multiple formats and for whom mobility is constrained due to a dependency on family, but for whom freedom and the right to communicate about their daily lives is opened up within multiple social-network platforms.

The 'public compilation of personal recollections' by young people can be seen as a domestic version of Ashuri's joint memory agents in action (2011: 106). Such agents in Ashuri's research serve to undermine the 'domination of professional agents who establish, maintain, and hence control the channels of description by which memory travels from people who have experienced a certain event first-hand to those who lack such experiences' (2011: 106). As such, young people representing their everyday lives from phone to internet may not be witnesses to the kind of events that professionals are narrating (as in newsworthy events). Rather, their childhoods and development are being narrated and documented by parents and family members who have hitherto established, maintained and controlled the stories through analogue means. With this in mind, it is important to understand their friendship photography as one that is dynamic and mobile.

Mobile Phones: Wearable Albums

Interestingly, Anna Reading's (2008) mobile-phone-using female participants aged 20–35 involved in her 2006 research project viewed the 'family album' contained within the phone as a transient and contingent album. It was either not worth keeping, transferring or producing in hard copy, or not possible to keep due to the commercial imperative of short-term phone contracts. Like Rubinstein and Sluis (2008), Reading identified the transitory nature of taking photos (being able to delete instantly) and the proliferation of images captured (again due to the delete function). The women used the phone as a 'portable "family album"' (2008: 361) to embed visually their daily lives and carry those visual memories with them to show to others. As in Gillian Rose's extensive research of doing family photography (2003, 2004, 2005), the producer had not changed: women were controlling how the family was represented within this emergent and networked intimacy.

Anna Reading's research (2008: 356) foregrounded the 'family gallery' and its wearability on the human body through what she termed the 'memory prosthetic' of the mobile phone. Here, mobile-phone users perform and shore up their identities through co-present screenings in public spaces of mobile photo albums. Yet, one should not let the mobility of the camera phone undermine the desire to *joint* the device to the places we inhabit and the memories that we connect to geographies (see Jones and Garde-Hansen 2012). Mobile blogging (or 'moblogging') sites such as Twitter or Sina Weibo and social-networking sites such as Facebook use prompts that want to know what you are doing and where you are at any given moment, and photographs provide the proof of this with geo-tagging potentialities. Hence, the mobile phone's camera is a visual extension of 'the most intimate aspect of a user's personal sphere of objects (e.g. keys, wallet, etc.)' (Srivastava 2005: 113) and it visualizes the intimacy of the people and places that position the user in a specific space (like visual anchors), thus allowing the ephemerality of Facebook images to be tagged vertically into place as much as horizontally across online networks.

Anna Reading's more recent concept of 'memobilia' draws on research within the field of digital and mobile memories (see Garde-Hansen, Hoskins and Reading 2009). Such that '[m]obile digital phone memories or memobilia are wearable, shareable multimedia data records of events or communications' which are 'deeply personal and yet instantly collective through being linked to a global memoryscape of the World Wide Web' (Reading 2009: 81–2). This in turn is a development of her earlier theorization of a gendered mobile gallery made possible through the wearability of the camera. It is the new relationship with photography and everyday life (particularly family life) that is of importance here, and, by extension, the central question becomes who gets to represent that domestic sphere and in what ways: parents or children?

Like Reading, Rubinstein and Sluis identify the most significant feature of the technological shift from analogue camera to digital camera phone as the drawing of the means of production and distribution closer to the individual (2008: 12). Yet, what if that individual is not yet considered to be a legitimate maker of family memories? Once the subject of a childhood narrative and now the producer of that narrative outside the direct control of the family, the teenager can construct his or her own version of family life. As Sara McNamee (2000) has argued about children's everyday lives, they are finding within their leisure spaces Foucauldian heterotopias that enable them to resist and escape control, which can now be extended much farther into the decreasing boundaries of online life.

As I have argued in *Media and Memory* (2011: 139), the 'creative imperative has become far more central to [teenagers'] existence in a mediated world.' Rather than 'occasional or dedicated consoles of ludic and narrative connectivity' mobile camera phones are swiftly becoming 'emergent nodes of creativity and digital art' (Richardson 2005). Thus, I have proposed that the concept of 'connected memory' (Garde-Hansen 2011: 136) will have far more resonance in teenagers' everyday lives than Kuhn's continuously structured flow from personal to collective memory (2002: 4) that she isolates in her analysis of family life and photography. Rather than emphasize

mobility (Reading 2008, 2009) and itinerancy (Richardson, 2005), Nicola Green and Leslie Haddon (2009: 48) have argued that camera phones and social networking can intensify *strong ties* through the connected presence of established cliques. In my research, I found that all the teenagers had acquired their mobile phones when they were 11 or 12 years old. The majority owned the most up-to-date handset (often a better version than their parents'). They knew how to use the device to produce strong ties to connect and disconnect. Some had even programmed a shortcut button onto the screen, which they could secretly press to make their phone ring. This was for the many awkward, boring and uncomfortable social situations they sought disconnection from, and many of them considered it to be fundamental to lived life.

(Dis)connecting Memories

With the majority of male and female respondents defining their phone as a source of entertainment, connection and a lifeline, it is no surprise that photographs and connecting with friends were the two main functions used by teenagers, whether the latter is through texting or social networking. The older the participants, the more photographs they had accumulated on their phones (in most cases more than 200 photographs were stored in the phone's memory) and these consisted of images of everyday life for them: friends, family and fun times. The camera phone was theirs to document daily life, whereas special family occasions were considered in the control of parents: Christmas, weddings, formal birthday parties were imagined to require the stability, dependability and tradition of a stand-alone (albeit digital) camera. Hence, family rituals that involved the remaking of relationships between family members fell within the domain of parents with their more expensive equipment.

Photos of friends and everyday life, or as they termed them 'out and about' photos, were frequently cited as the main use of their camera phones.

Regardless of gender, photos of friends, family and funny things were shared face-to-face, mobile-to-mobile and mobile-to-internet, in order to establish trusted networks of connected memories. These fell outside the 'official' family narratives produced by parents, and the teenagers had complete control over them, thus according with Reading's (2008: 362) statement that:

> Rather than the personal album or shoebox of memories in the dusty cupboard, the mobile 'archive' suggests that even in relation to their own personal memories the individual now performs the role of a public librarian or trained archivist, ordering and maintaining documents relating to the past with its concomitant status, authority and location within the public realm of the lifeworld.

Unlike their parents, the teenagers were not precious about their images. They did not conceptualize their mobile phones as handsets of digital treasures, but they did see their importance for establishing and maintaining friendships and connections offline and online.

However, throughout my research I was keen to focus on the hows and whys of teenage archiving and storage of memories using mobile phones. It is important to note that 67 per cent said that they deleted their photographs from their handset through what I termed in the book *Media and Memory* four deletion dynamics: *not MY memory, future memory, save memory* and *transfer memory* (2011: 145–8). It is the first two of these that I wish to focus on in more depth in the context of this chapter's attention to photography and its changing practices in capturing everyday life. The *not MY memory* deletion dynamic was driven by a sense of ownership and aesthetic standards, suggesting that the teenage users were not just randomly taking digital snaps in a throwaway manner as a deliberated use of the camera phone. Rather, common to this age group were accidental shots, delayed image-taking by the handset, poor construction or out-of-focus photos. Moreover, the production of images not taken by them when their phones had been knowingly or unknowingly purloined was a frequent occurrence (what in the

context of stealing and despoiling social-networking sites is termed 'fraping' or 'Facebook raping'). Regardless, the *not MY memory* deletion dynamic was driven by temporal and spatial factors rather than content: *out of date, needs updating, forgotten what the photo is about, I did not take that photo*. Such an excess of images of the everyday speaks to the movement from 'scarcity to saturation' that Ben Highmore considers fundamental to the question of 'the ordinary', posed for media not as 'a question of representation but of attention' (2010: 115) and, I would add, of necessary forgetting.

Quality control, privacy control and constant updating were frequently cited by the teenagers as the mobile-phone camera practices they undertook because they intended to connect and share the images with a wider audience off- and online. I have termed this the *future memory* dynamic, in which, as image-entrepreneurs, they effectively brand their identities through online self-portraiture. Aware of how they want to see themselves and how they want others to see them, the teenagers recognized their own development as young people, the changeability of their everyday lives and the constant need to replace images in light of new haircuts, clothes, pets, activities, friendships and places. Furthermore, the deletion dynamic allowed the *future memory* photo to emerge into being, to be tested with an audience and then to become memorable. They even cited that their best photos for sharing online were the unintentional, the accidental or simply the ones that had escaped deletion on their phones (and so by a process of de-selection were selected). Friendship photography is about working out how to deal with a saturation of everyday images by paying attention to media as heterogeneous and complex through pragmatic and deliberate forgetting rather than the active remembering so important to family photography.

Therefore, deletion was a conscious and deliberate forgetting in order to move forward (particularly when their camera phone had captured them in a pose they considered ugly). As Paul Connerton (2008: 63) explains of the wider social context of history, but which is equally applicable to these teenagers deleting the photographs that do not represent them in the best light at that moment in time:

The emphasis here is not so much on the loss entailed in being unable to retain certain things as rather on the gain that accrues to those who know how to discard memories that serve no practicable purpose in the management of one's current identity and ongoing purposes. Forgetting then becomes part of the process by which new memories are constructed because a new set of memories are frequently accompanied by a set of tacitly shared silences.

The power over erasure is very important here compared to their parents' desire to hold on to memories. As I have argued previously, 'we cannot ignore the powerful politics of archiving and friendship at stake in social-networking sites', in which Facebook architecture 'may not be liberating personal memory at all but enslaving it within a corporate collective in order to shore up abiding ideologies through its public sphere and commercial activities' (Garde-Hansen 2009: 136). Thus, teenagers' anarchivization of everyday memories evolves within a context of technological remembering, whereby nothing is forgotten and everything is archived. Deletion then becomes far more important a practice than preservation. Not because of commonplace assumptions that the digitally literate generation is a throwaway generation, but because they may emerge to understand the politics of archiving and who controls the archive (see Derrida 1996).

In the last decades, the family photograph has been largely theorized as a project in which the messy unconventionality of everyday and real life is represented as a socially acceptable, coherent and happy unit (see Chalfen 1987; Slater 1995; Rose 2003). The internet has not changed that project. In fact, it has remembered it with a renewed intensity to fit in. My own Facebook page is testimony to the social Darwinism at play, in which strong family units are photographed as engaging in ceremonial and ritual events even though the single unit of a social-networking site is the individual. Though full of friends, one of the interesting things to note in social-network sites is the predominance of happy faces. People often use these sites for posting photographs of smiling faces: smiles over the birth of a baby, smiles

at the altar, smiles on the beach. These are still Annette Kuhn's 'imagined communities', pre-existing public faces whereby 'every effort' is made 'to keep certain things concealed from the rest of the world' (Kuhn 2002: 1–2) while at the same time opening out the intimacy of family lives to an online network. Are happy smiles also prevalent among these teenagers?

The teenagers in my research (formerly the subjects of family photography) were consciously forgetting themselves and their families through practices of deletion in order to remember their lives as dynamic and lived in the present. They persistently reiterated the phrases: 'rubbish photo', 'I don't like them', 'boring', 'not nice ones', 'I look ugly', 'embarrassing', 'they don't mean anything to me anymore', 'I don't need them', 'they're not wanted', 'my friends don't like them', 'they need updating', 'they've got old'. Aware of the mythic function and cultural myths that images enact, they took an entirely pragmatic approach toward photographing their lives. The vast majority of the more than 2 billion photos uploaded each month to Facebook functions to bolster existing networks of relationships and allows users to manage their relationships in a connected, communal and emotionally rewarding way. Teenagers know this and we do a disservice to them when moral panics over cyberbullying position them as entirely vulnerable. Awareness of every image's future actualization, its future affective value built in at the moment of production, means that instant deletion and forgetting is the pragmatic solution.

Friendship Photography and Networked Intimacy

In *Media and Memory* (2011), I used my research to evoke a concept of connected memory. However, further exploration of how friendship photography is fundamental for making visible emotional and social ties has compelled a revisiting of the research data of the teenagers' cameraphone usage. While they clearly engaged in practices of deletion for future memory purposes, I missed their articulation of deletion in the context of

their emotional connection to their own handsets. The mobile phone was their friend and they were emotionally attached to it. Thus, intimacy was as important to consider as memory. Ongoing research by Amparo Lasén (2004, 2010a, 2010b, 2011; Lasén and Gómez-Cruz 2009) reveals that while mobile-phone users are emotionally attached to their phones, and although mobile culture may be shared, that does not mean that it feels the same to those within the network. Thus, multimodal possibilities and practices for the performance and consumption of intimacy online are afforded through the transpersonalization of media and communication devices that bridge the gap between collectivity and individuation (see Lasén 2010a). A tension is created between sameness and difference. For while one's *friends* online become 'dormant memories' as Andrew Hoskins describes them (2010), they continue streaming visual data of ordinary memories across a diverse network of members, many of whom have never met each other.

I am not the only one to have noted these tensions between individuation and collectivity, active intimacy and dormant memories, proximity and distance: Facebook itself has. And, for the purposes of thinking through this concept of friendship photography, it makes sense to understand how a social-networking site with almost 1 billion active users at the time of writing images and imagines friendship online as big data. If we take a look at the diagram produced by Cameron Marlow (Facebook's own sociologist) for his weblog *Overstated.net* (see figure 5.1), we can see the data connections of one person's network.

In researching whether Facebook increases communication in a network, Marlow and his colleagues illustrated the data to create a diagrammatic representation of four ways of looking at the connections a co-worker was making. Marlow draws attention to the intensified 'clusters' as seen in the top-left diagram, which denote the highly connected network of the Facebook co-workers as a whole. If we contrast this cell with the one on the bottom right, Marlow points to the fact that in this network of mutual communication (the most meaningful and emotionally supportive) we see that many 'of the individuals in his network are completely disconnected or

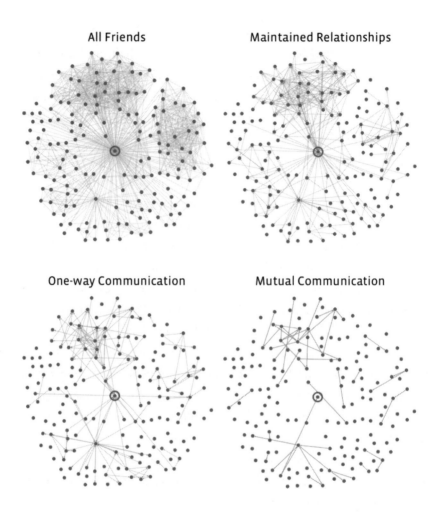

5.1 Screenshot from webpage of diagram of systemic effects of a twofold increase in connectivity for a network. Marlow et al. (2009), 'Maintained relationships on Facebook', posted 9 March 2009.

out of touch with each other' (Marlow 2009). Key for social networking is that the network can expand and contract through 'passive networking' via the news feed. Marlow often cites the uploading of an ordinary photograph of a new baby as the example par excellence, which when passively consumed through the news feed may prompt intensified connections, which

then retract back to the reciprocal network. The other connections do not disappear; they are simply not expanded upon and only do expand when the demand for lay friendship photography is met.

Sharing photos of everyday life and the milestones of living have a particularly important function then in visualizing networked intimacy in our new media ecology. They propagate connections very quickly, allowing relationships to be maintained and users to manage those relationships. They track back memories and track forward to future potential connections. They also provide the Facebook Data Team with the valuable 'tipping' points for understanding how social networks fade and intensify within a system of networked experiences. The connections expand and contract as friendship photography is created and shared.

The increase in the importance of online self-portraiture (see Schwarz 2010a, 2010b), the rise of online friendship (see Boyd 2008; Boyd and Ellison 2007) and the importance of social-networking profile images for learning about others suggests that friendship photography has an integrated sense of sharing built in, which moves it very quickly from personal to public. Research by Larissa Hjorth (2007) notes the positivity of the gift-giving economy imbued in camera-phone practices whereby the sharing of moments between intimates becomes commonplace privately and publicly. The concept that 'we are all friends online', alongside the proliferation of the domestic sphere into online spaces and the technologization of the home in real space, serves to reinforce the notion that what is private is also (by rights) public.

The appearance of images of family and friends on Facebook pages, which function now as archives of everyday life (caching and storing memories to be shared with others), suggests that we have found a new way to photograph intimacy as ordinary and shared. For young people, the emergence of a demand for lay photography has dovetailed with their affective relationship with their mobile phones. Their everyday lives (hitherto under-represented in family photography) have become the testing ground for new uses of the friendship photograph: from baby photos on the news feed to the

autotelic uses of camera phones as self-portraiture, whereby teenagers, for example, might photograph their bodies and body parts for the purposes of self-exploration, learning and self-representation (see Garde-Hansen and Gorton 2013).

Thus, the shift from the domestic to the public also changes the production and consumption of photography and intimacy, which was once firmly rooted in the family. Parents controlled the means of production and how the intimacy of the family was represented to their children and the other family members. Yet, it seems that young people's use of mobile camera phones for representing their own strong ties is symptomatic of a haptic–affective economy of individualized media (see Campbell and Park 2008). This may no longer be focused on the family but on their own lives as they ordinarily live them. Jane Vincent argues in 'Emotional attachment and mobile phones' (2005) that '[t]he very act of using a mobile phone involves the simultaneous engagement with more senses than we use for other computational devices as we simultaneously touch, hear and see via the mobile phone in order to keep in touch with our buddies' (2005: 120–1).

For Hjorth, mobile phones and ICTs are defined by the 'various forms of labour and intimacy' that produce them and 'have become part of the emotional landscape of the Internet' to form 'imaging communities' that 'demonstrate unofficial forms of reterritorialisation that counteract the bounded territorialisation of "imagined communities"' (2008). Whether these are 'tribes' or 'communities' of shared emotions, what we are witnessing through the visualization of friendship (particularly among young people) is the emergence of new audiences for lay photography (see Schwarz 2010b). My research has revealed that teenagers' control of this new audience for images of their young lives can only be managed through instant and mobile editing (deleting/forgetting) and not simply storage, selection and sharing (remembering).

This new audience of lay or friendship photography demands the ordinary. In the light of Ben Highmore's *Ordinary Lives: Studies on the Everyday*, the intimate private life of 'friends' that 'routinely takes place in cyberspace' is

a symptom of the 'suggested collapse of the private/public spheres' (2010: 16). The teenagers' photographs that were shown to me during the focus groups for my research (taken of domestic spheres, out and about, during daily routines or of one-off adventures) were aesthetic, spontaneous, dull, enviable, repetitive, creative, uninhibited, crowded, contrived and familiar in their non-event-ness. They *called my attention* and *called attention to* ordinary lives turned into *events* in the moment of viewing. Their pervasive ubiquity that made them non-events (ordinary, shared, mundane) was mediatized as a form of 'ceremonial participation' akin to Dayan and Katz's live broadcasting of history (1992). At that moment (and only in that moment), I was invited to feel and to display sentiment towards their images of ordinary life. Friendship photography, then, expands and contracts the intimacy of the family well beyond personal and collective memory and remembering. It seeks to make an emotional connection in the present, establish a social tie, perform intimacy and joint memory as simultaneously offline and online.

BIBLIOGRAPHY

Ashuri, T. (2011), 'Joint memory: ICT and the rise of moral mnemonic agents', in Neiger, M., Meyers, O., and Zandberg, E. (eds), *On Media Memory: Collective Memory in a New Media Age*, Basingstoke: Palgrave Macmillan: 104–13.

Booth, K. (2008), 'Risdon Vale: place, memory and suburban experience', *Ethics, Policy and Environment*, 11(3): 299–311.

Boyd, D. (2008), 'None of this is real', in Karaganis, J. (ed.), *Structures of Participation in Digital Culture*, New York: Social Science Research Council: 132–57.

Boyd, D. and Ellison, N. (2007), 'Social network sites: definition, history and scholarship', *Journal of Computer-Mediated Communication*, 13(1), article 11, [online], <http://jcmc.indiana.edu/vol13/issue1/boyd.ellison.html>, accessed on 1 March 2012.

Campbell, S.W., and Park, Y.J. (2008), 'Social implications of mobile telephony: the rise of personal communication society', *Sociology Compass*, 2(2): 371–87.

Chalfen, R. (1987), *Snapshot Versions of Life*, Bowling Green, OH: Bowling Green State University Popular Press.

Connerton, P. (2008), 'Seven types of forgetting', *Memory Studies*, 1(1): 59–71.

Dayan, D., and Katz, E. (1992), *Media Events: The Live Broadcasting of History*, Harvard: Harvard University Press.

Derrida, J. (1996), *Archive Fever: A Freudian Impression*, trans. E. Prenowitz, Chicago: University of Chicago Press.

Garde-Hansen, J. (2009), 'MyMemories?: personal digital archive fever and Facebook', in Garde-Hansen, J., Hoskins, A., and Reading, A. (eds), *Save As… Digital Memories*, Basingstoke: Palgrave Macmillan: 135–50.

—— (2011), *Media and Memory*, Edinburgh: Edinburgh University Press.

Garde-Hansen, J., and Gorton, K. (2013), *Emotion Online: Theorizing Affect on the Internet*, Basingstoke: Palgrave Macmillan.

Garde-Hansen, J., Hoskins, A., and Reading, A. (2009) (eds), *Save As… Digital Memories*, Basingstoke: Palgrave Macmillan.

Green, N., and Haddon, L. (2009), *Mobile Communications: An Introduction to New Media*, London: Berg.

Halbwachs, M. (1992; originally published 1952), *On Collective Memory*, Chicago: University of Chicago Press.

Highmore, B. (2010), *Ordinary Lives: Studies in the Everyday*, London: Routledge.

Hirsch, M. (1997), *Family Frames: Photography, Narrative and Postmemory*, Cambridge, MA: Harvard University Press.

Hjorth, L. (2007), 'Snapshots of almost contact: the rise of camera phone practices and a case study in Seoul, Korea', *Continuum*, 21(2): 227–38.

—— (2008), 'Framing imaging communities: gendered ICTs and SNS (social networking systems) in the Asia-Pacific', *T-Mobile Hungarian Academy of Sciences Conference, Budapest*, Pre-proceedings, [online], <http://www.socialscience.tmobile.hu/2008/Preproceedings.pdf>, accessed on 1 May 2012.

Hoskins, A. (2010), 'The diffusion of media/memory', in *Warwick Writing: Complexity*, [online], <http://www2.warwick.ac.uk/newsandevents/warwickbooks/complexity/andrew_hoskins/>, accessed on 31 March 2012.

Jones, O., and Garde-Hansen, J. (2012) (eds), *Photography and Memory*, Basingstoke: Palgrave Macmillan.

Katz, J.E., and Aakhus, M. (2002), *Perpetual Contact: Mobile Communication, Private Talk, Public Communication*, Cambridge: Cambridge University Press.

Kuhn, A. (2002), *Family Secrets: Acts of Memory and Imagination*, revised edition, London: Verso.

Landsberg, A. (2004), *Prosthetic Memory: The Transformation of American Remembrance in the Age of Mass Culture*, Columbia: Columbia University Press.

Lasén, A. (2004), 'Affective mobile phones: an insight into how mobile phones mediate emotions based on fieldwork carried out in London, Madrid and Paris', Paper for the 5th Wireless World Conference 'Managing Wireless Communications', 15–16 July.

—— (2010a), 'Mobile culture and subjectivities: an example of the shared agency between people and technology', in Fortunati, L., Vincent, J., Gebhardt, J., Petrovcic, A., and Vershinskaya, O. (eds), *Interacting with Broadband Society*, Frankfurt am Main: Peter Lang: 109–24.

—— (2010b), 'Mobile media and affectivity: some thoughts about the notion of affective bandwidth', in Höflich, J.R., Kircher, G.F., Linke, C., and Schlote, I. (eds), *Mobile Media and the Change of Everyday Life*, Frankfurt am Main: Peter Lang: 131–54.

—— (2011), ' "Mobiles are not that personal": the unexpected consequences of the accountability, accessibility and transparency afforded by mobile', in Ling, R., and Campbell, S. (eds), *Mobile Communication: Bringing Us Together or Tearing Us Apart*, Piscataway, NJ: Transaction Publishers: 83–105.

Lasén, A., and Gómez-Cruz, E. (2009), 'Digital photography and picture sharing: redefining the public/private divide', *Knowledge, Technology and Policy*, 22: 205–15.

McNamee, S. (2000), 'Foucault's heterotopia and children's everyday lives', *Childhood*, 7(4): 479–92.

Marlow, C., et al. (2009), 'Maintained relationships on Facebook', *Overstated.net*, posted 9 March 2009.

Reading, A. (2008), 'The mobile family gallery? Gender, memory and the cameraphone', *Trames: Journal of the Humanities and Social Sciences*, 12(3): 355–65.

—— (2009), 'Memobilia: the mobile phone and the emergence of wearable memories', in Garde-Hansen, J., Hoskins, A., and Reading, A. (eds), *Save As… Digital Memories*, Basingstoke: Palgrave Macmillan: 81–95.

Richardson, I. (2005), 'Mobile technosoma: some phenomenological reflections on itinerant media devices', *Fibreculture: Internet Theory, Criticism and Research*, 6, [online], <http://journal.fibreculture.org/issue6/issue6_richardson.html>, accessed on 9 November 2011.

Rose, G. (2003), 'Domestic spacings and family photographs: a case study', *Transactions of the Instititute of British Geographers*, 28: 5–18.

—— (2004), ' "Everyone's cuddled up and it just looks really nice": the emotional geography of some mums and their family photos', *Social and Cultural Geography*, 5: 549–64.

—— (2005), '"You just have to make a conscious effort to keep snapping away, I think": a case study of family photos, mothering and familial space', in Hardy, S., and Wiedmar, C. (eds), *Motherhood and Space: Configurations of the Maternal through Politics, Home, and the Body*, Basingstoke: Palgrave Macmillan: 221–40.

—— (2010), *Doing Family Photography: The Domestic, the Public and the Politics of Sentiment*, Aldershot: Ashgate.

Rubinstein, D., and Sluis, K. (2008), 'A life more photographic: mapping the networked image', *Photographies*, 1(1): 9–28.

Schwarz, O. (2010a), 'Going to bed with a camera: on the visualisation of sexuality and the production of knowledge', *International Journal of Cultural Studies*, 13(6): 637–56.

—— (2010b), 'On friendship, boobs and the logic of the catalogue: online self-portraits as a means for the exchange of capital', *Convergence*, 16(2): 163–83.

Siegel, E. (2010), *Galleries of Friendship and Fame: A History of Nineteenth-Century American Photograph Albums*, New Haven, CT: Yale University Press.

Slater, D. (1995), 'Domestic photography and digital culture', in Lister, M. (ed.), *The Photographic Image in Digital Culture*, London: Routledge: 129–46.

Sontag, S. (2004), *Regarding the Pain of Others*, London: Picador.

Srivastava, L. (2005), 'Mobile phones and the evolution of social behaviour', *Behaviour and Information Technology*, 24(2): 111–29.

Tebbe, J. (2008), 'Landscapes of remembrance: home and memory in the nineteenth-century Bürgertum', *Journal of Family History*, 33(2): 195–215.

Tolia-Kelly, D. (2004), 'Locating processes of identification: studying the precipitates of re-memory through artefacts in the British Asian home', *Transactions of the Instititute of British Geographers*, 29: 314–29.

van Dijck, J. (2007), *Mediated Memories in the Digital Age*, Palo Alto, CA: Stanford University Press.

—— (2011), 'Flickr and the culture of connectivity: sharing views, experiences, memories', *Memory Studies*, 4(4): 401–15.

—— (2012), 'Facebook as a tool for producing sociality and connectivity', *Television & New Media*, 13(2): 160–76.

Vincent, J. (2005), 'Emotional attachment and mobile phones', in Glotz, P., Bertschi, S., and Locke, C. (eds), *Thumb Culture: The Meaning of Mobile Phones for Society*, New Brunswick, NJ: Transaction Publishers: 117–22.

Wilson, E.O. (2012), *The Social Conquest of Earth*, New York: W.W. Norton & Co., Inc.

6

Play, Process and Materiality in Japanese Purikura Photography

METTE SANDBYE

'The social aspect of purikura is the most important'
Sayaka Y., October 2010

'You look much better in purikura than on ordinary photographs'
Shino F., October 2010

Purikura (Japanese: short for *purinto kurabu*, derived from the English 'print club') photography is a widespread phenomenon in contemporary Japan. It is a kind of digitally manipulated photo-booth photography, created and used by almost all – particularly, but not exclusively – female teenagers, often several times a week. You typically see the purikura vending machines in shopping malls and game arcades where they are used in association with a social event or gathering among teenagers. The purikura photo booth is similar to a traditional automated passport photo booth, with a chair behind a curtain, installed to allow privacy, a slot in which to insert money, a digital camera mounted behind a glass plate, connected to a computer and a colour printer, and another slot on the outside wall of the booth where the final strip of images is pushed out. This process used to take several minutes in the old 'wet chemistry' booths, but is now accomplished in about 30 seconds with

6.1 Sample of Shino F.'s purikura books and little metal box for 'extras'.

digital technology. In the case of purikura, within the space of a few minutes, you pose yourself (or often several girls at a time) and the images come out as sticker sheets of typically six to ten images. In recent years, it has become possible to have the images sent directly to your cell phone. The printed sticker photos are then exchanged and put in little scrapbooks (see figure 6.1).

In other words, purikura photography is at the same time a digital, convergent technology, a very material and indeed performative practice, and a technologically produced object used as a social and communicative tool (Ono 1997). In this chapter, I take a closer look at how digital technology keeps enhancing the idea of purikura, while the very material fundament behind this digital technology is both still being kept alive and of extreme importance. At the same time, this kind of digital photography also underlines the need to look at photographs not just as images, but also as material and social objects: objects that mould and create identity and social relations between people. There are many relevant aspects to discuss in relation to

purikura: are all these staged teenage photos a sign of conformity and adjustment to both the machine and the group mentality, or is it the opposite, a free, creative and highly gestural play with identity, gender, sexuality, and so on? Do they actually represent rebellious behaviour? What is the social value of this kind of photography and what kind of affect does it produce? Why has this phenomenon caught on so strongly in Japan and not in the rest of the world? I will touch upon many of these questions, but my main concern will be to consider purikura – and thereby vernacular, amateur, private photography in general – as a means of strengthening social bonds, friendship ties and group belonging, not unlike Joanne Garde-Hansen's take on Facebook photography (see Chapter 5 of this book).

As a digital process to make photographs circulate socially, purikura resembles the purpose of social-media sites such as Flickr, Facebook and Instagram. But the case of purikura, as I will show, also underlines that the material, physical aspect of photography as 'a thing' still survives. With this example, I want to show that 'materiality matters' in photography studies, as Elizabeth Edwards, Janice Hart and others have emphasized (see Edwards and Hart 2004). Materiality has a profound impact on the way photographs are read, used and understood:

> Materiality is closely related to social biography. This view, which has emerged from the material turn in anthropology over recent years, argues that an object cannot be fully understood at any single point in its existence but should be understood as belonging in a continuing process of production, exchange, usage and meaning. As such, objects are enmeshed in, and active in, social relations, not merely passive entities in these processes. (Edwards and Hart 2004: 4)

The materiality of the purikura photographs is indeed considered to be of major importance to the users. The images are mounted in small scrapbooks, and 'extras' are kept in little, often nicely decorated, boxes, to be used as objects of exchange. As such, my conclusions regarding purikura

photography point towards other, more general and non-Japanese premises of photography that need to be considered when studying 'digital snaps'.

A New Leisure Technology

The purikura format and the machine to make it were invented in 1995 by a 30-year-old female employee at the Tokyo-based company Atlus. She and Atlus had intended the new technology for families, but it did not really catch on. A few months later, Atlus joined forces with the much bigger company Sega Enterprises, which primarily produced video games and technology for game arcades, karaoke bars, fast-food restaurants, and so on (Chalfen and Murui 2004: 167). At the time, being introduced as a technology within the game arcades, this new leisure activity immediately caught on in Japan, especially among an adolescent audience. In 1996, 3,500 photo booths for making purikura were located in the major Japanese cities; in 1998, 25,000 were in operation (Chalfen and Murui 2004: 167). Since then, it has spread to other Asian countries, especially to Taiwan, where it is very popular, and to a minor degree to the US, but it never really caught on in Europe. Today, however, Japan is still the country where most purikura photography is produced. In May 2003, the magazine *Cawaii!* asked 100 young people: 'How often do you use a print club machine?'; 68 per cent of respondents answered 'at least once a week' (Miller 2003: 32).

When visiting Tokyo for the first time in 1998, I 'tried' it myself, fascinated by this new, extremely booming and popular kind of photography. It was similar to the well-known passport-photo format, but, in contrast, the images were printed as stickers to put on letters, on schoolbooks, in diaries, and so forth, and you could choose your own lighting and portrait background out of hundreds of possibilities, transporting your face and body from Disneyland to Mount Fuji. When I visited Japan in 2010 to do a general fieldwork study on Japanese family photography and snapshot culture, I realized that the purikura phenomenon was as active as it was in 1998, but

that it had changed slightly because of new digital capabilities. Now a puri-kura vending machine most often consists of *two* booths, and they are both bigger than the original ones, allowing several people to pose for the same image. The machines are heavily decorated on the exterior and often music is pumping inside to enhance the feeling of hectic tension, leisure and fun.

In the first booth you choose a backdrop. This booth thus serves the production of an only slightly visually manipulated photograph; meanwhile, a clock is ticking down while you pose yourself and your friends. However, most of the digital manipulation takes place in the neighbouring booth, where the images appear on a screen, offering hundreds of visual as well as graphic design possibilities. The machine now also offers a much larger variety of image sizes than the few standard formats in 1998. Today, the range of possibilities for personal manipulation and manufacturing of the image has been widely expanded: you can still change the background, but now – in the second booth – you can add text, as well as other images or small visual symbols, and also change the hairstyle, eye colour, and so on. As we will see, some of the machines automatically change your physiognomy. In many purikura arcades, you can also borrow wigs and costumes to be used for producing a staged portrait photo; typically costumes of a geisha, schoolgirl, nun, bride or Disney figure – most of them more or less overtly loaded with sexual connotations. In the majority of cases, the manipulation work in booth number two is time-restricted: a clock is counting down, so you typically have two to three minutes to do your manipulating. This enhances the tension and excitement of the whole 'charade' and encourages the feeling of spontaneity and immediacy often already connected with youth culture. One strip or one shooting costs around €5 or US$7.

Recently, purikura has become a real convergent digital technology, because together with the printing, you can often have the photographs sent to your mobile phone, so they also get a digital circulation and afterlife. Several of my informants posted their purikura photographs on Facebook or on the Japanese version called Mixi. Mostly, however, they are used as very physical material objects to be circulated among friends and to be put in

particular sticker albums or scrapbooks. Sometimes they gain an even wider public circulation, because the girls send them to specific girls' magazines such as *Seven* and *Cawaii!*.

In 2010, in Tokyo, I interviewed 12 (10 female, 2 male) Japanese junior-college and undergraduate university students aged between 18 and 23 about their production and use of purikura photography both then and when they were in high school. They all had several purikura scrapbooks. My analysis of the phenomenon, presented below, is primarily based on this fieldwork, but also on studies done by others (Miller 2003, 2005; Chalfen and Murui 2004).

Girl Culture

My informants and the literature on Japanese visual and youth culture in general (Ono 1997; Matsui 2005; Ashcraft and Ueda 2010) emphasized that purikura is part of the girl culture, primarily associated with girls between the ages of 13 and their early 20s, although a few boys do also make them, and some couples make them as an integrated part of courtship. Initially, the purikura phenomenon was often associated with *kogaru* or *kogal*, terms meaning stylish Japanese urban high-school girls. The term caught on in the late 1990s (as did purikura) when Japanese schoolgirls were discovered to be a new consumer segment and became extremely influential on the market as trendsetters because they had both money and the time to spend it (Best and Suzuki 2003; Ashcraft and Ueda 2010): 'Between 1995 and 1998 real schoolgirls in uniform became a perpetual presence on national television […] many intellectuals suggested that the concept "high-school girl" had itself become a kind of unofficial brand label' (Kinsella 2002: 227, 229; cited in Best and Suzuki 2003: 63).

These *kogaru* high-school girls also became trendsetters for fashions in communication tools, and purikura especially caught on among *kogaru*, as Best and Suzuki have described: 'Purikura or Print Club (photo stickers) became a fad among kogaru within three months of their debut in July 1995.

Purikura booths in Japanese cities were crowded, not only with kogaru, but also with junior-high-school students, college students, and adults' (Best and Suzuki 2003: 63).

In the purikura photo albums, the girls often wear their school uniforms, not only because the images are taken directly after school, but also because the uniform is an important part of the identity of young Japanese women. In Japan, most schools require that their students wear school uniform. Each school has its slightly varying style, but in general the boys' uniform bears a passing resemblance to a soldier's uniform, whereas the typical girl's uniform is sailor-style, with a skirt, long white stockings, a sailor blouse and sometimes a cardigan, typically in beige or blue. From primary level to high school, schools are often gender-segregated, and many children go to two schools or to a second so-called 'cram school' in the afternoon or evening. This leaves very little leisure time, but the limited time is often spent in a shopping mall or at sports activities.

All my informants, typically rather hastily, visited the purikura booth several times a week on their way from one school to the next or from school to home, although, as they stated, both their teachers and parents warned them against it because of the time and money wasted (one said that she went with her friends every day). Now that they are in college, they typically 'do purikura' once every two to three weeks. Shino F., now 20 years old, still does purikura, but remembers junior high school:

The school didn't allow us to take purikura after school. We had to go straight home and do our homework, and be home before dark. Then we did it a little farther from school, but if they discovered it, we were given a punishment, depending on the teacher. It could be writing a letter of excuse to the school or staying home from school a couple of days.

This quote underlines that purikura is closely tied to school life and that it is an activity that the teachers are also very aware of. Several informants

reported both producing albums and swapping images at school, and not after or outside of school.

So purikura did not catch on among families but became an integrated part of especially girls' school culture: 'Thus, rather than finding a home in family photography, as initially predicted, Print Club generally produces pictures that reinforce peer-centred friendship communities rather than kin communities' (Chalfen and Murui 2004: 179).

In the following, I focus on this aspect of 'friendship production activity' and regard it as related to the medium of photography in general. 'I never do it with my family, only once my brother and I did it, when we went to the cinema with my mother and were waiting while she purchased the tickets,' says Shino, quoted above. The primary group doing purikura are junior-high-school and high-school girls (13–18 years old), but they seem to continue to do it later on, just less often. As Shino, born in 1990, says: 'I'm the generation that was brought up with the purikura boom. I started when I was 11 and therefore I still do it.' Some girls even dress up in fake school uniforms when making purikura after having left school, because the activity is so closely linked to school life.

Purikura as an Activity

Through my research, I found several – interrelated – dominant purposes of purikura. They all point towards regarding purikura photography much more as an activity or a 'doing' than as images related to a nostalgic freezing or 'mummification' of a moment 'that has been' (see also chapters 1 and 4 in this book). This perspective is otherwise what the phenomenologically inspired – and enormously influential – theory of photography has suggested as the foremost ontological characteristics of photography (Barthes 1981; Bazin 1981). This approach is of course still relevant, but it is not the *only* relevant way to understand the purpose of purikura.

Purikura seen as an activity can be divided into subcategories. First, it

is seen as *a memory activity* and a visual diary, as mentioned above and as photography always has been: we were there, we did that, we were so happy that day (Barthes 1981; Bazin 1981; et al.). In Japanese, this aspect of photography has its own term, *kin'en shashin*, meaning 'memory photograph'. Several of my informants used this term to describe purikura. 'My purikura album is a diary of happy memories,' as one said.

Secondly, and more importantly, purikura is regarded as a *social activity*, something 'done' with friends, often as an integrated part of having a night at the cinema or taking a trip to the shopping mall and then sealing the day with a collective purikura shot, where the informants, for instance, comment on the film they saw directly on the image. 'The texts are often about describing what you did the moment before the picture was taken. If you went to the movies, you wrote "awesome movie", or if you came from karaoke or a rock concert, you wrote the titles of the songs. Or it can be used to exchange mutual agreements between friends that no one else understands,' says Sayaka Y. In many albums, movie-theatre tickets and train tickets are glued in the purikura scrapbook alongside the images.

Important to purikura as a social activity is the exchange of images among friends at school. An integrated part of school life is to exchange images, show albums and even prepare the albums when at school. 'It is a way to show or to pretend that you have many friends,' says Sayaka Y., indicating that purikura implies social capital. In that sense, it can be related to the tradition of collecting business cards, which is very widespread in Japan.

Thirdly, an important aspect of this 'doing', there is a strong element of *role-playing, staging the self* and *doing 'something creative'*, as many of my informants called it, by manufacturing the images in the process as well as putting them in a scrapbook. 'It is a place to express yourself,' says Yuko Y. 'It is about dressing up,' says Asuka I. Together with a friend, she makes her own costumes, such as kimonos and 'religious' costumes – nuns and monks, for example – to be used exclusively when taking purikura images. They pose wearing theatrical make-up and their costumes, not unlike the

tradition of doing 'cosplay' (an abbreviated term for costume play), which is very popular in Japan. As Daisuke Okabe has shown, photographing yourself and exchanging photographs is a vital part of the Japanese cosplay youth tradition, where young people dress up, typically as figures from manga, anime and video games and meet at special events with other 'cosplayers' (Okabe 2012).

Chalfen and Murui locate the practice historically within the rich Japanese visual culture and the general Japanese attention to the visual, including calligraphy, house and garden design, flower arrangement (ikebana), food preparation and the contemporary manga culture. Many of the scrapbooks include fashion images, commercial photos cut out from girls' magazines or handwritten diary-like texts.

Often the text consists of one word that is supposed to capture the situation, such as 'stupid', 'smile', 'freedom', 'cute', 'love' or 'friendship'. Many of them are prefabricated in the digital program, and many are in English. As Shino F. says: 'It is more cool in English, and the Japanese love everything that's in English.' This might be seen as a paradox, but it shows how Japanese youth unproblematically mixes local visual-culture tradition with a global language and modern mass-culture phenomena such as cartoons, pop stars, celebrities and films.

Group Adaptation or Resistance?

Finally, I want to introduce the fourth purpose of purikura. As a part of my larger research on Japanese family photography in general, and family albums in particular, I have noticed that taking a lot of snapshots and making a family album, and also a personal teenage purikura album, are associated with the concept of *adapting and belonging to the group*. Compared to Danish or American private photo albums (Sandbye 2009, 2011), a typical Japanese album includes more posed group portraits. It is normal to bring a professional photographer on school trips and to sporting events and to

document the event with a group portrait that ends up in the private home album. A typical Japanese family photo album is most often dedicated to following the life of one child chronologically instead of the whole family as an entity, which is much more common in Denmark and elsewhere (Langford 2001; Sandbye 2009, 2011). But in these individual-centred albums, it seems extremely important to make the single child appear as a member of a larger group, through the group portrait.

> In Japanese society, people are primarily group-oriented and give more priority to group harmony than to individuals. Most Japanese consider it an important virtue to adhere to the values of the groups to which they belong. This loyalty to the group produces a feeling of solidarity, and the underlying concept of group con-sciousness is seen in diverse aspects of Japanese life. (Davies and Ikeno 2002: 195)

The Japanese make a clear distinction between *uchi* (insiders) and *soto* (out-siders) (Davies and Ikeno 2002: 196). This is symbolized in the Japanese proverb: 'The nail that sticks out will be hammered down' (*Deru kui wa utareru*). My research indicates that a central aspect of purikura is the production of group solidarity and adaptation. While they are collected by individuals, they are produced, used, seen and circulated in groups, among members of the same group of close school friends.

Chalfen and Murui also underline the importance of group member-ship and belonging in Japanese culture in general, and in purikura as well. Although their studies were carried out in the early days of purikura, when there were not as many manipulation possibilities as today, it is an interpreta-tion that my fieldwork confirms. A typical purikura album consists of huge numbers of images of girls posing as 'best friends', smiling and doing the typical V-sign with their fingers, the most commonly recurring posture in all Japanese photography. Originally a gesture used as a victory sign among American soldiers during World War II, the gesture now means 'peace' and

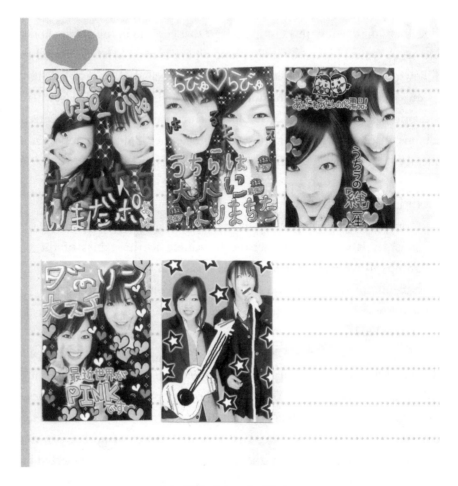

6.2 Girls doing the V-sign.

has become the most widespread, almost unconscious, gesture in Japanese photography. As I see it, this bodily gesture also serves to underline the element of ritual group adaptation in purikura. My informants also told me that when done close to the face, it can make a girl's face seem slimmer, therefore making her look more *kawaii*, meaning 'cute', a word highly valued in Japanese culture and among teenage girls themselves (Matsui 2005). 'You can show off your *kawaii* face here,' as Sayaka T. reported. Going through a lot of purikura albums, this gesture, especially the particular female way of doing it close to the face, was very dominant (see figure 6.2).

6.3 Automatically face-manipulated purikura of the author, Oct. 20, 2010.

Adding to this is the fact that very many – or, according to one of my informants, 'all' – new purikura machines are preprogrammed to change the face in the photograph already during the shooting: making hair lighter, the skin more clear and soft, thinning the face and making eyes bigger – all elements of the preferred Japanese female beauty ideal, an ideal that we also see in many manga figures. The machine is thus pre-designed to make you 'look your best'. Figure 6.3 is an example of the dark-haired and normally chubby-chinned author's own 'purikura face' being automatically 'made over' by the machine itself. Eye make-up and glasses are added afterwards in booth no. 2, but the colour of my eyes and hair were changed by the machine itself; as well as my skin's tone and surface, my high-boned cheeks and my eyes were also made bigger during exposure, as if I were a manga-cartoon figure. So, from my material, the most common pose was one that adopted conventional codes of femininity as cute, which the machines were already programmed to support.

Laura Miller criticizes other researchers such as Chalfen and Murui for focusing exclusively on 'the cuteness' of purikura. She sees purikura, or 'graffiti photos' as she calls them, as a culture of resistance and as a way to express female adolescents' disdain for adult society (Miller 2003: 31). She talks about purikura as 'empowering self-expression' (2003: 34): 'Within the confines of the graffiti photo, girls are free to express impermissible

sauciness in a frank departure from expected girlish innocence' (2003: 34). Through her research, Miller has found 'forms of transgression that are distinctly uncute' (Miller 2005: 131) and argues that purikura can also be a way to undertake a critical attitude towards typical Japanese gender representations, including ugly grimaces, repulsive drawings of faeces, vomit or bugaboos, posing with Winnie the Pooh in a naughty way or wearing a bra on your head. She names these kinds of purikura photographs 'bad girl photography': 'Bad girl photos provide visual-linguistic access to a deep vein of discontent that bubbles beneath the surface of contemporary girls' culture' (2005: 128). Miller continues:

> Japanese girls are well aware of the commercialised and sexualised uses to which photographs of women have been put in mainstream and male-authored media, so they usurp this prerogative by altering their own photos at the point of manufacture. These ugly photos critique compulsory femininity and the oppressive emphasis placed on female beauty and cuteness through unsettling imagery. (2005: 133)

The purikura material she has studied goes almost ten years back in time. Although it is a genre that has survived many technological changes and improvements, and apparently will never die, and although all Japanese girls have their own mobile camera phones and could take the photographs themselves, there are currents and fashions within purikura as elsewhere in lifestyle fashion. Asked why purikura is so widely used when they all have digital cameras, one girl says: 'You look much better in purikura than in ordinary photographs.'

I saw very few examples of images that could be called 'transgressive bad-girl photography'. Shino F. reports that 'five years ago when *kogals* [Shibuya/Harajuku girls with tanned skin, bleached hair, heavy make-up and sexually provocative behaviour] were very much in fashion, we all wanted to imitate that, but that period is over, luckily enough,' and she emphasizes that she

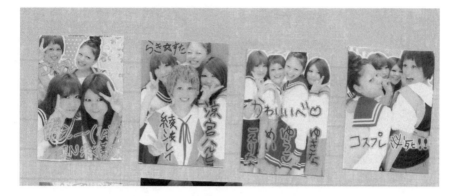

6.4 Yuko and three friends posing with borrowed uniform dresses.

would never dream of acting deliberately provocatively or offensively in her purikura images.

'It's a place to express yourself,' Yuko Y. says, showing a photo of herself and three girlfriends posing in borrowed school uniforms, with her hair painted blue in booth no. 2 (figure 6.4). My informants used phrases such as 'a fun hobby', 'it's about dressing up and having fun', but mostly they stress that 'it's about friendship'. Many also emphasize the feeling of 'high tension' during the production, something that I have experienced myself. Since time is counting down in the 'manipulation booth', you experience a feeling of excitement, intensity and a great deal of tension while working on the image in the booth.

Sayaka Y., 23 years old in 2010, also underlines that purikura is a positive thing, related to positive memories: 'Purikura is a very Japanese thing and *kawaii* is the keyword. You can show off your *kawaii* face here.' She explains the importance of being feminine in order to get married and not end up as *make-inu*, or 'loser-dog', a new expression inspired by a Japanese novel, used negatively in reference to unmarried women in their 30s and 40s. 'Gradually you learn how to appear and to pose in the booth in order to look feminine,' Sayaka says.

In the material that I have collected, the V-sign is very often used to make the face look slimmer and cuter. In Sayaka's albums, I saw several

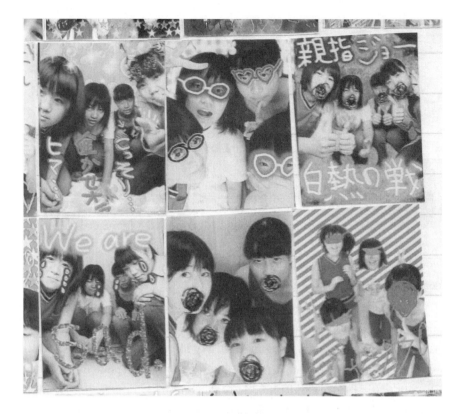

6.5 From Sayaki Y.'s purikura album.

group images where all the mouths had been covered with black spots, added in the purikura manipulation booth (figure 6.5). This was because the girls did not like their mouths and felt they were too big, she informed me. In Japan, a female beauty ideal is to have a small mouth; this is an old tradition (cf. the small painted mouth of a geisha) and an ideal that is now exaggerated in the typical female manga figure.

Authenticity and Screen Behaviour

Adaptation to the group and to the gender roles and attitudes related to the group are important to purikura. Indeed, a certain investigation of and

playing with these roles and attitudes is a natural behaviour within the group. The 'schoolgirl' is almost a visual icon in contemporary Japanese visual culture, an icon invested with many different concepts and feelings: sex and eroticism, courage, virtue, innocence, childhood and adolescence. In sex shops, you can buy girls' school uniforms, pop groups dress up in school uniforms; in Tarantino's *Kill Bill*, the schoolgirl is a brutal killer, as in many Japanese manga cartoons. Some of my informants showed me purikura images in which they pose in imitation school uniforms, either for nostalgic reasons or to continue some of the feeling of independence and innocence they associated with high-school life into their current adult lives (figure 6.4).

Thus staging yourself and playing with gender roles are certainly central elements of purikura, as they are with photographs on social-networking sites such as Facebook, Flickr, Instagram and Picasa. Photographs have merged into our everyday lives on a much larger scale than before, especially among teenagers, who are used to posing on a daily basis and having intimate relationships with places and people who are far away via photographs on social-networking sites or sent via mobile phones.

Are people then living phoney lives in which they stage themselves in photographs circulated within social circles (whether they be on internet sites or as material objects) and where they hide their 'real' selves? In his book on Indian studio photography in the village of Nagda, Christopher Pinney (1997) shows how a heavy amount of staging and image manipulation, such as hand-colouring, are perceived as authentication tools. In these studio portraits, people pose and stage themselves inspired by dominating media codes from, for instance, Bollywood movies, and they dislocate themselves geographically via the backdrops, not unlike early European and American studio portraits. But whereas this practice disappeared in European and American portrait photography in the twentieth century in favour of cleaner and less manipulated forms – because photography became tied to notions of 'capturing inner qualities', and so on – the 'theatrical' forms are still the most used in Indian as well as African studio portraits. Pinney (1997: 201) concludes by writing:

I have tried to show how, in Nagda, little value is placed upon photography's documentary ability to record the random and inconsequential. On the contrary, photography is prized for its ability to record idealized staged events characterized by a theatrical preparedness and symmetry.

Pinney's point is that these portraits are not seen as inauthentic to their users, and – in polemic discussion with Barthes's *Camera Lucida* – he demonstrates how the Indian tradition has implications for our traditional Western conceptual connection between concepts such as authenticity, truth, indexicality and non-manipulation. Pinney (1997: 209) ends his book thus: 'It is this freedom from the need to conform to a particular order of signification, the absence of any burden of self-representation, that guarantees the creativity of Nagda photographic practice.'

Laura Miller notes how some advertisements in Japan appear with purikura photos used as personal and authentic testimonials from people who have used the new products (Miller 2006: 190). My informants certainly did not see their purikura albums and the creative self-representation in them as inauthentic. On the contrary, they saw them as creative products and memories of their youth, which they cherished in their adult lives. They realized that the purikura-screen format provided them with a form that was very regulated and ritualized; at the same time, however, they took endless enjoyment in filling in this form with their own creativity.

It is important to keep the ambivalence of purikura photography alive when we try to understand the phenomenon. Midori Mitsui explains how the term *kawaii* has a significant psychological impact on the minds of the Japanese: 'Prolonged infancy or adolescence is a defining characteristic of contemporary Japanese society. Its ambivalent character is obvious: it may protect individuals from conventional social constraints, but it also entails a chain of dependency' (Matsui 2005: 209). She describes how *kawaisa* or 'cuteness' has also been explored by visual artists, especially in the 1990s.

This was at the same time that the specific amateur genre 'girl's photography' appeared, when young girls started to document their everyday lives with the camera. Matsui sees this kind of photography as creative, everyday life counter-images to the traditional image constructed by male desire: 'Girl's Photography as a phenomenon incited the desire of young women to become agents of creation. While the boom was short-lived, the phenomenon made a large impact on young women by showing them the possibility of becoming artists without special training or theoretical equipment' (2005: 225).

To embrace this ambivalence of purikura, Homi Bhabha's term 'mimicry', from his essay 'Of mimicry and man: the ambivalence of colonial discourse' (Bhabha 1994), is also productive. He uses the term to describe the behaviour of 'the colonial other' mimicking the pose of the colonizer or mimicking the convention *as* 'the other', formulated by the gaze of the colonial suppressor. The discourse of mimicry is constructed around an ambivalence: Bhabha sees it as a double articulation, where you both regulate yourself according to the conventional colonial 'other' and mock the colonial discourse by being 'almost the same, but not quite', as he puts it.

The 'cute' posing of the Japanese high-school girls is to a certain extent also an ironic mimicry of poses and conventions formulated in Japanese society as such. It is a way of posing that, at the same time, they adapt to, identify with and play around with, behaving as typical Japanese girls, 'but not quite'.

Conclusion

The Japanese are major producers as well as consumers of photographic technology. As Shanks and Svabo mention in Chapter 11 in this book, Japanese mobile internet use is the highest in the world, with more than 85 per cent of adults owning a mobile phone. Why bother paying for purikura photos when you could just as well make them with your own camera phone

and upload them directly to Facebook or Mixi and share them with your friends that way? My purikura example shows how the idea, conception, production and use of 'digital snaps' have changed and how the social and communicative aspects of photography must be conceptualized as a part of the ontology of the medium. It demonstrates how photography is as much about the present as it is about the past. At the same time, this example shows how the digital-photo culture is not something totally different from the 'old' photography. The material aspect of photography is still important. In many ways there is a direct link from the Japanese teenage purikura album to the practice of scrapbook making and circulation of scrapbooks among Victorian women in the nineteenth century (Di Bello 2007). The digital production tools (the manipulation possibilities and the fact that it is time-constrained) do not contradict the original use of purikura; rather they enhance it.

The family photo album is currently undergoing tremendous change. It used to be a material object produced to locate the individual in the larger context of family bonds, ultimately serving as an existential confirmation of living in time, as has been described by phenomenological philosophers from Bergson and Heidegger to Ricoeur, and by Bazin and Barthes within photography studies. But with the new digital practices, both the actual taking of the photograph and the conservation in the album have changed radically. Likewise, the reception situation has been transformed from a private family space (the album in the private living room) to a semi-public space on the internet. The family photo album has thus been transformed into new and different, but not *entirely* different, forms. Through a specific case study of contemporary Japanese youth purikura photography, I have shown how concepts such as friendship production, group adaptation, social communication, performance, mimicry, presence and aesthetic involvement are much more relevant when describing what goes on in the 'new' digital photo album.

BIBLIOGRAPHY

Ashcraft, B., and Ueda, S. (2010), *Japanese Schoolgirl Confidential: How Teenage Girls Made a Nation Cool*, Tokyo: Kodansha International.

Barthes, R. (1981; originally published 1980), *Camera Lucida: Reflections on Photography*, New York: Hill and Wang.

Bazin, A. (1981; originally published 1945), 'The ontology of the photographic image', in Trachtenberg, A. (ed.), *Classic Essays on Photography*, New Haven: Leete's Island Books.

Best, J., and Suzuki, T. (2003), 'The emergence of trendsetters for fashions and fads: kogaru in 1990s Japan', *The Sociological Quarterly*, 44(1): 61–79.

Bhabha, H. (1994), 'Of mimicry and man: the ambivalence of colonial discourse', in id., *The Location of Culture*, London: Routledge.

Chalfen, R., and Murui, M. (2004), 'Print club photography in Japan: framing social relationships', in Edwards, E., and Hart, J. (eds), *Photographs Objects Histories: On the Materiality of Images*, London: Routledge: 166-85.

Davies, R.J., and Ikeno, O. (2002), *The Japanese Mind: Understanding Contemporary Japanese Culture*, Tokyo: Tuttle Publishing.

Di Bello, P. (2007), *Women's Albums and Photography in Victorian England*, London: Ashgate.

Edwards, E., and Hart, J. (eds), (2004), *Photographs Objects Histories: On the Materiality of Images*, London: Routledge.

Langford, M. (2001), *Suspended Conversations: The Afterlife of Memory in Photographic Albums*, Montreal: McGill-Queen's University Press.

Matsui, M. (2005), 'Beyond the pleasure room to a chaotic street: transformations of the cute subculture in the art of the Japanese nineties', in Murakami, T. (ed.), *Little Boy: The Arts of Japan's Exploding Subculture*, New Haven: Yale University Press.

Miller, L. (2003), 'Graffiti photos: expressive art in Japanese girls' culture', *Harvard Asia Quarterly*, 7(3): 31–42.

—— (2005), 'Bad girl photography', in Miller, L., and Bardsley, J. (eds), *Bad Girls of Japan*, New York: Palgrave Macmillan.

—— (2006), *Beauty Up: Exploring Contemporary Japanese Body Aesthetics*, Berkeley: University of California Press.

Okabe, D. (2012), 'Cosplay, learning, and cultural practice', in Ito, M., Okabe, D., and Tsuji, I. (eds), *Fandom Unbound: Otaku Culture in a Connected World*, New Haven and London: Yale University Press.

Ono, P. (1997), 'Print club', PhotoGuide Japan, [online], <http://photoguide.jp/txt/Print_Club>, accessed on 1 June 2012.

Pinney, C. (1997), *Camera Indica: The Social Life of Indian Photographs*, London: Reaktion Books.

Sandbye, M. (2009), '"Til min søn": familiealbummet som materielt objekt', in Christensen, H.D., and Illeris, H. (eds), *Visuel Kultur: Viden, Liv, Politik*, Copenhagen: Multivers.

—— (2011), 'Emotive templates: the family photo albums and its presentation of the good life', in Simonsen, D.G., and Vyff, I. (eds), *Amerika og Det Gode Liv, 1950–70*, Odense: Syddansk Universitetsforlag.

7

'Buying an Instrument Does Not Necessarily Make You a Musician': Studio Photography and the Digital Revolution

SIGRID LIEN

A nationwide campaign by the Norwegian Photographers' Association in late March 2012 featured the quote, 'Buying an instrument does not necessarily make you a musician.' Other posters in the series stated: 'Who cuts better? You or your hairdresser?' and 'It isn't the equipment that's the determinate factor, but the ability to use it.'[1] Even though the posters did not state it specifically, the press release that followed the campaign clearly indicated that professional photographers consider digital cameras in the hands of amateurs to be a major threat to their business.

> The digital revolution has entailed great changes for us all, and we photographers are among those who perhaps more than anyone else have noticed these changes. Not only do they have a huge impact on our working day, but they have also altered the way other people regard our profession. The aim of the campaign is to inform people about the differences between using a professional and doing the job by oneself.
>
> The posters are not meant as a provocation, but rather as an eye-opener. We have made some pointed remarks in order to make people

understand that being a professional photographer entails so much more than owning an SLR-camera.[2]

This perspective on the consequences of the digitization of photography appears very remote from the academic discussions of the subject. In such contexts, digitization tends to be approached in relation to the traditional understanding of photography as an accurate reflection of reality. These debates seem to be overshadowed by what W.J.T. Mitchell has labelled 'a prevailing myth', that digital photography has a different ontology than chemical-based photography (Mitchell 2010: 15). However, arguing convincingly against this myth, most clearly stated by his colleague William J. Mitchell in *The Reconfigured Eye* (Mitchell 1992), W.J.T. Mitchell claims that there is little reason to believe that digital photography does in fact have a different ontology from chemical-based photography. Consequently, according to this argument, 'the authenticity, truth value, authority, legitimacy of photographs, as well as their aesthetic value, their sentimental character, their popularity, etc. etc. is quite independent of their character as "digital" or "chemical analogue" productions' (Mitchell 2010: 15).

However, if we approach the question of digitization and its impact by looking at photography as a commercial aesthetic practice, we may come up with a different answer. For the photographers working within such practices, digitization certainly represents a challenge in aesthetic as well as business terms. For many of them this is also, as the poster campaign presented above indicates, a matter of survival. Following W.J.T. Mitchell's argument further, I will, therefore, discuss the impact of the digital image not in relation to its ontology, but as part of a social practice 'that involve[s] skills, traditions, genres, conventions, habits, and automatisms, as well as materials and techniques' (Mitchell 2010: 15).

The social practice in which I am interested here is more specifically that of the studio photographer, and I shall discuss the question of the consequences of the digital image in the context of his or her work. This is perhaps also a timely approach, since much of what has been written so

far about digital portrait practices has dealt with the image production of amateurs or artists (Lipkin 2004; Palmer 2010). Studio photography has, on the other hand, been regarded as a marginalized or dying phenomenon, given the evolution of amateur practices, with digitization as its final phase. It is thus characterized as something that has 'left the studio and entered the home' (Hirsch 1999: xvi). Furthermore, commercial studio photography often tends to fall under the category of family photography, a genre that has been considered 'predictable in content and conservative in style' (Batchen 2008: 195), as well as 'banal and stereotyped' (Rose 2010: 13).

But is this really the case? Is studio photography on the brink of disappearing in the wake of the evolution of digitally based amateur practices? Is it (still) as repetitive and conventional as it has been considered to be for so long? Or has digitization represented new possibilities in business as well as aesthetic terms? In this article I shall discuss these questions through a case study on the practice of one of the initiators behind the above-mentioned campaign: the young photographer Dagrun Reiakvam (b.1982).[3]

Dagrun is a third-generation photographer in the family business Photographer Reiakvam in Førde, a small town on the western coast of Norway. After several years of photography-training in Norway and the United Kingdom, she returned to her home town a few years ago to work in the studio that her grandfather, Dagfinn Reiakvam (1917–83), established just after World War II. Dagrun and her father Olav (b.1949) now share the commissions. Her entrance to the profession is, however, different from that of her father and grandfather. She is not only trained as a studio photographer to do 'traditional' portraits, wedding groups, and so on, but also as an artist, educated at the prestigious photography department at Bergen National Academy of the Arts.

Furthermore, as the first of the Reiakvam photographers to learn in the digital age, she has addressed the challenges presented by the so-called 'digital revolution' from the very beginning of her professional career. A study of the Reiakvam family firm may, therefore, provide an opportunity concretely to address questions concerning the continuities and breaks between analogue

and digital photography practices. Dagrun Reiakvam's practice exemplifies how commercial studio photographers are adapting to the digital context by developing new strategies. These strategies not only involve new ways of communication with clients – for example, by extensive use of social media (blogging and Facebook) – but they also represent new developments in the aesthetics and performances of posing. These new developments seem to have much in common with the informal snapshot-like, yet strongly aestheticized, style of photography that is networked through everyday communication technologies.

'They Expect More Now Than Ever Before': A Visit to the Photographer's Studio

In a study of digital tourist photography, Jonas Larsen, in line with the argument of W.J.T. Mitchell, points out the need to speak about the *practices* of digital photography. According to Larsen, the act of photographing is absent from most theory and research, which 'jumps straight from the photography to photographs'. Thus, Larsen claims, most research 'goes directly to the representational worlds of photographs and skips over their production, movement and circulation' (Larsen 2008: 143).

But let us now, challenged by Larsen's statement and inspired by art-history writing, which for many years has focused on images as anchored in cultural practices (see, for example, Baxandall 1988), visit the Reiakvam studio in Førde town centre. We will study the photographer at work before we continue by looking at the movement and circulation of the studio photographers' work. We are doing so on a Saturday morning in January, and we are far from the only ones present in the two-storey building, where picture frames and other kinds of photographic equipment are sold on the first floor and a studio is located on the second. A young family – mother and father with four children, the eldest around ten and the youngest still in diapers – has arrived to have their family portrait taken. They seem slightly

nervous and excited, but also well prepared, all in matching white clothes and with freshly combed hair. Dagrun Reiakvam welcomes them and in a friendly and efficient manner arranges their postures against a neutral grey background under radiant studio lamps, first sitting and then standing. The work progresses quickly and with full concentration. For the photographer there is much to take into consideration. The lighting is relatively easy in the studio (as opposed to working on location) as everything is more or less set in advance. But the composition and the positioning of the subjects may be more difficult, especially when there is, as in this case, a height difference of about one and a half metres between the father and the youngest child. Communication with the portrait's subjects represents a challenge in itself: after a while, the toddler wants to get away from the camera and annoying bright lights and to move around freely in the spacious studio. Being the experienced photographer she is, Dagrun solves the problem by asking the child's mother to make funny faces. Soon all the children are giggling and happy. The photographer continually checks to see that she has at least one good shot of each of the family members. A couple of clicks later the session is over.

Judging from this, Dagrun's work *behind* the camera does not differ much from the way her father and her grandfather worked in the studio in the analogue era. Or, to quote her father Olav: 'Even though the image now is stored differently than before, the camera works in very much the same way as it has done for the last hundred years.' The digital 'storing' he is referring to, however, has already made a large difference to the way the Reiakvam firm runs its business and generates income. In the late pre-digital period (late 1980s and early 1990s), selling and developing film represented the firm's main source of income, not the work they did as professional photographers. These services led the firm into a golden age, especially after investing in a colour laboratory. But according to Olav, digitization changed all this. 'Digitization has been a disaster for local enterprises like ours – yes, for all laboratories, large and small,' Olav said. 'Most of them are gone now, Preus, Schröder, Ellingsen [major photography firms in Norway]

and Kodak. Everything is gone.' The problem as he sees it is that people no longer bother to make prints of their images and that, if they do, the competition among printing services has become stronger and more global.

> Well, we do have an Internet service and we do make some images even now. But we are making less than before. The competition is stronger and more international. The prints can be made in the US and you simply receive them by mail. We are thus making fewer images for a much smaller profit than before.

These tendencies became apparent around 2003–4, when digital cameras became less expensive and more people could afford to buy them. Since then, the laboratory income of Photographer Reiakvam has gradually decreased. The family still keeps their laboratory in business, but it is now serving a smaller circle of customers: people who do not want to change their habits, people with artistic ambitions and the occasional customer who wants to experiment with an old camera found at the flea market or in the attic. Even though portrait commissions have always been a vital source of income for the firm, they have paradoxically grown in importance after the event of digitization.

In addition to its renewed importance in terms of income, portrait production has also been affected in more practical ways by the event of digital photography. It is, however, the digital processing *after* the portrait sessions that represents the biggest difference in the photographers' daily work. In the analogue era, retouching had to be done by hand, a time-consuming and complex process. These days, Dagrun and her father are using Photoshop to enhance their images, a process that they describe as a much simpler way of working. First they correct the 'raw' digital file for colour and light temperature, and then they do other sorts of adjustments. If, for example, one of the children in the group session described above should look bad in a shot where all the other family members look good, the photographer has the ability to 'swap heads'. An image of the child's

head will be manipulated from another shot into the successful one. 'This [digital enhancement] is an important part of what people are paying for,' Dagrun explains, 'and they expect more now than ever before. I remember one customer who even believed that we could digitally remove the coat she was wearing in her portrait. People seem to think that there is some kind of great magic going on in Photoshop.'

What the customers are buying, however, are not the processed digital files, but prints of the images. Customers may be given low- but never high-resolution files, a policy that, according to Olav Reiakvam, is in keeping with copyright laws in Norway. He emphasizes the necessity to inform the customers about this policy before the sessions take place, as many of them are somewhat reluctant to accept it.

People believe that they are free to have the files to copy, to print out and to share with others. They are used to downloading for free. But we cannot survive if things are to be free of costs. We only distribute low-resolution files, but some photographers also give their customers high-resolution files. We, however, want to have control over the total production of the images. If images are stored and processed by amateur producers, the outcome may not always be good. This is an argument for not letting the customers have the high-resolution files. It is the same problem as in the music industry. And there is not always an understanding of this. It is therefore necessary to settle the matter before we take the images and to establish a clear understanding with the customer. But the law is clear on this point. It is the copyright related to photography that is important here. The whole thing is really a challenge.

Since customers are buying prints, they also tend to demand more of this product. While in the analogue days they could be satisfied with one single image, they now, as Olav points out, expect a whole series of images. Customers also want the prints mounted in personal albums, preferably

individually designed by the photographer (who consequently needs to muster some skills in graphic design). Digitization has thus, as Olav sees it, opened a whole range of possibilities in the post-production phase of the photographer's work. The firm is, for example, able to produce albums in the shape of books, with a limited circulation number of one, something that was previously impossible. These services are advertised in detail by Dagrun on the company's blog, where she describes, for example, how she produces ready-made wedding albums.

> We present our wedding photographs in different album variations from which the wedded couple may choose. These vary from the very simple to specially designed montages or engraved, handcrafted leather-bound albums. A designed album is without passepartouts and has laminated individually designed pages. After the photographs are taken, I design each page with images in colour and black and white. They are then sent to the couple for approval, and as soon as they give the all-clear, I begin the production process.

Even though time and resources are saved on the digital processing of the images, more time is spent on this kind of post-production work. Thus, paradoxically, digitization in practice has led to a stronger product-based image culture than ever before. If people, as Olav suggests, no longer bother to print out their own images, they certainly expect their photographer to do so.

Furthermore, digitization has expanded marketing to the kind of products exemplified above. Dagrun spends much of her time updating the firm's blog and Facebook site. Only a short time after their studio session, the portraits of the young family that visited the studio were published on the firm's professional blog, accompanied by Dagrun's own comments on the event:

> When one of last year's wedding couples wants to order more family photographs as early as in February, I take it as a compliment. Anne

Gry and Joakim married in August last year and even then had their children posing with them in some of the images. But now they wanted some more family portraits taken, this time in everyday clothing. The younger as well as the older members of the family were in a good mood, and we took many great pictures of them in the studio. It was perhaps a little too much for the youngest one, so tomorrow she and her mum will be back to take the one-year-old's portrait in a more peaceful setting. We will see each other again then!

Because they have been digitally produced, the studio photographs easily find their way into social media such as Facebook and various blogs. In relation to tourist photography, Larsen (2008: 141) has argued that 'the practices and flows' of the genre, as well as 'doings and circulation', have changed in the wake of their convergence with new media technologies. This also appears to be the case concerning commercial studio photography, where, as here, the convergence takes place in social media on the internet, that is, on the Reiakvam firm's blog and on their Facebook site. This is, as I will demonstrate, perhaps the most important aspect of digitization in the day-to-day practice of the studio photographer. Not only does it make new ways of communication with new and existing clients possible, it also, as I will demonstrate in the last section of this article, contributes to transformations of portrait aesthetics.

Movement and Circulation: The Blogging Photographer

For Photographer Reiakvam, the blog and Facebook site clearly represent a way to make the business enterprise and their products more visible. The blog serves as their most important communication channel, which Facebook supplements by presenting short announcements about new blog entries, and so on. Let us therefore focus primarily on the blogging activities of the firm.

søndag 24. april 2011

Hei og velkommen!

Velkommen kjære gjest som fann oss i mylderet av bloggar som finns der ute! Kanskje er du her fordi du er på leit etter ein fotograf som skal ta brudebileta dine, eller kanskje du er her fordi du har fått tips om at nokon du kjenner har vore hos oss, og at du no kan sniktitte på bileta vi har tatt av dei. Uansett årsak så håpar eg du finn noko du syns er interessant her på bloggen!

Fotografane Reiakvam er far og dotter. Olav vart fødd i 1949 og har arbeidd som fotograf sidan tidleg på 70-talet. Han har utdanninga si frå Harrow School of Photography i London og har brei erfaring som fotograf i Førde. Dagrun kom til verda i 1982 og har si utdanning frå Kent Institute of Art and Design i Storbritannia og ein bachelor i fotografi frå Kunsthøgskulen i Bergen. I tillegg er vi veldig stolte av å kunne seie at vi er 2 av 3 generasjonar fotografar. Butikken Reiakvam Foto vart starta i 1946, men Dagfinn Reiakvam begynte å fotografere allerede før krigen! Vi har difor eit enormt arkiv med bilete av

Copyright

Etter andsverkslova har Fotograf Reiakvam copyright på sine bilete.

Om oss

Fotografane Reiakvam
Førde, Sogn og Fjordane, Norway
Olav og Dagrun deler på oppdraga og tek mellom anna portrettfoto, familiebilete, bryllaupsbilete, reklamefoto, gruppebilete, utdrikkingslagsbilete, barnebilete og avfotografering av kunst. For timebestilling: ring 57 82 19 77

Vis heile profilen min

7.1 First page of the Reiakvam blog.

As noted by Jill Walker Rettberg, businesses that blog generally do not want to monetize a blog through ads or sponsorships. Instead, they want to use the blog to boost an existing income stream by generating new attention for their products or services. The most successful way of corporate blogging has therefore been to present a firm's personality by letting the readers get a sense of the individuals who run the business (Rettberg 2009). This is clearly also the strategy behind the Reiakvam blog (figure 7.1), which has a clean, airy design with the heading and logo 'Reiakvam. Your photographer in Førde since 1946' partly in Dagrun's own handwriting. This text, placed on a background of a hazy, slightly unfocused colour photograph of wild flowers from the local flora, contributes not only to placing the firm in the local topography and emphasizing the value of tradition and the personal touch, but also to framing it all in a relaxed, summery atmosphere.

As a younger member of the staff, Dagrun addresses her readers with seemingly effortless digital confidence. By doing so in an informal and personal tone, she creates a blog that comes across as a hybrid between a diary and a business enterprise. She invites the reader not only to view her products, the portrait work, but also to take part in her life as a newly established photographer in a small community, almost on a day-to-day basis. The blog's visitors may thus follow her professional diary where she presents slices of her life, episodes and anecdotes through the seasons. For example, she reports on springtime meetings with couples in love who are planning their weddings ('Love is in the air'); sessions with newborn babies ('Welcome to the world'); summer weddings ('Blooming love'); visiting Norwegian–American relatives; pre-Christmas portrait work in November; a proud December presentation of a book project on interior design ('I'm in a book!'); a much needed off-season holiday ('Recharging batteries'); and finally the recent renovation of the shop ('A new spring').

In this way, the blog works like a local chronicle by creating a sense of continuity and belonging in the small community, for the photographer as well as the blog's visitors. But it also establishes personal relationships between the photographer and her existing and potential customers. Dagrun Reiakvam consequently stresses her own identity as 'a local' by introducing and addressing her subjects as old friends and acquaintances (many of whom are). Some of the blogs even include the history of these relationships in the form of a personal letter in the blog narrative itself, as exemplified in the following:

> There are quite a lot of weddings in the course of a summer, and I am incredibly lucky to get to meet so many interesting and different people on their happy day. Nevertheless, I will allow myself to admit that it is particularly pleasant when the couple happen to be my close friends. Ingvild and Nikolai have been together for about nine years and I have known the bride since we were at Hafstad School together between 1998 and 2001. There was no doubt ever that Ingvild and Nikolai were going to be an item, so it was wonderful to get to know

that they were planning their wedding and that they wanted me to take their official wedding photographs! I certainly managed to get many nice images throughout the day – from the early hours and until I let myself off duty around half past midnight. It is indeed difficult to choose between all the fantastic motifs, but I will now let curious wedding guests and others see a selection of images here on the blog[…] Thank you for letting me take your photographs. Both you and the wedding party were simply magic! Good luck with your life together, dear Ingvild and Nikolai! Hugs from Dagrun.

In other blog entries the continuity of the firm is accentuated as a stable backdrop for the generational changes in the lives of their clients. This was the case when an older couple that had their wedding photograph taken by Dagrun's grandfather Dagfinn in the early 1960s revisited the studio:

Yesterday Ragnhild and Magne, a nice married couple from Haukedalen, came to visit us. They wanted to know whether we could find time for a little portrait of them together. They were married on 20 May 1961 and were now celebrating their 50th wedding anniversary. Therefore they had the wonderful idea of visiting Photographer Reiakvam 50 years to the day after having first been here to have their wedding photograph taken by Dagfinn Reiakvam! As the true romantics that we are, we really appreciated this. We found the negatives of their wedding photographs in the archive and compared them to those of 2011, taken by Olav[…] We hope their recent portrait from 2011 will find its place on their wall, next to the wedding photograph they had taken at their first visit to the Reiakvam photographers!

Tradition, stability and craftsmanship were also highlighted when the mother in the family who attended the Reiakvam studio on the Saturday morning in January was asked about why they had decided to have their family portrait taken professionally:

For my part, I guess it's a kind of tradition. I have, for example, always gone to the photographer when each of my children has been around a year old. I want them documented by a professional. There are a lot of people going around with big SLR-cameras, but I guess it has something to do with professionalism [...] It really means something to have a good, clear picture.[4]

So far, we have primarily looked at the narrative, the textual elements of Dagrun's blog. The most important component of the photographer's blog is, nevertheless, the visuals, the photographs. But how and to what extent is tradition an important notion in her aesthetic practice? Has the digital turn in the Reiakvam firm resulted in new developments in the aesthetics and performances of posing, or is the young photographer still following the traditional forms that (at least some of) her customers seem to expect? In the following section I will discuss this question of tradition against the background of wedding photographs, which have been, and still are, the most lucrative subgenre in the firm's product range.

Portrait Aesthetics in the Digital Era: Tradition and Renewal

In Dagrun's blog from July 2011 (figure 7.2), we find a representative example of her work in this genre: the wedding photograph of the beautiful, young and obviously very style-conscious couple, Ingvild and Nikolai (see blog presentation above). The newly wedded couple is posing outdoors at their wedding party. She is wearing a simple white-cotton dress in a 1920s style which complements her short bobbed haircut. Her husband is dressed in a 1950s suit with a matching hairstyle. They are photographed from the front in full figure, sitting on a strikingly green wooden bench, while holding hands and kissing. The narrow country road behind them is winding into the scenery, accentuating the natural beauty of the landscape, the green freshness of the Nordic summer in contrast to the blue mountain in the

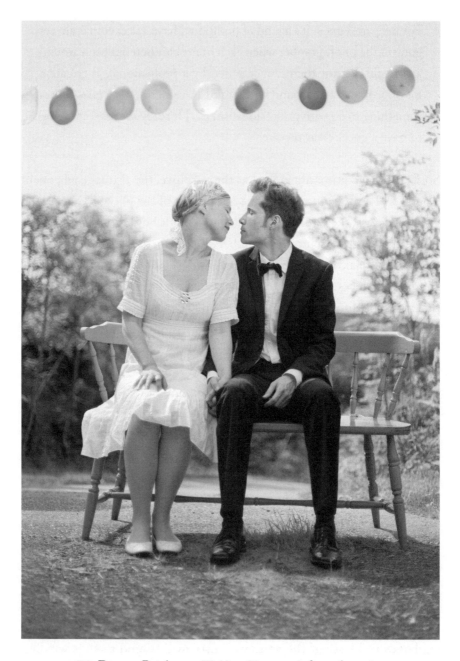

7.2 Dagrun Reiakvam: *Wedding Photograph*, from the series of images from Ingvild Grane and Nikolai Bergstrøm's wedding, Hersvikbygda in Solund, Norway, July 2011.

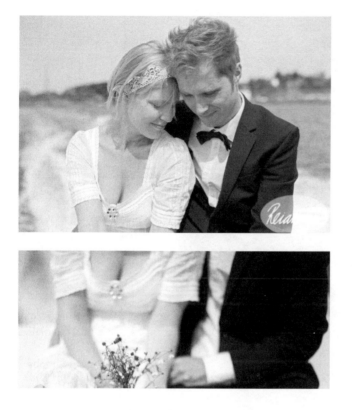

7.3 Reiakvam-blog: entry with Ingvild and Nikolai's wedding photographs, July 2011.

distance. A string of colourful balloons over their heads contributes to giving the scene a touch of retro-romanticism with allusions to the sentimental postcard culture of the 1920s and 1930s.

But this image is only one of a whole series of wedding photographs of Ingvild and Nikolai that are also presented on Dagrun's blog. Some of the images are in colour, others in black-and-white, shifting between intimate close-ups and more complete framings of the couple. They are photographed on the bench, but also rowing a small boat on the fjord, resting and dancing in a field of blooming wild flowers, and in the late hours as they are letting golden paper lanterns raise to the air in the blue summer's night. Seen together, these images form a snapshot-based story of their wedding day.

Comparing continuity and change in relation to digitization requires a look at a representative, pre-digital example of the Reiakvam photographers'

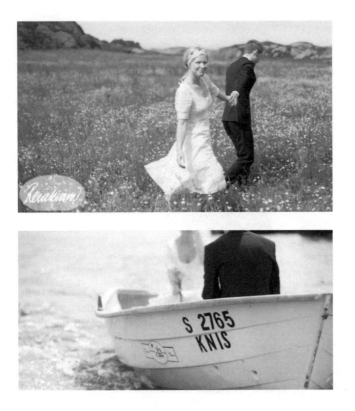

7.4
Reiakvam-
blog: entry
with Ingvild
and Nikolai's
wedding
photographs,
July 2011.

work in the wedding-photograph genre. In a black-and-white photograph
(figure 7.5) taken in 1965 by the founder of the studio, Dagfinn Reiakvam,
the bride and the groom, Kari and Johannes Berge, are solemnly portrayed
on the home farm, surrounded by the entire local community, including the
fiddle- and accordion-players with their instruments. Had it not been for the
bride's traditional silver crown, it would in fact have been difficult to spot the
newly wedded couple in the large crowd of people that surrounds them, nearly
all of whom are dressed in regional costumes, according to custom for rural
marriages in the area. Their faces, in fact, only appear as tiny spots in the large
group portrait. Contrary to Dagrun's image, it is the nature of the occasion
that is in the forefront, not only for the couple, but also for everyone around
them. Everyone is attentively looking at the photographer, who becomes
what has been termed a 'modern master of ceremonies' (Reiakvam 1997).

To organize the posing of such a large group must clearly have been a task in itself. Olav Reiakvam, in his youth, sometimes accompanied his father to such on-location commissions. Olav explains how stressful they could be compared to the ease of digital photography, where the photographer can immediately correct mistakes, for example in relation to lighting or technical issues with the camera. 'Back then everything was much more uncertain and straining,' Olav said, 'particularly when you came back and were about to develop the films. Consequently you were more bound up and had to run the whole thing very safely.'

Dagrun, in a similar vein, points to how other practical aspects of digitization, such as the possibility for moving around more freely with a smaller camera and taking an unlimited number of images, makes her working conditions different from that of her grandfather's. Such differences also affect the outcome of the work in aesthetic terms. As Dagrun said, 'Earlier,

7.5 Dagfinn Reiakvam: *Wedding Photograph*,
Kari and Johannes Berge, Førde area, Norway, 1965.

we produced single images; now we are able to produce series. We can tell a story. I think album. I think presentation. Grandfather never did. But it is, of course, easier to do so with a small SLR-camera.' What Dagfinn's analogue 1965 wedding portrait exemplifies is thus not the aesthetics of multiple viewpoints, narration, seriality and transition that we have seen exemplified in Dagrun's work, but the aesthetic of the frozen and strongly directed single image.

In contrast to her grandfather's strongly directed, passive portrait subjects, Dagrun invites her clients to take a more active part in the practical and aesthetic considerations related to the wedding photography sessions. Visiting her blog they have easy access to study other people's wedding photographs and their choices for poses, locations, and so on. While reading her post-production reflections, they are also more or less directly encouraged to reflect on how they want their own potential wedding photographs to look:

Last Friday I was hired to photograph a wedding on the island of Atløy, an hour's driving plus one ferry ride from Førde. I have never before visited Atløy, so I found it both exciting and nice to be photographing a couple in a completely new place. Merete and Torben were first married in Vilnes church, and I took part in documenting the ceremony. Afterwards, we took a group-portrait by the church before I brought the newly wedded couple with me in my battered old Golf and drove them towards the open seas. When I am in a new place like this and about to start working, I have to 'switch on my photographer's eye' to pick out potential motifs and backgrounds that may work in such a setting. Often it is no more than finding a nice wall, a romantic grove or a small path. How I look at a 'location' is, however, not necessarily the same as how others would have looked at it. After a short ride, we made a little detour and found a fantastic place with a small pier, surrounding green trees and a beautiful red wall. Perfect! The couple took part in the fun, even though the wind was strong and the rain at the end became a nuisance. We took a lot of great

pictures – including the obligatory one with [the mountain] Alden in the background. I hope these images will contribute to keeping the memories of the happy day alive! Thank you for the commission.

Commercial Studio Photography in the Digital Flow

Judging by the outcome of such working processes as exemplified in Nikolai and Ingvild's portraits, Dagrun's subjects seem to be playfully enjoying the act of posing and co-authoring their own images. As observed by Lisa Gye, they belong to a generation that, to a large extent, maintains social relationships through the use of visuals. They do so by sharing their unique view of the world, their intimate visual co-presence with others by the use of camera phones and the internet. According to Gye, the transitory nature of, for example, camera-phone images means that their self-expression also has shifted away from 'this is what I saw then' to 'this is what I see now' (Gye 2007: 285). In a similar vein, Mette Sandbye suggests that the new digital practices on the internet may be seen as manifestations of a new photographic construction of presence (Sandbye 2012). Murray also argues that the social use of digital photography, as, for example, represented on Flickr, has resulted in a particular kind of engagement with the everyday image and a move away from the special and rarefied moments. Furthermore, it has led to a new conception of photography, not just as an embalmer of time but also as an immediate, fleeting display, a collection and framing of 'the small and mundane' (Murray 2008: 147).

Dagrun Reiakvam appears to be able to cater to an audience that conceives of photography as a fleeting presence and, therefore, also expects to view the single image as part of a series. Some of the images from her varied series of photographs from Nikolai and Ingvild's wedding visualize the small, the ordinary, and even the surprising. On occasion, the photographer boldly presents fragments of the total scenes, like a telling framing of the couple's feet, their hands, her hand resting on his knee, or even their bodies while

sitting in the boat, heads cropped (figure 7.4). Thus, the transitory nature of the event is accentuated. The photographer herself is aware of how her portrait aesthetic to a certain extent corresponds with the 'digital way of speaking' that is to be found, for example, on photography blogs.

But the fragmentary, authenticity-seeking 'hipster aesthetics' on such blogs are also inspired by rock photography of the punk era, when photographers like Pennie Smith emphasized the importance of 'seeing people' (rock stars) 'as ordinary people'. In her now-legendary work on the Clash, she photographed the band as a group of people in motion, in changing surroundings and moods. Like later blog photographs, each of her individual photographs came across as a fragment of a story, a singular element of a large and richly varied series of images (Lien 2010).

Dagrun Reiakvam similarly appears to be in line with this tradition when she talks about her clients' demand for, and her ambitions to create more, 'natural images', as well as the challenges of getting people 'to look natural and relaxed in unnatural settings'. But as we have seen, the digital technology and distribution channels have created an opportunity for her serial, narrative approach to commercial portraiture, as exemplified by her wedding photographs. Nevertheless, the demands of the genre carry certain limitations as to what kind of stories may possibly be told through such images. It is thus a question of balance. Dagrun's series of wedding photographs may have touches of rough, random aesthetics, but they are still capable of capturing the story that everybody wants to remember about their wedding day, one of fleeting moments, of sunshine and happiness. She eternalizes the event as relaxed, easy, unpretentious and informal, but at the same time strikingly beautiful and romantic, like a movie. In this way she adds the attractive 'something out of the ordinary' element that makes her portraits something different and more than what her clients could have produced on their own. Finally, this also suggests that, while it may be true that family photographs have, as they say, entered the home, and partly also that the commercial photographer has left the studio, Dagrun Reiakvam never left her business.

NOTES

1 For more information on the campaign, see <http://fotografiens-hus.no/2012/03/landsomfattende-markedskampanje-fra-norges-fotografforbund/>, accessed on 22 August 2013.

2 Press release from the Norwegian Photographers' Association dated 30 March 2012. The original Norwegian text can be found online at <http://fotografiens-hus.no/2012/03/landsomfattende-markedskampanje-fra-norges-fotografforbund/>, accessed on 22 August 2013.

3 I am indebted to Dagrun and Olav Reiakvam at Photographer Reiakvam, and also to some of their clients, for generously sharing with me their time, thoughts and experiences.

4 Communication with Anne Gry Niemonen, dated 14 March 2012.

BIBLIOGRAPHY

Batchen, G. (2008), 'Previous future: art history and the snapshot', in Fontcuberta, J. (ed.), *Soñarán los androides con cámaras fotográficas?* [Do Androids Dream of Cameras?], Madrid: Secretaría General Técnica.

Baxandall, M. (1988), *Painting and Experience in Fifteenth-Century Italy: A Primer in the Social History of Pictorial Style*, Oxford: Oxford University Press.

Gye, L. (2007), 'Picture this: the impact of mobile camera phones on personal photographic practices', *Journal of Media & Cultural Studies*, 21(2).

Hirsch, M. (1999) (ed.), *The Familial Gaze*, Hanover and London: University Press of New England.

Larsen, J. (2008), 'Practices and flows of digital photography: an ethnographic framework', *Mobilities*, 3(1).

Lien, S. (2010), 'Stars as human beings – and timeless icons: Pennie Smith's and Anton Corbijn's artist portraits', in Grønstad, A., and Vågnes, Ø., *Coverscaping: Discovering Album Aesthetics*, University of Copenhagen: Museum Tusculanum Press.

Lipkin, J. (2004), *Photography Reborn: Image Making in the Digital Era*, New York: Harry Abrams.

Mitchell, W.J. (1992), *The Reconfigured Eye: Visual Truth in the Post-Photographic Era*, Cambridge, MA: MIT Press.

Mitchell, W.J.T. (2010; originally published 2006), 'Realism and the digital image', in Baetens, J., and van Gelder, H. (eds), *Critical Realism in Contemporary Art: Around Allan Sekula's Photography*, Leuven: Leuven University Press.

Murray, S. (2008), 'Digital images, photo-sharing, and our shifting notions of everyday aesthetics', *Journal of Visual Culture*, 7(2): 147–63.

Palmer, D. (2010), 'Emotional archives: online photo sharing and the cultivation of the self', *Photographies*, 3.

Reiakvam, O. (1997), *Bilderøyndom, Røyndomsbilde, Fotografi som kulturelle tidsuttrykk*, Oslo: Det Norske Samlaget.

Rettberg, J.W. (2009), *Blogging*, Cambridge: Polity Press.

Rose, G. (2010), *Doing Family Photography: The Domestic, the Public and the Politics of Sentiment*, Aldershot: Ashgate.

Sandbye, M. (2012), 'It has not been—it *is*. The signaletic transformations of photography', *Journal of Aesthetics & Culture*, 4.

NEW
PUBLIC FORMS

8

Paparazzi Photography, Seriality and the Digital Photo Archive

ANNE JERSLEV AND METTE MORTENSEN

Introduction

With the emergence of digital media, archival practices have become integrated into our everyday consumption of images. Snapshots uploaded on social-media sites such as YouTube, Flickr and Facebook are used to construct and share 'all kinds of archives or fragments thereof' (Røssaak 2010: 14). Along the same lines, many news and entertainment sites feature archival functions for saving and storing their vast number of published images. While individual photographs and series of photographs last only a few hours as illustrations for news stories or as news stories in themselves, their afterlife is prolonged by online accessibility, facilitating continued circulation and recirculation. These archival practices raise the questions: how are we to make sense of the digital photo archive and its seemingly endless inventory? And what functions are fulfilled and meanings acquired by filed images?

This chapter addresses these questions in relation to online paparazzi photography, which constitutes a fascinating example of how the emergence of digital modes of production and distribution has profoundly changed established media genres (Jerslev, Mortensen and Petersen 2011). Increased

volume and speed of dissemination have resulted in a serial structuring of images, which not only feeds the overall archival organization in so-called 'galleries' on entertainment sites, but also has a bearing on the snapshot aesthetics and everyday content of contemporary paparazzi photographs. Prior to digital media, paparazzi photography was confined to a more marginal, yet conspicuous, position in tabloids and gossip magazines (see, for example, Sofia Johansson 2007). Paparazzi photographs – taken by both amateurs and professionals – have now moved towards the centre of mainstream news and entertainment culture as one of the primary outlets for the visual construction of celebrities. Moreover, contrary to the scandalous and dramatic scenes that used to define paparazzi photography (Squiers 1999, 2010; Howe 2005; Mendelson 2007), snapshots of celebrities engaged in everyday activities represent by far the largest share of the online genre today (Jerslev and Mortensen 2013). Paparazzi photography is characterized by an aesthetics and discourse of ordinariness: celebrities apparently caught unawares while engaged in everyday routines such as walking along the street carrying a cup of coffee, shopping, exiting the gym, passing through an airport, picking up their children from school, and so on. This ordinariness contrasts with the extraordinariness characteristic of the other major genre of contemporary celebrity photography, which could be termed 'red-carpet photography', showing celebrities exposing their glamour at events and celebrations.

While in an earlier article we conducted a quantitative survey of online postings of celebrity photography and discussed at length the idea of the ordinary in paparazzi photography (Jerslev and Mortensen 2013), this study investigates issues arising from digital modes of distribution and draws on the research traditions of media studies, the theory and history of photography and celebrity studies. This chapter first outlines a theoretical framework for understanding the photographic archive and seriality as a structuring logic. For an example of a photographic archive, we then map the online archive of paparazzi photography on the entertainment news site *Just Jared*. Finally, we analyse the serial organization of images on this site

as well as paparazzi photography's generic kinship to street photography, that is, how snapshot aesthetics, implying the ephemeral and amateuristic, structure the genre and inscribe the celebrity's bodily pose.

The Photographic Archive: From Analogue to Digital

Following the invention of photography in 1839, the photographic archive came into being in the second half of the nineteenth century as a result of emerging positivist sciences such as criminology, anthropology and psychiatry, which deployed the camera as an instrument of control and classification (Mortensen 2012: 61–126). With the well-known Foucauldian coupling of the archive with power and knowledge, photographic documents were produced and collected with a dual aim: the camera was deployed as a means not only of identification and surveillance but also of gathering empirical evidence for theories concerning the character and type of groups deviating from societal norms. According to Allan Sekula's seminal essay 'The body and the archive' (1986; see also Haworth-Booth, Squiers and Phillips 1997; Regener 1999; Mortensen 2012), the archive was used as a bureaucratic and scientific device for storing and classifying photographs on the basis of two paradigmatic structuring logics personified by the ideology and practice of the pioneering criminologists Alphonse Bertillon and Sir Francis Galton. Whereas Bertillon, director of the Identification Bureau at the Paris police, sought to establish an archival system for the positive and unambiguous identification of each criminal individual, the British scientist and forerunner in eugenics, Galton, attempted to define the criminal type. Although the projects of Bertillon and Galton were idiosyncratic and specialized (Sekula 1986: 55), they nevertheless outline the two major approaches to conceptualizing and systematizing the photographic archive. On the one hand, the archive may be conceived of as a non-hierarchical and paratactic accumulation of images in the spirit of Bertillon. On the other hand, it may, according to Galton's ambition, be understood as an essentialist entity from

which an overall meaning may be deduced or constructed. As the organization of most archives combines these two logics, the positions of Bertillon and Galton are illustrative as extremes.

During the nineteenth century and most of the twentieth century, the ordering and meaning-making of the photo archive took place within the realm of the professional – that is, the scientist, librarian, archivist or bureaucrat tending his or her job – or the photographic artist maintaining his or her oeuvre. In a remarkable shift, the photographic archive in today's digital global visual culture constitutes an everyday vernacular object with which the audience can interact and co-create. Facilitated and hosted by diverse news, entertainment and social-media sites, the archive has evolved into a general experience as a mode of consuming pictures and as a way for users to structure and conserve the visual documentation and communication of their daily lives. In fact the internet and mobile media have instigated 'a general storage mania' (Røssaak 2010: 11), which renders the sense of the archive 'all-encompassing' (Røssaak 2010: 16). To name but one example, the precious physical object of the photo album, with its carefully crafted narrative of family life (Sandbye 2001; Kuhn 2002), has to a large extent been replaced by the digital production and ordering of our personal photographs, which tends to take on an archival form on account of the mass and heterogeneity of pictures, situating users as 'interactive producers and consumers of knowledge' (van Dijck 2007: 116).

An important discussion in connection with the transition from the analogue to the digital archive is the extent to which the notion of the archive must be rethought: according to Røssaak (2010), digital technologies have altered the archive from stasis to motion and challenged the traditional idea of the permanence and stability of the archived document. We are thus experiencing a change of paradigm from a culture concerned with storage to 'a new media culture built on permanent transfer' (Ernst 2002: 23; cited in Røssaak 2010: 11). One may, however, question this understanding of the analogue archive as static: a defining trait of such an archive was and still is its openness to take in information and to

reconfigure preserved information into new patterns. The archive has always been dynamic and open-ended within the framework of an overall policy of collecting and organizing items according to different logistical, professional, political and ideological concerns and constraints. Therefore, we would rather like to make the case that the digital archive emphasizes and significantly intensifies the interactivity and flexibility that has always been an affordance of the archive.

Narratives on Demand

The urge to archive digital snapshots appears to be at odds with how they are commonly understood as casual, ephemeral and disposable (see, for example, van Dijck 2007: 111). Contemporary digital images hold a paradoxical position between the transient and fleeting vis-à-vis the seeming reluctance to dispose of the visuals. This sense of the accidental and passing is tied to modes of production and distribution, to the way in which snapshots are quickly taken and quickly circulated. Yet, when saved in a digital archive, the spatial dimension of the image is brought to the fore: the accidental and the passing are experienced as a particular 'snapshot aesthetics' (Sandbye 2007) and as a means of documenting a past reality tied to the photographic capture of the 'here–now', in Roland Barthes's semiotic terms (1977: 44).

Along with the intensified speed and volume of producing and disseminating information, the capacity to store information similarly expands. According to Terje Rasmussen (2010: 118), this results in a 'coherence surplus, a redundancy of orientation pillars for the construction of meaning', and, as a result, 'information must be eliminated, such as yesterday's news. The art of forgetting must be kept alive in order to enable coherent meaning production.' One might, however, object to the argument put forward by Rasmussen that, in fact, yesterday's news is not eliminated. Yesterday's news is stocked in archives and may be accessed and retrieved online. This raises the issue of how sense can be made of filed information

such as past news photographs, news texts and paparazzi images. In 'Archive fever', Jacques Derrida juxtaposes memory and the archive, since the latter always emerges 'at the place of originary and structural breakdown of the said memory' (1995: 14). When the archive, so to speak, is built on the ruins of memory, the filed objects are kept hovering in a state between remembrance and forgetting.

The digital archive thus obtains what might be termed a 'narrative on demand' function. By virtue of the accessibility and interactivity of the archive 2.0, the audience creates stories in a performative and personalized manner, and the meanings of the digital archive are established whenever they are looked for, wanted or needed. The stories are obviously determined by the visuals available and the structural framework of the site, but they are nevertheless generated in the act of browsing through the pictures and did not exist beforehand in precisely the same form. In other words, online sites facilitate a continued mediation and remediation of digital images in ever-new serial formations, which we are now going to examine more closely.

The Allure of Seriality

In relation to paparazzi photographs and other digital images, seriality is to be understood on two levels: first, seriality constitutes a basic form in the posting of the images, as photographers tend to record multiple images of the same situation in which slight changes in bodily compositions and facial expressions suggest the passing of time;[1] secondly, seriality is an overall organizing principle of entertainment sites. Incoming series are also circulated in one or – more often – multiple pre-existing 'galleries' – i.e. archival functions – that collect series of specific celebrities or of subject matters such as celebrity children, pregnant celebrities or celebrity injuries. The series remain in the galleries after their limited periods as top news stories have passed. With these two distinct levels of seriality, time has, in

effect, collapsed between the publication and the storage of the images. The sum of multiple images adds up to seemingly endless series of paparazzi photographs on entertainment news sites, featuring the 'visual serialization of the celebrity's public life' (McNamara, 2011: 9).

This seriality characteristic of paparazzi photography as an online celebrity news genre should not be mistaken for the journalistic news update, which Kostas Saltzis (2011) defines as every new version of a story, no matter how significant or elaborate the additions are to the original story. Paparazzi images accumulate in quantity but do not usually supply new information apart from the mundane registration of daily routines, outfits, styles, and so on. To the celebrity-interested crowd, a new image works as yet another collector's item, which provides the perfect starting point for talk and gossip about celebrities (cf. Jerslev 2010), with the repetition of undramatic, everyday scenes leaving room for identification, projection and fantasies.

The manner in which celebrities are serially and successively documented secures the authentic flow of everyday lived life. As digital technologies have significantly reduced time between the production of images and their distribution, and following celebrity sites' growing demand for paparazzi photographs, they are bought and uploaded as quickly as possible. Perceivably, this provides the viewer with a greater sense of proximity to the celebrity since the relevance to the audience seems to be dependent on the speed of distribution (McNamara 2011: 8–12). Speed is emphasized in the publication of the pictures, which, in most cases, are carefully dated. Establishing when the celebrity was recorded appears to be of great importance, which may seem somewhat puzzling in light of the uneventfulness characteristic of most of today's paparazzi photographs. However, the seriality of paparazzi images offers users a parallel to their own lives by enabling them to follow selected celebrities in their lives – day by day, hour by hour and even second by second. This allure of seriality is highlighted by the interactivity introduced by digital platforms inviting users to post comments, gossip and in other ways engage with the flow of paparazzi photos.[2]

Mapping the Archive of JustJared.com

Online sites thus facilitate a continued circulation and recirculation of digital images in ever-new serial formations. The archival structuring of digital paparazzi photography can be studied on entertainment and celebrity news sites, where images are posted in ever-changing series. In the following, we analyse the site *Just Jared*, which was launched in 2005 and claims to offer 'premium pop culture trends, extensive celebrity photo galleries and breaking entertainment news'.[3] This site is not on the list of the largest entertainment news outlets online in terms of numbers of visits, which includes sites such as omg.yahoo.com, people.com, tmz.com, popeate.com, eonline.com, mediatakeout.com, usmagazine.com, celebuzz.com, starpulse.com and gawker.com (Jerslev and Mortensen, 2013). However, *Just Jared* is characteristic of entertainment news sites in terms of graphic design and content, primarily paparazzi photography but also red-carpet photography, film stills, and so on, which are simultaneously posted as news and archived. The 'extensive celebrity photo galleries' referred to in the quote above are therefore an archival function and appear to contain all of the images published on the site since as far back as 2006. The term 'gallery' suggests a spatialization of digital images, as in an exhibition room of photos, just as the galleries provide temporal documentation of the lives of high-profile celebrities by storing all of the photos published on the site in reverse chronological order. Thousands – or, more likely, millions – of photos typically bought from photo agencies, which have specialized in 'Breaking news entertainment' (McNamara 2011: 9) are preserved in the various galleries. For example, the gallery for Angelina Jolie, who figures as Number One on the site's list of 'top celebrities', held 10,432 images as of 24 April 2012. Usually the photos are credited with the name of the agency. Users are never informed whether photos are taken by a professional paparazzi photographer employed by an agency, by 'freelance guys' (Day 2008) or by 'citizen paparazzi' – amateurs snapping celebrities with their mobile camera – the last of which have, according to McNamara (2011: 9), become a significant player next to the professional photographer in recent years.

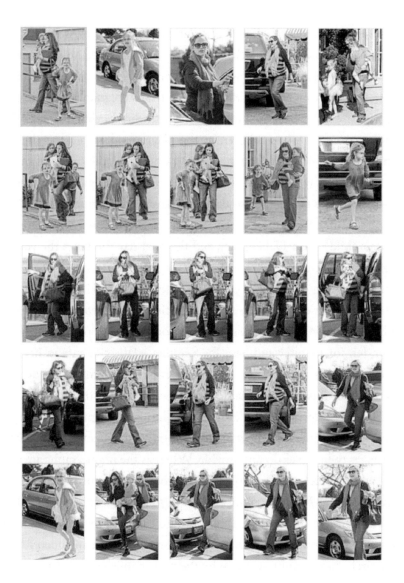

8.1 *Jennifer Garner: Karate & Ballet with the Girls.*
Just Jared, 20 February 2012.

Here we focus on the series 'Jennifer Garner: Karate & Ballet with the Girls', of actress Jennifer Garner, visibly pregnant and with her two daughters, which was first published on *Just Jared* on 20 February 2012 (figure 8.1).[4]

The series is posted in the form of a square or grid and consists of a total of 20 photographs. To the celebrity-interested audience, this framing of Jennifer Garner and her family will be recognizable inasmuch as many similar situations have been recorded during the actress's pregnancy, depicting her entering or exiting cars, walking the dog with her husband Ben Affleck, spending time with her children at the playground or picking them up from leisure activities. Although we can gather from the captions and the different clothes worn by the family members that this particular series of photographs was taken on two successive days, the situations in the photos are quite similar. According to the caption, Garner is leaving a karate class with her children on 17 February, and the next day she takes the younger daughter 'Sera' with her when accompanying the older daughter to a ballet class. The posting of the series establishes familiarity and intimacy with the celebrity and her children. Even if the caption starts formally by referring to Garner by first name and surname, it soon shifts to pet names, Vi for Violet, Jen for Jennifer and Sera for Serafina – 'Vi is so cute in her tutu,' the text exclaims. The caption anchors the factual meaning of the depicted situation, which is so recognizable to the average visitor that it could mean anything, an impression underlined by Garner's insignificant everyday clothes. At the same time, however, the caption constructs a proximity that the images themselves do not provide. Whereas the photographs are taken from some distance and frame the family in long shots or medium-long shots (only one of the 20 is a medium close-up), *Just Jared*'s captions establish a twofold intimate connection. This communicative form both simulates a bond between users and the depicted celebrities (we are included in their inner circle, in which know them by their pet names) and links the series to the overall site by miming the gossipy tone used by the audience in the often extended comments posted below the photographs.

The series is organized in three different layers. The 20 pictures posted on *Just Jared* on 20 February constitute the first layer. However, this particular constellation of pictures was not available in the same form on later visits to the site. The first posting of the pictures represents a unique configuration,

which changes as new photos are added. As Niels Brügger argues in connection with website philology, websites cannot simply be copied because live elements, such as interactivity and updates, mean that one invariably creates a 'unique version' (2008: 156). Even though the selection of pictures has been changed, the title 'Jennifer Garner: Karate & Ballet with the Girls' as well as the date and time remain the same, '20 February 2012 at 7:58 am'. It seems that the specific photos and the number of photos are not as essential as keeping an overall photographic record of these two days. In other words, this typical paparazzi-style everyday depiction of Jennifer Garner and her children is defined by the way in which the scenes could take place on any two ordinary days, and the dating is therefore to be understood as a marker of authenticity, as a means of fixing indexicality. Moreover, the date and time enhance the dynamics and interactivity of the site, with the flow of constant updates encouraging users to keep paying visits.

Concerning the second structuring layer, the series serves as an entry to the galleries of the people tagged. This series leads to five different galleries, listed in alphabetical order below the images, all of which are of a considerable size: 'Ben Affleck' (5,635 images), 'Celebrity babies' (48,312 images), 'Jennifer Garner' (7,807 images), 'Seraphina Affleck' (2,182 images) and 'Violet Affleck' (4,689 images). Three of the linked galleries are self-explanatory, referring to the people depicted in the series, while the two remaining galleries lead to the overall category of 'Celebrity babies' and the absent husband/father Ben Affleck: by tagging Affleck, the posting of the series symbolically unites this idealized celebrity family. In this way, the series is archived instantaneously in a range of galleries, opening up the possibility of viewing the images in different contexts or narratives. If we click on one of the galleries, we do not immediately find the series again, since time has passed and new images have been added as the pictures posted most recently are shown first. We must go back and may not find the photographs in the same order. By having saved all of the photos since 2006 (apart from the gallery for Seraphina Affleck, born in 2009), the galleries document the passing of time as an alternative family album – and,

in the case of the children, present a chronicling of their entire lives from when they were babies.

The third structuring layer comprises all of the tags for the photos in the five galleries, which lead back in a loop to the same galleries as well as to new ones. For instance, the gallery for Jennifer Garner also contains solo pictures of other celebrities, such as Charlize Theron, Anne Hathaway and Reese Witherspoon, who happened to be present at the same event or to appear in the same TV or film production and are therefore mutually tagged in each other's galleries. In this way, the series is interconnected with the sum the galleries, and the audience browsing through the pictures might discover potentially infinite meaning-making tours to take through celebrity culture.

In mapping the three structuring layers of *Just Jared*, it becomes apparent how the interactivity of the online photo archive grants users easy access to stored images. Even though the site documents several years of celebrity culture, the images are not available as historical documents in the conventional sense because they are not retrievable as they once were. Instead, *Just Jared* and other news and entertainment sites recirculate images as an immediate and intensely 'present past' (Hoskins 2009: 92), which is co-created by the audience in a personalized manner. Photographs used to be conceptualized as objects of the past, entangled with the functions of memory (see, for example, Barthes 1984). In contrast, images in the digital interactive archive offer a dynamic 'presencing'[5] (Scannell 1996) of past moments and encourage viewers to 'imagine and invent the present' (van Dijck 2007: 116), thereby creating, in the case of *Just Jared*, proximity to the depictions of celebrities in everyday attire.

Seriality and Street Photography Revisited

We have thus far discussed in a general way how seriality contributes to the construction of paparazzi photography in terms of presence and authenticity

as well as to the construction of entertainment sites as important nodes for uploading ever-new images. Of course, there is also a technical explanation for the many series of almost identical pictures, related to the affordance of the digital camera: that is, the option to shoot one image after another in quick succession. In the following section, we approach paparazzi photography from a generic angle and begin by examining how seriality and its concomitant snapshot aesthetics and 'presencing' cannot simply be explained as traits of the digital genre, but rather have photo-historical roots as well. Paparazzi photography has a kinship with street photography in the setting, composition and aesthetics of most of these snapshot-like images of celebrities. So, from the point of view of genre, we are once more going to ask how we can understand the continuous side-by-side uploading of nearly identical photos of celebrities looking ordinary, walking, eating, fetching kids, talking on their mobile phones and showing off a body not completely perfect.

Carol Squiers (1999) regards paparazzi photography as a hybrid of several photographic genres: photojournalism, documentary, celebrity photography and surveillance photography. Two comments should be made in relation to this characterization of the genre. First, generically speaking, paparazzi photography is a subcategory of celebrity photography and should not be understood in the same sense as, for example, surveillance photography. Secondly, Squiers does not mention the genre that arguably possesses the strongest affinity with paparazzi photography: namely, street photography, with its capturing of everyday life on the city streets. Hereby, her understanding of paparazzi photography misses the genre's likeness to the snapshot, both in terms of aesthetics and modes of production.

Interestingly, in comparison with the serialized form of online paparazzi photographs, Colin Westerbeck and Joel Meyerowitz (1994: 34) claim that, as a genre, street photography is characterized by 'instantaneity and multiplicity'. Street photography arrests the contingency of street life in snapshot form. Moreover, in another similarity with paparazzi photography, the snapshot aesthetics of street photography and the street photographer's working methods mean that his or her work 'has a special reliance on the *multiplicity*

of photography, its ability to create *serial imagery* and *sequences* of pictures' (Westerbeck and Meyerowitz 1994: 34; emphasis our own). Decades before digital technologies, the small portable camera, which emerged at the beginning of the 1930s, made it possible to shoot multiple images in an instant and to cultivate the specific aesthetics of catching street scenes and people unawares. Contrary, however, to the linear and consecutive non-hierarchical publishing of rows of images on *Just Jared* and similar sites as if they were digital contact sheets, most street photographers seem to have scrutinized their contact sheets for the one perfect snapshot to publish, taken at the moment, or just before the moment, when everything gathers into a perfect whole.

Opposed to French photographer Henri Cartier-Bresson's idea of the 'decisive moment', which, according to Peter Galassi (1987: 9), 'is not only a pictorial climax that yields a satisfying photograph but also a narrative climax that reveals a truth about the subject', there is no build-up to a narrative climax in paparazzi photographs; no individual image contains condensed meanings or moments in time. Most of the photos just point to a particular time and place at which a photographer came close enough to a celebrity to take his or her picture. Each and every photo is concrete and aesthetically banal: they are 'sloppy, unremarkable images' as Sekula (1984: 24) would have it, and their motifs are equally insignificant, with the exception of the celebrities involved in these unspectacular scenes. In this way, seriality forms no narrative coherence and is, as such, of no consequence. And should it be the case that the photographs are not all equally banal, the random, non-systematic juxtaposition makes any small significant detail obsolete. Take, for example, the detail in the first photo in the 'Jennifer Garner: Karate & Ballet with the Girls' series (figure 8.2), in which it seems that Garner is just about to blow a bubble with her gum. Here, a certain kind of 'moment' is attached to the photo, an elastic 'just before', reminiscent of Cartier-Bresson's understanding of the moment: 'This element of the moment is of hiatus and anticipation and not of conclusion, that which is just *before* a decision is made' (Ward 2009: 136). Yet if, indeed, this image contains a 'just before', a promise of a climax, this promise is left unfulfilled since

8.2 *Jennifer Garner: Karate & Ballet with the Girls.*
Just Jared, 20 February 2012.

the next photo in the sequence shows the oldest daughter on her own. The photos do not build up, they simply add up.

Westerbeck and Meyerowitz (1994: 34) elaborate further on the way in which street photography's seriality is the result of two different understandings of the genre and two different artistic methods:

a paradox is implicit to which street photography is very sensitive. On the one hand, the many shots that they can get at even a rapidly moving, changing subject allow them to strive for the singular image, some one, perfect composition into which all the other possibilities are condensed. On the other hand, they might make purposely open-ended, unbalanced pictures that can't stand alone and need to be played off one another in groups or run in books. The choice

between the two ideas is, in large measure, the choice between Henri Cartier-Bresson's work and Robert Frank's.

As should now be clear, the seriality displayed on celebrity websites such as *Just Jared* does not equal Westerbeck and Meyerowitz's first description of seriality. The adding is a point in itself, and it should not be mistaken for the trace of the professional photographer's skilled ability to decide what marks one photograph as better than the others or his or her eagerness to keep shooting until the perfect framing is secured. Seriality does not testify to an aesthetic gaze and to the effort to fulfil an artistic vision, the search for *the* moment. The logic of digital paparazzi photography is purely quantitative. Could we then claim that the seriality of celebrity news sites equals Westerbeck and Meyerowitz's second description of street photography's seriality, that none of the photographs stand alone because each one opens up to the preceding one and the next one? This is not the case either. The images are basically so alike that seriality comes close to repetition, and no aesthetic or thematic tension is possible. A slight change in movement creates a sense of continuity in time, no playing off of one image against another.

This is basically how seriality on celebrity websites makes sense. The digital dissemination of 20 photographs of Jennifer Garner and her daughters – more or less alike but meticulously added one by one, shot within a very short time span on two different days – gives the impression of movement in time, like a moving-images sequence united by an abundance of jump cuts. Whereas the snapshot emphasizes the defining trait of photography – the freezing of a motif in an instant that is over before it has begun – the series of snapshots sets time in motion while maintaining a delimited spatial view. In so doing, it opens up a privileged space for the user to occupy. The series provides an impression of the *unfolding* of the ordinary in time and thereby it constructs a special position from which the viewer may watch this unspectacular event. In this sense, the series offers the same as the caption – a position of proximity. Thus, fans and other users are provided not only with quantity, but also with a particular privileged relationship to the images.

An Aesthetics of Candidness

Westerbeck and Meyerowitz (1994: 31) define the street of street pho-
tography as 'any public place where a photographer could take pictures of
subjects who were unknown to him and, whenever possible, unconscious
of his presence'. In so doing, they further characterize street photography
as candid photography and situate the photographer as an obscure, anony-
mous presence in the crowd. Candidness is also a key feature of paparazzi
photography even though the subject is quite obviously known to the
photographer. Despite the candid look so characteristic of contemporary
paparazzi photography, stars are probably conscious of the possibility that
photographers are present, and paparazzi photographers have accounted
for what seems to them like tacit or explicit collaborations with celebrities
(Howe 2005; Mendelson 2007; Currid-Halkett 2010; McNamara 2011).
Contemporary paparazzi photography also resembles street photography
in terms of the places depicted being public, which in the former constitute
the characteristic tension between public and private present in celebrity
culture. Finally, one could argue that the typical posting of online paparazzi
photography in series of nearly identical photographs calls attention to street
photography's aesthetics of the passing and the fluid: each frame shows a
star's body in motion, with one movement only slightly different from that
in the next frame. By emphasizing motion, the series adds to the inscribed
sense of candidness and, by highlighting motion, the series transfers the
veracity of street photography – snapshot aesthetics' take on indexicality
(Doane 2002) – to paparazzi photography.

How snapshot aesthetics' candidness is constructed but also negotiated
may be illustrated by taking another look at the series picturing Jennifer
Garner and her children. As already mentioned, the 20 small rectangular
images are recorded on two consecutive days. However, the images are not
arranged progressively, but rather are placed at random within the square,
even though two or three could have formed a narrative unit and constituted
a move forward in time. In some of the shots, Garner is alone. Some show

her together with her children and a couple depict only the older daughter. But there is motion in all of the pictures: Garner is caught walking one leg in front of the other or in a bodily turn to exit a car. Hence, all pictures inscribe instantaneity and the passing of the fleeting moment.

However, a few of the photos deviate from this candidness established by the self-absorbed body in motion. In four of the photographs, Jennifer Garner's older daughter poses overtly and somewhat mockingly for the camera. She has her hands on her hips, and taking a slightly exaggerated bodily posture, she faces the camera and looks directly into the lens. With this gesture, she makes us aware of how this situation is not quite as ordinary as it appears in the other photographs. The daughter in a sense deconstructs the genre's inherent claim to defining the star's appearance as ordinary through snapshot aesthetics and candid camera by occupying a pose well-known from playful self-presentations by children and teenagers in digital photography.

The snapshot presents the unposed body or, at least, the body pretending not to pose. In her interesting Barthes-inspired discussion of the photographic pose, Kaja Silverman (1996: 205) argues that the pose 'needs to be more generally understood as the photographic imprinting of the body': the pose indicates an acknowledgement of the photographic situation and thus of the body as somehow photographically impregnated. To the extent that Silverman seems to describe a general bodily condition in an image-based culture, her argument is a radicalization of Roland Barthes's reflections on the inevitability of posing as a bodily interaction in the presence of a camera: 'Once I feel myself observed by the lens, everything changes: I constitute myself in the process of "posing", I instantaneously make another body for myself, I transform myself in advance into an image. This transformation is an active one' (1984: 10). The posing body is one that attunes to the photographic capturing of the moment. At once, it accepts and adjusts itself to a photographic situation – or even, as implied by Silverman's argument, to the possibility that a photographic situation might occur at any time.

To pose is, in a sense, to occupy a predefined, mediated bodily appearance – to mimic an image that already exists in the cultural image repertoire,

as Silverman observes. However, to pose is also to *freeze* – 'as if anticipating the still I am about to become', as art historian Craig Owens (1992: 210) puts it. According to Owens, to pose is to freeze the body's movement before it is 'stilled' by the camera and to freeze time into a condensed gesture of signification. The posing body freezes movement and thereby anticipates and performs its own telling stillness. Silverman and Owens, with their takes on the posing body, contribute to an ontology of the body in contemporary media culture, which is of general interest to celebrity-culture studies. Whereas the body in motion in paparazzi photography is posing on this general level by adjusting to a photographic situation, the genre is nevertheless distinguished by bodily movement and candidness. The celebrity body in movement, with its appearance of fleeting insignificance, embodies the flux of everyday life and the beat of the street.

Paparazzi photography offers snapshots of celebrities caught apparently unawares. They either genuinely show the unposed celebrity body or are a result of a tacit agreement (voluntary or involuntary) between the photographer and his or her subject to pose as if not posing. We will probably never know what we are really seeing. The important point is that most contemporary online paparazzi photographs conceal any sign of the photographic situation (Jerslev and Mortensen 2013). In contrast, Garner's daughter poses deliberately, and by the open gesture of transforming herself into an image she exposes what is outside the frame of the photograph. With her bodily pose, she makes the statement that the ephemerality inherent in the snapshot claim to truth and the concomitant construction of the photographer as a 'rather elusive transient figure' (Westerbeck and Meyerowitz 1994: 34) is not the actual truth behind the 'accidental' meeting of photographer and celebrity but a staged transaction. The child deconstructs the accidental and contingent so important to the lure of paparazzi photography as candid snapshots of celebrities. Simultaneously, she reveals her mother's self-absorbed doing as a pose, an enactment of 'doing being ordinary' to borrow an illuminating phrase from Harvey Sacks's (2003) work on conversation analysis. While the child poses openly, the mother poses in

a more subtle way. She poses as if not posing. Apparently, she does what she usually does, absorbing herself in the flux of the everyday, *pretending* that there is no photographer around and hence refusing to transform herself into an image. She thus *performs* the routine everyday task of being occupied with something ordinary, of doing what any mother would do. By posing as not posing, she subsumes herself to the genre and occupies an already existing photograph as well, namely that of the paparazzi photography. In so doing, she co-produces contemporary paparazzi photography's generic traits, of which the seeming paradox of celebrities being ordinary fuels the constant demand for ever-new pictures of the same.

The caption frankly states that 'Seraphina Affleck poses for the cameras' – in the plural, indicating that several photographers were present and emphasizing how the photographic truth rests with the posing celebrity child, not with the mother. The daughter at once points out what is obviously there, outside the image frame, and acts accordingly, without taking part in the tacit alliance her mother seems to have contracted. Thereby, the daughter turns the logic of paparazzi photography upside down and reveals how, in contrast to street photography, the genre is based on a social transaction. The mother contributes with another example of 'the spectacle of invaded celebrity privacy' (Sekula 1984: 26): by pretending the cameras are not there, she cooperates with the photographing bystanders in maintaining paparazzi photography's inherent logic of 'the higher truth of the stolen image' (Sekula 1984: 29). The child, on the other hand, by posing openly and obfuscating an important genre convention – the candid snapshot taken in the street – confers upon the image another truth, that of the unguarded and private as pose.

Conclusion

In this article, we have discussed seriality and archiving as characteristic traits of online posting of paparazzi photography. Increased volume and

speed of distribution is an immediate reason for the serial organization of images. Furthermore, the layered structuring of the series in galleries facilitates interactivity by granting easy access to and retrieval of images. We have, moreover, proposed that the series of celebrity bodies in motion on celebrity sites construct a sense of flux, of time as continuously unfolding and hence a sense of presence or 'presencing'. By using Scannell's term, we emphasize how presence is constructed in two ways: through the site's own constant reorganization of the images and through user activity, where the layering of images makes it possible for users to construct ever-new meanings by organizing the images in ever-new ways. Not only are new images posted continuously at a rapid speed, but their serialized unity is broken down just as quickly in order for new unities to appear. Thus, seriality and the dynamic, layered archiving of the images all seem to partake in the same effort: that is, to construct a sense of dynamism and, hence, to give users an impression of the site's being indispensable when it comes to the consumption of celebrity images.

In addition, we have emphasized how image captions, by way of their address to users, participate in creating a feeling of proximity, which may prompt future user visits. Paparazzi photography as a contemporary celebrity genre fits in perfectly with this overall sense of dynamism. Whether taken by professional photographers or by amateurs, whether taken by a tacit agreement with celebrities or of celebrities unaware of photographers, by means of their snapshot aesthetics they appear as candid photography. As if taken by accident, they show celebrities looking unremarkable, doing unremarkable things. Yet by this lack of significance and by the images' apparent ephemerality – their sense of having captured a fleeting moment in the everyday life of a celebrity – they provide a feeling of authenticity and stimulate a desire to see more. Contemporary paparazzi photography is rooted in photo history; however, its significant snapshot aesthetics contributes to its particular generic appearance online as serialized photography.

NOTES

1 The series of paparazzi photographs is almost reminiscent of the serial photographic studies of animals and humans in motion recorded by Eadweard Muybridge in the 1870s and 1880s with the purpose of documenting patterns of movement.
2 The sites also extend to social-networking sites like Twitter and Facebook, to which users gain entrance via their private profiles, thereby crossing the border between a public and a private way of engaging with the images.
3 See <http://www.justjared.com/about/>, accessed on 1 October, 2013.
4 See <http://www.justjared.com/photo-gallery/2630604/jennifer-garner-karate-ballet-with-the-girls-09/>, accessed on 8 March 2012.
5 Scannell coined the term 'presencing' in the context of television.

BIBLIOGRAPHY

Barthes, R. (1977; originally published 1964), *Image, Music, Text*, London: Fontana Press.
—— (1984; originally published 1980), *Camera Lucida: Reflections on Photography*, London: Flamingo.
Brügger, N. (2008), 'The archived website and website philology: a new type of historical document?', *Nordicom Review*, 29(2): 155–75.
Currid-Halkett, E. (2010), *Starstruck: The Business of Celebrity*, New York: Faber and Faber.
Day, E. (2008), 'A good year for the paparazzi? Just ask Amy and Peaches', *Guardian*, 17 August.
Derrida, J. (1995), 'Archive fever: a Freudian impression', *Diacritics*, 25(2): 9–63.
Doane, M.A. (2002), *The Emergence of Cinematic Time: Modernity, Contingency, the Archive*, Cambridge, MA, and London: Harvard University Press.
Galassi, P. (1987), *Henri Cartier-Bresson: The Early Work*, New York: Museum of Modern Art.
Haworth-Booth, M., Squiers, C., and Phillips, S.S. (1997), *Police Pictures*, San Francisco: San Francisco Museum of Modern Art.
Howe, P. (2005), *Paparazzi and Our Obsession with Celebrity*, New York: Artisan.
Jerslev, A. (2010), '"Rarely a dose of pure truth": celebrity sladder som medieret kommunikationsform', *Nordicom Information*, 32(1): 23–46.

Jerslev, A., and Mortensen, M. (2013), 'Taking the extra out of extraordinary: paparazzi photography as a an online celebrity news genre', *International Journal of Cultural Studies*, published online before print 30 September, 2013, <doi: 10.1177/1367877913503425>.

Jerslev, A., Mortensen, M., and Petersen, L.N. (2011) (eds), *Challenging Genre – Genre Challenges: New Media, New Boundaries, New Formations, MedieKultur*, 27(51).

Johansson, S. (2007), *Reading Tabloids: Tabloid Newspapers and Their Readers*, Stockholm: Södertörns Högskola.

Hoskins, A. (2009), 'Digital network memory', in Erll, A., and Rigney, A. (eds), *Media and Cultural Memory / Medien und kulturelle Erinnerung: Mediation, Remediation, and the Dynamics of Cultural Memory*, Berlin: Walter de Gruyter.

Kuhn, A. (2002), *Family Secrets, Acts of Memory and Imagination*, London: Verso.

McNamara, K. (2011), 'The paparazzi industry and new media: the evolving production and consumption of celebrity news and gossip websites', *International Journal of Cultural Studies*, September 2011: 515–30 (first published on 8 April, 2011).

Mendelson, A.L. (2007), 'On the function of the United States paparazzi: mosquito swarm or watchdogs of celebrity image control and power', *Visual Studies*, 22(2): 169–82.

Mortensen, M. (2012), *Kampen om Ansigtet: Fotografi og Identifikation*, Copenhagen: Museum Tusculanum Press.

Owens, C. (1992), 'Posing', in Bryson, S., Kruger, B., Tillman, L., and Weinstock, J. (eds), *Beyond Recognition: Representation, Power, and Culture*, Berkeley, Los Angeles and London: University of California Press.

Rasmussen, T. (2010), 'Devices of memory and forgetting: a media-centred perspective on the "present past"', in Røssaak, E. (ed.), *The Archive in Motion*, Oslo: National Library.

Regener, S. (1999), *Fotografische Erfassung: Zur Geschichte medialer Konstruktionen des Kriminellen*, München: Wilhelm Fink Verlag.

Røssaak, E. (2010), 'The archive in motion: an introduction', in id. (ed.), *The Archive in Motion*, Oslo: National Library.

Sacks, H. (2003; originally published 1984), 'On doing "being ordinary"', in Atkinson, M.J., and Heritage, J. (eds), *Structures of Social Action: Studies in Conversation Analysis*, Cambridge: Cambridge University Press.

Saltzis, K. (2011), 'Breaking news online: a study on the patterns of news story updates in UK websites', paper presented at The Future of Journalism, Cardiff University, 8–9 September.

Sandbye, M. (2001). *Mindesmærker: Tid og Erindring i Fotografiet*, Copenhagen: Forlaget Politisk Revy.

—— (2007), *Kedelige Billeder: Fotografiets Snapshotæstetik*, Copenhagen: Forlaget Politisk Revy.

Scannell, P. (1996), *Radio, Television and Modern Life: A Phenomenological Approach*, Oxford and Cambridge, MA: Blackwell.

Sekula, A. (1984), *Photography Against the Grain: Essays and Photo Works 1973–1983*, Halifax, Nova Scotia: The Press of the Nova Scotia College of Art.

—— (1986), 'The body and the archive', *October*, 39: 3–64.

Silverman, K. (1996), *The Threshold of the Visible World*, London and New York: Routledge.

Squiers, C. (1999), 'Class struggle: the invention of paparazzi photography and the death of Diana, Princess of Wales', in id. (ed.), *Overexposed: Essays on Contemporary Photographs*, New York: The New Press.

—— (2010), 'Original sin: the birth of the paparazzo', in Phillips, S.S. (ed.), *Exposed: Voyeurism, Surveillance and the Camera*, London: Tate Publishing.

van Dijck, J. (2007), *Mediated Memories in the Digital Age*, Stanford: Stanford University Press.

Ward, K. (2009), *Augenblick: The Concept of the 'Decisive Moment' in 19th- and 20th-century Western Philosophy*, Burlington, VT: Ashgate Publishing.

Westerbeck, C., and Meyerowitz, J. (1994), *Bystander: A History of Street Photography*, London: Thames & Hudson.

9

Retouch Yourself: The Pleasures and Politics of Digital Cosmetic Surgery

TANYA SHEEHAN

In January 2012, a young commercial film director living in northern California released a mock commercial for a beauty product he dubbed *Fotoshop by Adobé*. According to the commercial's female voice-over, this 'next revolution in beauty' will allow you to 'look the way you've always dreamed'. Three models (also women) demonstrate the effects of Fotoshop's special formulas. The 'Healing Brush' formula treats blemishes 'by simply erasing them'. 'Hue/Saturation' can 'change hair or skin colour, brighten eyes, whiten teeth, even adjust your race'. A third formula, 'Liquify', allows women to reshape their bodies without the 'expense and mess of surgery' or the work of a proper diet and exercise. Before-and-after photographs show us Fotoshop's remarkable results, which are advertised as 'so dramatic they're almost unrealistic'. And indeed they are: grotesquely wrinkled and pimpled women transform into perfectly complexioned beauties before our eyes, and pounds of flesh disappear from already slim figures (figure 9.1).

Jesse Rosten introduced his two-minute commercial into public life on Twitter and Facebook. Within 24 hours, half a million users had viewed it on video-sharing websites; days later that number rose to 5 million, as *Fotoshop by Adobé* was picked up by major blogs and online news magazines.[1] The parody struck a chord with viewers, especially in the USA and

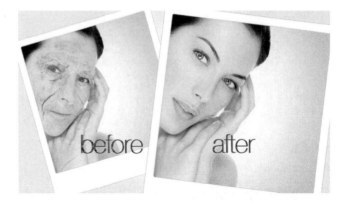

9.1 Jesse Rosten, *Fotoshop by Adobé* film still, 2012.

the UK, who associated it with the very real practice of using software such as Adobe Photoshop to alter women's bodies in celebrity and fashion magazines. Knowledge that this practice has been controversial is built into Rosten's commercial, as infamous digital doctoring scandals of the last decade appear on our screens: Kate Winslet on the cover of British *GQ* (2003), Faith Hill on *Redbook* (2007), Demi Moore on *W* (2010), Gabouray Sidibe on *Elle* (2010), and so on. In the earliest and most talked about of these covers, a photograph of Winslet was subjected to liberal retouching that lengthened her legs, flattened her stomach, and generally concealed the 'womanly' curves for which she is known. The English actress (then in her late twenties) objected publicly to this operation, performed without her consent, by asserting that her body and her identity were not represented truthfully by the published images. The British and American press in turn expressed both excitement and (mild) dismay over *GQ*'s treatment of Winslet's photographs, using the incident as an opportunity to proclaim a new era in photography. 'No diet, no exercise, no surgery, no pills. Just a little digital wizardry,' reported the *Miami Herald* in the wake of the scandal. 'Point and click here, point and click there, and unwanted pounds magically melt away—from your photographic image, that is' (Pitts 2003).[2]

Like *Fotoshop by Adobé*, such media controversies foreground connections between medical and photographic discourses that have a long history in

American culture. There is nothing new, for instance, about equati͏
ing with cosmetic surgery or about the potential for a photograph to ͏ᴗ
'doctored' to the extent that a sitter no longer recognizes him- or herself. And
yet there is something specific about the pleasures and politics of altering
photographic bodies in recent decades. Part of that specificity stems from
the fact that digital doctoring participates in a now pervasive 'makeover
culture' that conceives of everybody as essentially in need of improvement
and equates health with a 'beautiful' external appearance achieved through
material or technological intervention. In its most spectacular and contro-
versial form – medical makeover television – Americans subject their bodies
to a scrutinizing public gaze that brands them 'ugly', 'ordinary', and thus
in need of continuous and often radical reconstruction (Heller 2007; Jones
2008; Weber 2009; Wegenstein 2012). The imagined result is 'a whole new
you', as *Fotoshop*'s voice-over put it – a better, happier self.

Photography's participation in American makeover culture not only
informs the work of commercial artists for high-profile magazines; it
shapes the experiences of 'ordinary' Americans equipped with basic cam-
eras and personal computers. Fotoshop by Adobé was once available only
to *them* (female celebrities), Rosten's commercial reminds its audience, but
is now available to all of *us* (American women). The mass availability and
distribution of this powerful tool is significant, as it extends the pervasive,
purposeful, and at times anxious medicalization of digital photographic
manipulation into 'everyday' life. Approaching digital cosmetic surgery as
both a commercial and a vernacular practice, this essay begins by looking
back – way back – to the moment when the term 'doctoring' first became
common in discussions of American portrait photography. It then explores
how doctoring's seemingly ubiquitous presence in American culture is now
shaping digital photography's cultural identity, its social function and its
particular relations to the body. While steeped in the rhetoric of the new,
the practice of digital cosmetic surgery ultimately complicates narratives
of media revolution that have attached themselves to photography in the
age of Web 2.0.

Doctoring Debates, Then and Now

As their trade literature attests, American studio photographers in the 1870s were preoccupied with identifying and then remedying the 'more prominent peculiarities' of their sitters' faces. For this work they could use certain lighting effects, apply make-up to their subjects or rub their skin to produce a blush. Photographers could also position bodies strategically away from or near to the camera in order to highlight some features and conceal others. The most widespread treatment, however, was retouching or doctoring photographs. Because most retouching was performed directly on the photographic negative, the printed portrait typically bore little evidence – few discernible pencil marks or brushstrokes – of the retoucher's hand. This process aimed to remove two kinds of defects: blemishes produced by the photographic process and those apparent on and peculiar to the sitter himself. The first class of defects included areas of the negative that were under- or overexposed, scratches on the film, and dark spots caused by dirt and dust on the photographer's equipment. The second class comprised a range of anatomical and dermatological abnormalities. In treating these defects the work of the nineteenth-century retoucher bore a striking resemblance to that of the reconstructive surgeon; both manipulated a subject's face in order to remove its (pathological) signs of individuality and difference. The result, operators imagined, would be a 'pleasing' image of the subject's 'true' and 'best' self.

In a pair of portraits printed before and after retouching, which appeared in a trade manual for photographers in 1875 (Vogel 1875: 245), we find both kinds of defects: the photographic and the corporeal. These are visible in the portrait on the left and have been touched out on the right (figure 9.2). Several spots on the negative have been removed, one of which produced a prominent white mark on the young lady's cheek in the untouched print. The retoucher also softened the heavy contrast of light and shade, which was likely due to an improper diffusion of light at the time of exposure and was exacerbated by the deep contours of the sitter's face. The result is

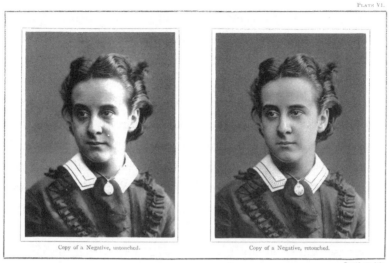

PLATE VI.

Copy of a Negative, untouched. Copy of a Negative, retouched.

EFFECT OF THE RETOUCHING OF NEGATION. *See pp. 50, 245.*

9.2 *Portrait of Mlle. Artot, untouched and retouched,*
ca. 1875. From Vogel 1875: 245.

the appearance of blemish-free skin with even pigmentation, fuller cheeks, a straighter mouth and well-rested eyes – features that contribute to our reading of the subject as youthful, racially white, feminine and middle class. In her retouched portrait Mlle Artot becomes, quite simply, the picture of health, as it was defined in medical and popular discourses of the period.[3]

While doctoring photographs became a powerful means of positively making over the American studio public and shaping the professional character of photographers themselves (Sheehan 2011), there was much about the public's relationship to this practice that had to be managed carefully. Surgeons who performed 'plastic operations' in the context of the American Civil War (1861–5), for example, were certain to define them as 'the reparation or restoration of some lost, defective, mutilated, or deformed part of the body' in order to establish the legitimacy and necessity of their practices (Prince 1868: 1). But portrait photographers were increasingly expected to operate with few limitations and often without reference to a lost original. As a result, the precise limits they should place on their

retouching makeovers became the subject of heated debate. One of the most vociferous opponents of radical doctoring summarized the terms of this debate in 1872 by asking commercial operators:

> If a person has an habitual freckled face, and you touch out the freckles in the picture, is the original rendered correctly? If one has high cheek-bones, do you give a correct representation of the individual by 'judiciously touching out the shadows in the negative that reproduce them in the photograph'? If one has a 'snub' nose, or a broken nose, do you make a correct likeness by 'touching out' the defect?

His response: 'Certainly not' (Snelling 1872: 300). What this critic questioned was not photography's power to alter appearances but instead the ethics of exercising it. It was one thing to correct the blemishes that photography created or exaggerated on a sitter's face, he reasoned; it was quite another to touch out those features that were deemed essential to her class, race and gender. Within the latter scenario, photography could connote artifice instead of truth and its operations could be seen as the 'wrong' kind of medicine.

We might say that history is repeating itself, as the aesthetic and ethical questions raised by digital manipulation in fashion and celebrity photography recapitulate debates first waged in the 1870s. Unsurprisingly, media editors who print such images defend their efforts to slim down and cosmetically 'clean up' the bodies they present to their predominantly female readership. When asked whether she retouched the figure of American singer Kelly Clarkson on the September 2009 cover of *SELF*, for example, the editor-in-chief of this popular women's magazine replied definitively, 'Yes!' Lucy Danziger (2009) went on to explain the process on her blog:

> When the cover girl arrives at the shoot, she is usually unmade up and casually dressed [...] Once we do her makeup and hair, and dress her in beautifully styled outfits and then light her, we then set the

best portrait photographer we can on a road to finding a pose and capturing a moment that shows her at her best [...] Then the shoot starts and after about 100 images are snapped, there are outfit changes and more lighting adjustments, more hair touch-ups and fans blowing, etc. [...] Then we edit the film and [...] allow the postproduction process to happen, where we mark up the photograph to correct any awkward wrinkles in the blouse, flyaway hair and other things that might detract from the beauty of the shot.

Among the 'things' that Danziger and her post-production staff believed would detract from the beauty of Clarkson's picture was some 'extra' weight the singer has been seen to carry. That they chose to remedy this by placing Clarkson on a 'Photoshop diet' disturbed critics since it suggested that *SELF* was more invested in the appearance of fitness than in the material reality of women's health.[4] Danziger negotiated the apparent disjunction by citing the higher authority of truth, much as nineteenth-century portrait photographers had done before her: 'in the sense that Kelly is the picture of confidence, and she truly is, then I think this photo is the truest we have ever put out there on the newsstand.' Danziger then offered some industry doublespeak, claiming that the doctored picture of a noticeably thin Clarkson is 'meant to inspire women to want to be their best' *and* that the 'truest beauty is the kind that comes from within' (Danziger 2009).

One of the most influential critiques of efforts to equate doctored images with truth and beauty came from within the beauty industry itself. In 2004, the multinational company Unilever, maker of the Dove brand of soap and body products, launched its Campaign for Real Beauty, which aims to 'make women feel beautiful every day, by widening today's stereotypical view of beauty' (Unilever 2012). After running advertisements that featured ageing women, women with curves and women of various ethnicities, the campaign responded to the media's reliance on digital cosmetic surgery by creating a short time-lapse film. Titled *Evolution*, the film went viral upon its internet release in 2007 and earned a top prize at the Cannes Lions International

9.3 Ogilvy and Mather, *Evolution* film still, 2006.

Advertising Festival later that year. Over 20 hours of footage were reduced to 75 seconds in which we witness the process by which a 'real woman' becomes a billboard model (figure 9.3).

We see this figure experience every 'thing' that Danziger described and implied above – from lighting, hair-styling and make-up to airbrushing the model's complexion, elongating her neck and enlarging her eyes with image-manipulation software. Mentally comparing the resulting billboard advertisement to the 'undoctored' woman on the video becomes unsettling to viewers, but in a productive sense; the comparison forces viewers to accept that our 'perceptions of beauty are distorted', as are the 'ideal' bodies onto which we map them.

Criticism of extreme digital surgery remains prolific, often highlighting its impact on the health of our bodies and minds. In an interview published in the *New Yorker* magazine in 2008, the 'premier retoucher of fashion photographs' Pascal Dangin admitted the detrimental physical effects of 'excessive'

doctoring (Collins 2008: 94). Reflecting on his work for *Vogue, Vanity Fair, Harper's Bazaar,* and other high-profile magazines, Dangin explained that he once 'minimized [an] actress's temples, which bulged a little, tightened the skin around her chin, and excised a fleshy bump from her forehead'. On another occasion 'he had restructured the chest—higher, tighter—of an actress who, to his eye, seemed to have had a clumsy breast enlargement'. In this case, 'virtual plastic surgery cancelled out real plastic surgery, result-ing in a believable look.' But Dangin insisted that he avoids anatomically 'disfiguring' bodies in Photoshop. In fashion magazines, he remarked to the *New Yorker,* 'girls [have] their legs slimmed and they no longer have tibias and femurs, and it's weird' (Collins 2008: 94, 96–97, 100). The American Medical Association (AMA) recently condemned such extreme alterations for being more than weird. They contribute to the formation of unrealistic body images, the organization argued, and such images can lead to low self-esteem, eating disorders and even suicide, especially in adolescents and women (AMA 2011; *Economist* 2011). These are serious consequences and precisely what Jesse Rosten confronted through sardonic humor. 'You don't have to rely on a healthy body image or self-respect anymore,' *Fotoshop's* voice-over proclaims, echoing the sobering conclusions drawn by the AMA.

Talk of Revolution

The idea of photography as medicine emerged at a moment in US his-tory when the photographic medium, like the war-torn nation itself, was perceived to be facing a crisis of identity. As I have argued elsewhere, not only did the American public question the professional character of portrait photographers but the commercial photographic community itself disagreed on how to assert the cultural authority of their practices (Sheehan 2011). It is therefore no accident that medical metaphors began to resurface in the 1980s when many critics and image-makers anticipated a 'digital revolu-tion' that would have far-reaching, even catastrophic, effects on American

photographic culture. Digital technologies, they observed, have transformed the material characteristics of the medium we once knew, replacing them with electronic sensors, data processors and computer monitors that offer new ways of capturing, storing and transmitting images. With such changes, these observers predicted, much would be lost, from the physical space of the darkroom to the professional character of photography. What would be gained through that loss was a 'democratization' of the medium whereby anyone equipped with little more than a mobile phone would have the power to control photographic production. The focus of forecasters, however, has concerned photography's perceived relationship to objectivity and truth. That computer technologies enabled photographs to be infinitely manipulated – and even wholly invented without reference to a pre-existing physical reality – challenged popular assumptions about such images as 'relatively unmediating and trustworthy' (Ritchin 1990: 2). Although photographs have always been material and social constructions, the camera in the digital age has acquired a new capacity to lie – what William J. Mitchell would call a 'temptation to duplicity' – that informs the new means of seeing, knowing and shaping the world, which it offers photojournalists, art photographers and snapshooters (Mitchell 1992: 19; see also Willis 1990: 197–208; Batchen 2001: 128–43; Ritchin 2009).

Reports of the death of photography and the advent of a 'post-photographic' age continue to circulate in both the popular press and artistic circles, even though media historians and theorists have been quick to challenge their assumptions. The essays in *The Photographic Image in Digital Culture* (Lister 1995) mounted an early critique of the progressivism, technological determinism and ahistoricism they identified in such narratives. According to contributor Kevin Robins, the idea of a digital revolution promoted by Mitchell and others is predicated on the problematic 'belief that the future is always superior to the past, and [...] that this superior future is a spontaneous consequence of technological development' rather than the result of a gradual process through which technologies are shaped by any number of social, political and economic factors. By 'intensify[ing] contrasts between past (bad)

and future (good)', moreover, those who speak of revolution 'obscure the nature and significance of very real continuities' (Robins 1995: 30). Martin Lister framed this critique in the book's introduction, observing that 'the new image technologies are in an active relation, of some dependence and continuity, with a 150-year-old photographic culture', having never made a 'clean break' from its 'cultural forms, institutions and discourses' (Lister 1995: 8). Much of subsequent scholarship on the emergence of new media has remained committed to understanding the digital in relation to older visual technologies, speaking in terms of adaptation, imitation, transformation and rivalry (Kember 1998; Bolter and Grusin 1999; Manovich 2000; Thorburn and Jenkins 2003; Rabinovitz and Geil 2004; Baylis 2008).

As these discussions of revolution were unfolding, the concept of digital cosmetic surgery took shape. One explanation for this concurrence is that it highlights the camera's capacity to transform bodies in radical, visible and highly mediated ways. While the promise of virtual transformations of the body that rival medicine contributed to the social value of studio portraits in the nineteenth century, the idea that photography's authority can be constructed exclusively through a self-conscious denial of its perceived relationship to the real – variously understood in terms of its immediacy, indexicality, automaticity, objectivity or simply truth – is arguably a novel feature of digital-photographic discourse. Such an idea serves us well when considering the work of art photographers who make little effort to conceal the disjunction between the 'real' body and the digitally manipulated body, producing obvious, seemingly infinite and often bizarre transformations of the latter (von Amelunxen, Iglhaut and Rötzer 1996; Dawber 2005).

But do these pronouncements of the new imaginative qualities of photography help us comprehend the many comparisons between digital portraiture and cosmetic medicine *outside* of artistic circles? Do they allow us to make sense of such representations in instructional literature for snapshooters as well as in popular image-manipulation services and software? Can established narratives of media transition fully account, moreover, for the social motivations and implications of photography's *vernacular* medicine?

Doctors in Training

To address these questions, I turn the reader to two photographic manuals published in 2006, both intended for American snapshooters unfamiliar with the workings of Adobe Photoshop. The more self-consciously 'straight-talking' of the two, Tim Daly and David Asch's *Digital Photo Doctor* (2006) promises readers 'simple steps to diagnose, rescue, and enhance your images'. Illustrated by a series of pre- and post-operative photographs, each chapter presents 'symptoms' of and step-by-step 'treatments' for common photographic problems. Most of these address technical issues related to composition, colour, detail, lighting and exposure that stem from the requirements of the digital camera, the insufficient skills of its amateur operator, or both.

In a chapter titled 'Doctor, I want plastic surgery!', Daly and Asch acknowledge the negative effects of such problems on desired body images. The first section of the chapter teaches readers how to use Photoshop's 'spot healing brush' to remedy the 'uneven skin tone and minor blemishes' of a pale-complexioned twenty-something man who appears to suffer from a mild case of acne. Accentuated by the camera's flash, the authors explain, 'patchy skin tone [...] can turn a potentially flattering portrait into the picture you quickly flip past in the family album' (2006: 138). Several pages later we are shown how to treat the 'bulky body' of a young woman in an oversized T-shirt using multiple image layers in conjunction with the 'clone stamp' and 'healing brush' tools; these effectively remove the wrinkles in her shirt and reduce the appearance of fat beneath them, resulting in a body that looks relatively thin but not dramatically altered. While the book's claim that 'photographs capture and preserve a moment—however good or bad the subject looked at the time' suggests that the apparently overweight sitter makes such treatments necessary, its observation that 'harsh lighting and poor composition can change a person's appearance, often for the worst [*sic*]' puts the blame back on the technology that renders her likeness unattractive. Despite this ambivalence, the authors of *Digital Photo Doctor* remain unequivocal about the positive aesthetic and sanitary potential of digital

retouching, which 'can be used to straighten, tidy, and hide the features you'd rather not repeatedly see' (144).

Also written for the 'average' American who wants to 'retouch, enhance, improve, and manipulate digital photographs like a professional', Barry Jackson's *Photoshop Cosmetic Surgery* (2006) employs medical metaphor as it explores the corporeal possibilities and limits of digital photographic manipulation. The book's author adopts the guise of 'Dr Jackson', a middle-aged bald man dressed in either surgical scrubs or a white lab coat, who variously holds up a scalpel, a paintbrush, an examination light and an X-ray. Working alongside a provocatively clad nurse – aptly named Jane Peg (J. Peg) – he appears throughout the book in scenarios that combine light humour and sexual fantasy. These illustrations encourage readers to laugh and perhaps even turn them on as the book's 'surgical case studies' outline a wide range of 'doctoring' skills.

The case studies consist of a series of letters from potential 'patients' who have questions regarding particular 'cosmetic' and 'surgical' procedures. Jane Peg fields the former, explaining how to make a woman look like a 'supermodel' not only by digitally removing pimples and freckles, but also by virtually perfecting the symmetry of her face, changing her eye colour from brown to blue, straightening and whitening her teeth and treating her to a manicure. Dr Jackson responds to the 'surgical' cases by describing how to perform Photoshop 'face lifts' that tighten the skin of 'haggard' women and beer-drinking men over 40, construct a more prominent jaw line in a teenage boy or create ideal noses on subjects of all ages. He also teaches his male 'patients' how to build and define their muscles without leaving their computers, while women learn how to diet digitally or adjust their breast size. Many who supposedly wrote to Dr Jackson claim that they have been thinking about undergoing one of these actual medical procedures because they don't like what they see in the mirror. Rather than subjecting themselves to harsh chemical treatments or a nip and tuck, however, they are invariably advised to opt for the relatively quick, inexpensive, painless and risk-free operations that Photoshop offers them. In recent years online

companies have been marketing a similar opportunity to perform virtual cosmetic surgery on photographs of yourself and thus visualize what your body would look like after liposuction, a breast enhancement, a facelift, or rhinoplasty. The doctored photographs are meant to help doctors and their patients decide upon a surgical plan, or at least fuel patients' fantasies of having one.

Unlike *Digital Photo Doctor* and many of the virtual plastic surgery services online, which are careful not to 'overdo it', *Photoshop Cosmetic Surgery* does entertain the fantasy of limitless transformation. The manual's focus nevertheless remains on teaching readers to make their bodies appear believably thin and youthful as well as clearly feminine or masculine. It primarily targets working men and women who can't afford gym memberships or fancy photographic equipment but who seek some form of upward social mobility. Many of these subjects hope someday to succeed in modelling, acting or the music industry, reminding us that the ideal of beauty promoted by digital cosmetic surgery is defined largely in relation to celebrity culture and is thus subject to strict corporeal and social limits (Rojek 2004). There is a class-based dimension to the manual's lessons, moreover, in so far as physical 'excess' and ageing are equated with 'letting yourself go' and associated with lower-income subjects. The digital removal of tattoos works to normalize bodies economically marked as 'other', just as tools used to hide freckles, lighten skin and generally 'balance' skin pigmentation idealize 'pure' whiteness as the desired norm.

Digital Photo Doctor promotes social homogenization in part by choosing not to depict a single non-white person in its illustrations. Taking a different approach, *Photoshop Cosmetic Surgery* includes multiple races and ethnicities in its surgical case studies, only to pathologize their skin colour. Justine, for instance, explains in a letter to Dr Jackson, 'I love to look through my women's magazines and daydream about being a famous model with perfect skin' (Jackson 2006: 54). To that end, the doctor helps her create a modelling portfolio of photographs that use Photoshop filters to create 'a soft-focus, glowing kind of skin'. The 'before' portrait of Justine's face, however, reveals

not a single blemish. It is only in examining her doctored 'after' shot, in which her seemingly flawless complexion is lightened dramatically, that we discover the source of malaise for both doctor and patient: Justine's light-brown flesh tones. In another case, an African-American woman named Denise, who hates the dark circles under her eyes, asks Dr Jackson to recommend a 'cream or lotion that would banish them permanently'. He kindly offers Photoshop as the 'perfect product' for achieving the desired results, before crudely suggesting that if she is not convinced she can 'give Michael Jackson a call—he may have some tips on lightening skin' (92).

Private Pain, Public Pleasure

Although the language used in these 'diagnoses' makes specific reference to contemporary popular culture (to the King of Pop, no less!), on the whole there is little difference between their idealization of whiteness as respectability and that enacted by early retouching practices. What we might see as new in the discourse of digital doctoring therefore lies elsewhere. One difference between nineteenth-century and twenty-first-century practice is found in the emphasis the latter places on extreme, and often distinctly gendered, emotional distress as the primary motivation for remaking the photographic body. In *Photoshop Cosmetic Surgery*, explicit discussion of such anxiety abounds. The women in the book are generally hypersensitive to what they take as an omnipresent male gaze; they believe men only when they say their bodies are 'ugly' or 'too fat' and they imagine that their husbands and boyfriends are 'losing interest' in them because of their big noses or small breasts. This hypersensitivity contributes to dysfunctional relationships, low self-esteem and the unhealthy behaviours employed to cope with both.

One of the most tragic of the book's case studies concerns Suzanne, who admits to Dr Jackson that she has 'a real hang-up about my calves' because 'they are really solid and muscular, which I feel is very unattractive in a woman'. This poor self-image leads her to spend the whole evening at

her sister's wedding 'trying to find things to stand behind so that nobody could see my legs'. Instead of providing Suzanne with the mental-health support she clearly needs, the doctor assures her that 'nobody will remember how big your lower legs are' and recommends that she wear trousers in the future, after doctoring the wedding photos (144). The men in *Photoshop Cosmetic Surgery* are by no means emotionally fit, but they are not as consistently demeaned or mocked by the authority to which they have turned for treatment. Most are presented as 'very self-conscious' about their bodies and want to look more attractive to the women they work with or meet via the internet, who all seem to desire 'beefy' men with mops of hair. The most extreme of these cases would have to be Peter, whose 'weak chin', as he puts it, has 'affect[ed] my mental well-being [...] I can't bear to look at myself in photographs or reflective surfaces because my appearance upsets me too much.' Dr Jackson suggests that Peter doctor all of his portraits and 'paste them over every mirror and reflective surface of your home. It will then only be a matter of time before you begin to believe what you see and your mental well-being will greatly improve' (86). While these narratives of anxiety and self-loathing have important precedents in the history of photography – Hugh Diamond and Jean-Martin Charcot prescribed similar photographic treatments for their hysterical patients in the mid-nineteenth century – they will be all too familiar to contemporary viewers of medical makeover television, which offers extreme surgical reconstructions to address the emotional distress of their subjects. Even subjects who initially claim that they 'wouldn't change a thing' about their appearance end up submitting to the knife or trying some digital cosmetic surgery, if only to explore for themselves the relationship between visible looks and inner well-being.

Generated out of private feelings of inferiority, inadequacy or an abstract malaise, the images of health that extreme makeovers (digital or otherwise) produce are ultimately intended for public consumption, which seems to confirm their significant social effects. In the case of televised makeovers, their public nature is underscored by the requisite 'reveal', which marks

the subject's transition from 'ugly' social outcast to 'beautiful' socialized self. Vernacular forms of digital cosmetic surgery are also closely tied to public life in so far as they can be used to facilitate a subject's entrance into a variety of normative social relations. Many of the professional 'photo-doctoring' services that abound online, for example, invite Americans to submit their portraits via digital upload and select from a list of variously priced medicalized procedures, from the removal of a facial blemish to larger-scale bodily reconstructions. Such services encourage customers to upload a private image – a wedding portrait, a school picture or a self-snapshot from a personal camera – and then share the doctored results with family, friends and colleagues.

Photo-doctoring websites also remind customers that the public dissemination of a 'new you' can and should take place through social networking, photo-sharing, and online dating websites. 'Once, people used to get images retouched only for media purposes,' says Fixarphotos Retouching (2012), which describes itself as the 'world's largest' digital photo-editing agency, but 'as the social networking grows people are more likely to share their retouched photos…' Meanwhile, blogs and Wikis are fuelling these observations by instructing users to improve their internet lives through digital self-doctoring. In one article posted to wikiHow, 'How to make your life seem awesome on Facebook' (2012), a group of social-networking users named the first step in the process 'Give your photos plastic surgery'. This might include reworking your 'breasts, stomach, arms and legs' in Photoshop or modelling yourself on a celebrity whose body is 'better, sharper, more refined'. The article imagines that the pleasure of such doctoring stems from the presentation of the altered pictures to your Facebook friends as evidence of a 'better you'. Digital cosmetic surgery, in other words, can allow the 'lonely loser' to create a 'better life', one defined by socially normative beauty, populated by 'cool' friends and visually devoid of any psychological distress or disease. The ubiquity of such messages in the environment of Web 2.0 suggests that digital doctoring is as conventional as it was in the nineteenth century but, significantly, now lies in the hands of everyone.

The Results Don't Lie

So what does all of this doctoring add up to when it comes to understanding photography's relationship to truth, beauty and self-image in the digital age? First, we must acknowledge the ways in which the digital manipulation of a photographic portrait can be imagined in American public discourse as a substitute for, and hence conceptually equivalent to, surgically altering a living body. The personal narratives in *Photoshop Cosmetic Surgery* make this equivalence explicit; most of the correspondents quoted in the book write to Dr Jackson for his 'expert' advice because they are considering going under the knife and end up receiving a Photoshop tutorial. Never is the strangeness of this result acknowledged in the text, other than through the book's lightly comic frame; in fact, patients and readers alike are encouraged to see the doctor's virtual procedures as a logical substitute for, even an improvement upon, the 'real thing'. Rather than disrupt this fantasy, insistent claims in the popular press that changes to one's digital photographs are not indicative of changes to one's 'actual' body can likewise be read as promoting it. In the case of the *Miami Herald*'s comments on the Kate Winslet scandal, the newspaper's mention that a click of the mouse can make 'unwanted pounds magically melt away—*from your photographic image, that is*' (Pitts 2003) registers the fact that the digitally doctored photograph is imagined to be coextensive with the physical body, despite its apparent hypermediation. We find that a similar process takes place through the convergence of vernacular photo-doctoring and social networking. Warnings that you should not 'mess with facial features' or 'go to extremes' when creating a 'new' you in Photoshop suggest a commitment of sorts to associations among the body, the digital photographic image and claims to truth. The assumption of such warnings is that you would be met with surprise and disappointment outside of the virtual space if the 'Facebook you' and the 'real you' appear wildly incongruous.[5]

What has been largely unacknowledged in current scholarship is the challenge that these scenarios pose to theories of image revolution, which

see the advent of the digital as (adversely) affecting photography's relation-ship to the real. The idea of digital cosmetic surgery obviously does not deny that doctored photographs are the products of intention and tech-nological intervention. But is it fair to say that 'digitization abandons even the rhetoric of truth', as Geoffrey Batchen once put it, when Photoshop becomes the medicine of choice for subjects who seek body-altering pro-cedures (Batchen 2001: 134) or when Pascal Dangin uses 'virtual plastic surgery' to create a 'believable look' on the photographic body of a model who has already gone under the knife? Can we further mourn the loss of the traditional hallmark of photography's authority – the idea that the referent adheres to the photographic image – when medical metaphors for digital manipulation guarantee the existence of a true and natural body in the untouched photograph? What, after all, does Kate Winslet's outrage at *GQ*'s liberal doctoring do if not confirm the indexicality of her (digital) 'before' portraits or photography's status as a sign of the real before medicalized intervention? To look at it in a different way, why would Winslet need so vehemently to protest the operations performed on her photographic body if digital technologies have indeed caused the image's referent to become 'unstuck', as William J. Mitchell claimed? Wouldn't *GQ*'s readership assume that its illustrations are ontologically severed from the bodies they represent and therefore never mistake them for Winslet 'as she is'?

The medium of photography has hardly lost its perceived truth-telling capacity in other forms of American makeover culture, in which photographs routinely make visible individuals' desired body images. Digital photographic 'previews' of post-operative bodies are routinely represented on medical-makeover television shows as the most reliable indicators of surgical results, much as they are in the consultation rooms of American plastic surgeons. Subjects even rely heavily on photographs of their favourite celebrities to guide the transformation of their own bodies. In no case do they (or the show's producers) openly question the veracity of these images, which have almost certainly been digitally doctored. The fetishized photographs are

simply presented *as* Brad Pitt, Pamela Anderson or Jessica Simpson – real bodies to emulate.

This surprising yet persistent restoration of faith in photographic truth within discourses of digital manipulation may explain some of the strong public reactions generated by the new doctoring tools built into digital cameras. In 2006 Hewlett-Packard (HP) introduced a 'slimming' feature to some of its digital cameras marketed in the United States so that snap-shooters could 'instantly trim off pounds' from their subjects by adjusting a filter in the camera (Jasella 2006; HP 2007). Americans can also use the Beauty Retouch Mode in the newest models of the Panasonic Lumix to reduce the appearance of wrinkles, whiten teeth, adjust skin tones and 'virtually make up' faces (Panasonic 2012). Both HP and Panasonic have thus capitalized on a growing American market for self-doctoring. Significantly, this practice can now occur before an image even leaves the camera; it can take place *during* shooting. This reduces the time and labour – in a word, the *mediation* – evident in the manipulation of a photograph, thus making it possible for a 'false' image to appear 'true'. One blogger pointed to this problem by asking: 'Is there soon going to be a time when we literally will never see images of people (even ourselves and our family and friends) as we truly are?' (Parker 2011). Her assumption, of course, was that the digital photograph can *still* speak the truth in vernacular culture. Ironically, HP echoed that assumption in marketing its built-in slimming feature, reminding consumers that the camera adds ten pounds to a figure, and that is only what their feature aims to remove.

Increasingly part of Americans' everyday experiences, the practice of 'retouching yourself' sheds new light on our understanding of digital photography as a democratic tool and an expression of agency. We have seen how the wide availability and relative ease of doctoring can generate feelings of pleasure in individual (and typically female) users who want a 'better' self. As one author of an online photo-editing tutorial put it, 'I love digitally editing photos in a way that would create a similar look to having cosmetic surgical procedures performed. I like the artistic aspects. I like to

see what I'd look like skinnier. I like to see if I could ever get confused with someone who has great skin' (Miller 2009). Marketing for websites and smartphone applications equipped with virtual plastic-surgery tools associate a similar set of good feelings and personal choice with the doctoring of one's own photographs, claiming that a user will feel 'empowered to make more informed decisions' about her body and create a self-image that is right for her (Pixineers 2011). When using these tools, however, we are reminded that the body images they facilitate are never of an individual's own design. Rather, like cosmetic surgical operations themselves, they adhere strictly to an ideal cultural norm that can generate painful feelings of inadequacy and difference in any subject.[6] What is more, the sense of individual interaction with and control over digital operations can be quickly lost, as one click too many or the slightest slip of a finger on a touchscreen can produce grotesque changes that would surely translate into life-threatening results.

Attending to the convergence of digital portrait photography and cosmetic medicine in American culture thus poses important challenges to both the prophets and critics of the digital revolution. Doctored photographs of bodies can speak the truth at the same time as they can offer fleeting illusions of agency to those who produce and consume them. Likewise, new images of made-over selves are generating optimism and rekindling anxieties in a nation that sees itself as requiring continuous reconstruction – one pixel at a time. While we cannot predict how these tensions will unfold, history suggests that the photo doctor and the doctored photo will remain at the centre of critical questions about the pleasures and politics of photography.

ACKNOWLEDGEMENTS

Selections of this text first appeared in Sheehan 2011. I am grateful to Charlotte Alter, Geoffrey Batchen and the editors of this volume for their help with the research and writing of my essay. Thanks also to Jesse Rosten for providing still images from *Fotoshop by Adobé*.

NOTES

1 Rosten's mock commercial almost immediately received comment from the *Huffington Post*, *Adweek*, *National Lampoon*, *Scientific American*, the UK's *Daily Mail* and *Telegraph*, and many other online publications. In February 2012, the trade magazine *APhotoEditor* also posted an extended interview with Rosten about the project. See <http://www.aphotoeditor.com/2012/02/15/> (15 February 2012), accessed on 13 April 2012.

2 For a discussion of digital doctoring controversies in the media, see Batchen 2001: 128–43; Mitchell 1992; and Ritchin 2009.

3 The public display of studio photographs before and after retouching was rare in nineteenth-century America. Other examples include Ourdan 1880: frontispiece; and Anderson 1872: photographs 1–4.

4 Urban Dictionary defines the 'Photoshop diet' as the 'banishment of unsightly fat by image manipulation'. See <http://www.urbandictionary.com>, accessed on 13 April 2012.

5 Murphy and Jackson (2011) have likewise pointed to an investment in 'truth' within the 'love your body' discourse associated with advertising campaigns like Dove's. They note that the 'double emphasis on the body being both unclothed and unretouched in the "body love images" is often aligned with statements about "baring" the "truth" about the body'. Such statements indicate that 'a particular kind of image of the body can tell the entire truth of that body, or that reality is wholly available via the image' (2011: 24).

6 For debates on women's agency and cosmetic surgery, see Jones 2008 and Davis 1995.

BIBLIOGRAPHY

American Medical Association (2011), *AMA Adopts New Policies at Annual Meeting*, [online] <http://www.ama-assn.org/ama/pub/news/news/a11-new-policies.page>, accessed on 13 April 2012.

Anderson, E. (1872), *The Skylight and the Dark-Room: A Complete Text-Book on Portrait Photography*, Philadelphia: Berman and Wilson.

Batchen, G. (2001), *Each Wild Idea: Writing, Photography, History*, Cambridge, MA: MIT Press.

Baylis, G. (2008), 'Remediations: or when is a boring photograph not a boring photograph?' *Photographies*, 1(1): 29–48.

Bolter, J.D., and Grusin, R. (1999), *Remediation: Understanding New Media*, Cambridge, MA: MIT Press.

Collins, L. (2008), 'Pixel perfect: Pascal Dangin's virtual reality', *New Yorker*, 12 May.

Daly, T., and Asch, D. (2006), *Digital Photo Doctor: Simple Steps to Diagnose, Rescue, and Enhance Your Images*, Pleasantville, NY: Reader's Digest Association.

Danziger, L. (2009), *Pictures That Please Us*, [online], <http://www.self.com/magazine/blogs/lucysblog/2009/08/pictures-that-please-us.html>, accessed on 13 April 2012.

Davis, K. (1995), *Reshaping the Female Body: The Dilemma of Cosmetic Surgery*, New York: Routledge.

Dawber, M. (2005), *Pixel Surgeons: Extreme Manipulation of the Figure in Photography*, London: Octopus Publishing Group.

Economist (2011), 'Digital retouching: physical implausibility', [online], <http://www.economist.com/node/21540433>, accessed on 13 April 2012.

Fixarphotos (2012), *Digital Cosmetic Surgery*, [online], <http://www.fixarphotos.com/blog/hello-world>, accessed on 13 April 2012.

Heller, D. (2007), *Makeover Television: Realities Remodelled*, New York: I.B.Tauris.

Hewlett-Packard (2007), *HP Splashes into Summer with Hot New Products to Capture and Print Memories*, [online], <http://www.hp.com/hpinfo/newsroom/press/2007/070621xa.html>, accessed on 13 April 2012.

Jackson, B. (2006), *Photoshop Cosmetic Surgery: A Comprehensive Guide to Portrait Retouching and Body Transforming*, New York: Lark Books.

Jesella, K. (2006), 'The skinny something to smile about', *New York Times*, 22 October.

Jones, M. (2008), *Skintight: An Anatomy of Cosmetic Surgery*, Oxford: Berg.

Kember, S. (1998), *Virtual Anxiety: Photography, New Technologies, and Subjectivity*, Manchester: Manchester University Press.

Lister, M. (1995), 'Introduction', in id. (ed.), *The Photographic Image in Digital Culture*, New York: Routledge: 1–28.

Manovich, L. (2000), *The Language of New Media*, Cambridge, MA: MIT Press.

Miller, E.V. (2009), *Photo Editing Tutorial: Digital Cosmetic Surgery*, [online], <http://voices.yahoo.com/photo-editing-tutorial-digital-cosmetic-surgery-3534967.html?cat=15>, accessed on 13 April 2012.

Mitchell, W.J. (1992), *The Reconfigured Eye: Visual Truth in the Post-Photographic Era*, Cambridge, MA: MIT Press.

Murphy, R., and Jackson, S. (2011), 'Bodies-as-image? The body made visible in magazine *Love Your Body* content', *Women's Studies Journal*, 25(1): 17–30.

Ourdan, J.P. (1880), *The Art of Retouching*, New York: E. & H.T. Anthony and Co.

Panasonic (2012), *Lumix Digital Camera FX80 Retouch Functions*, [online], <http://panasonic.net/avc/lumix/compact/fx80/retouch.html>, accessed on 13 April 2012.

Parker, J. (2011), *The Latest Panasonic Camera – With Built in 'Beauty Retouch'*, [online], <http://www.beautifulyoubyjulie.com/2011/03/the-latest-camera-with-built-in-beauty-retouch>, accessed on 13 April 2012.

Pitts Jr, L. (2003), 'Beauty is not just smaller than life', *Miami Herald*, 31 January, 1B.

Pixineers, Inc. (2011), *iLipo by Aristocrat Plastic Surgery*, [online], <http://www.facetouchup.com/products/medical-mobile-apps/ilipo.html>, accessed on 13 April 2012.

Prince, D. (1868), *Plastics: A New Classification and a Brief Explanation of Plastic Surgery*, Philadelphia: Lindsay and Blakiston.

Rabinovitz, L., and Geil, A. (2004) (eds), *Memory Bytes: History, Technology, and Digital Culture*, Durham, NC: Duke University Press.

Ritchin, F. (1990), *In Our Own Image: The Coming Revolution in Photography*, New York: Aperture Foundation.

—— (2009), *After Photography*, New York: W.W. Norton.

Robins, K. (1995), 'Will image move us still?', in Lister, M. (ed.), *The Photographic Image in Digital Culture*, New York: Routledge: 29–50.

Rojek, C. (2004), *Celebrity*, London: Reaktion Books.

Sheehan, T. (2011), *Doctored: The Medicine of Photography in Nineteenth-Century America*, University Park: Pennsylvania State University Press.

Snelling, H.H. (1872), 'To touch or not to touch; that's the question', *Philadelphia Photographer*, 9(104), August: 300.

Thorburn, D., and Jenkins, H. (2003), *Rethinking Media Change: The Aesthetics of Transition*, Cambridge, MA: MIT Press.

Unilever (2012), *The Dove Campaign for Real Beauty*, [online], <http://www.dove.us/Social-Mission/campaign-for-real-beauty.aspx>, accessed on 13 April 2012.

Urban Dictionary (2012), [online], <http://www.urbandictionary.com>, accessed on 13 April 2012.

Vogel, H. (1875), *The Chemistry of Light and Photography*, New York: D. Appleton and Co.

von Amelunxen, H., Iglhaut, S., and Rötzer, F. (1996) (eds), *Photography after Photography: Memory and Representation in the Digital Age*, Amsterdam: G + B Arts.

Weber, B.R. (2009), *Makeover TV: Selfhood, Citizenship, and Celebrity*, Durham, NC: Duke University Press.

Wegenstein, B. (2012), *The Cosmetic Gaze: Body Modification and the Construction of Beauty*, Cambridge, MA: MIT Press.

wikiHow.com (2012), 'How to make your life seem awesome on Facebook', [online], <http://www.wikihow.com/Make-Your-Life-Seem-Awesome-on-Facebook>, accessed on 13 April 2012.

Willis, A.-M. (1990), 'Digitisation and the living death of photography', in Hayward, P. (ed.), *Culture, Technology, and Creativity in the Late Twentieth Century*, London: John Libbey: 197–208.

10

Virtual Selves:
Art and Digital Autobiography

LOUISE WOLTHERS

Self-imagery is everywhere. The possibilities for experimenting with visual autobiography in everyday culture – from total exposure to edited profiles – have exploded with mobile technologies and new means of digitizing and archiving older analogue photographs in online albums and blogs, on Facebook, Twitter, and so on. Along with, and possibly as an effect of, the increasing digital image circulation, a remarkable number of artists have, particularly since the 1990s, insisted on the value of pre-digital imagery and other traces of the past. Their renegotiation of history and historical sources has come to be known as the 'archival turn' (see, for example, Enwezor 2008; Danbolt, Rowley and Wolthers 2009). Here, as has been manifested in numerous exhibitions and theoretical writings, artists have turned to vernacular, visual, ephemeral and fictional archives in order to construct alternative biographies of the self and others. Now that digital photos are also rendered 'historical' and being archived together with digitized analogue snapshots, new potentials for reinterpreting historical sources and narratives have emerged. This article takes its starting point in the context of contemporary art that explores the biographical potentials of digital archives.[1]

In the following I shall present two innovative multimedia projects: *Reverb* (2004) by American artist Lorie Novak, and *AutoBiography* (2011)

by Danish artist duo Anders Bojen and Kristoffer Ørum. Both works refer to the current everyday use, and even overflow, of digitized imagery but they establish multilayered archives that evoke the performative power of photography. The two installations digitally employ analogue snapshots as well as historical photographs combined with audio narratives in order to explore the possibilities for self-representation and the genre of autobiography. In my reading of the pieces, I will argue that while the current tendencies constantly to upload, alter and expand self-imagery in everyday digital culture may be seen as a symptom of an individualist society of free-floating consumers, the virtuality of digital archives also offers productive encounters. In my interpretation the two artworks form virtual 'auto/biographies' that surpass the subjectivity, control and reality of the individual and enable a meeting point with the other.[2] Respectively, *Reverb* and *AutoBiography* multiply the autobiographical while deconstructing the idea of both author and authority. Through a strategy of de-individualization, the installations challenge the concept of autobiography as 'self-life-writing' as well as the conventional distinction between, on the one hand, (analogue) photography/ body/reality and, on the other, text/mind/imagination. Whereas Bojen and Ørum specifically employ digital random technologies from the point of view of the author/narrator, Novak makes use of digital modes of looking to address the act of reading/viewing. However, that analogue photographs comprise the original material in both works indicates to me that digital technologies do not mark a radical new shift in the construction of 'auto/ biographies', but rather that the digital and the analogue are intertwined in the practices of editing, handling, telling and performing of the self (see, for example, Rosen 2001).

The title of Bojen and Ørum's *AutoBiography* already indicates a strategy of automatization. The installation combines a vast collection of digitized private snapshots from the artists' and their families' albums with sound and multiple smaller, semi-transparent screens hanging from the ceiling.[3] Strangely fragmented biographies unfold in the projection of a slide show of family snaps accompanied by a neutral, computerized voice describing

Bojen's or Ørum's personal development. Bojen and Ørum have designed a computer program that chooses various facts about their pasts and inserts them into the popular system of developmental stages formulated by the psychologist Erik Erikson around 1950. The result is an unsettling automatic narrative where the two artists' autobiographies are merged into what I shall describe here as virtual biographies.

Lorie Novak also establishes an expanded virtual autobiography in her installation *Reverb*.[4] A large projection takes the viewer through an archive of Novak's private photos as well as pictures from history revolving around different conflicts, from feminist and civil-rights protests and activism through the 60s and 70s to the Holocaust, nuclear bombs, the Iraq War and 9/11 in New York City. A specially designed technique makes the images flow and dissolve into one another, inserting the artist–subject in a wider political and historical context. The visuals are accompanied by random audio fragments from online audio archives, which are complemented daily by a live online news feed at the exhibition. By inscribing herself visually into the cycle of historical events and the way in which they are presented in the media, Novak depersonalizes her own history. 'Reverb' or a reverberation refers to the persistence of a sound as an echo; similarly it is the virtual echoing of photographs that narrates the subject and, as I shall argue, calls for an ethics of spectatorship.

Narrating the Self Photographically

Autobiography literally means 'self-life-writing' and is by convention a literary genre. It is a narrative constructed around intersectional elements like memory, identity, experience and embodiment – all of which are part of different socio-historical contexts (Smith and Watson 2002: 9). Furthermore it is essentially intertextual (Stanley 1992: 14). However, writing is not the only medium suited for autobiography: photography is also employed in autobiographical narratives, particularly as a trigger of memories or as an

indexical anchor in a physical world (Rugg 1997; Adams 2000; Jay 1994; Stanley 1992). Roland Barthes's *Camera Lucida* is a key work here, and his book *Roland Barthes by Roland Barthes*, which reflects on the very genre of autobiography, contains photographs of the author's childhood and family.

'Autobiographical photography' covers various kinds of imagery of the self, from deliberate autoportraiture to a life's archive of snapshots from vacations, holidays, and so on. In a written autobiography the author is editing and controlling a public self-image. Similarly, in autoportraits the sitter will try to control the appearance; however, pictures have a power to alter the self-image. As Susanna Radstone notes: 'Autobiography shapes the subject,' by which she means that the subject is textually constituted (Radstone 2000: 203). Likewise the subject is visually constituted in personal image archives that are at once unique and conventional, themselves 'interpictorial', shaped by traditions and contemporary contexts. This too is obvious in the employment of snapshots in *AutoBiography* and *Reverb*.

In *Camera Lucida* Barthes reflects on the need for a profound self to coincide with a frustratingly mobile self-image, yet he realizes that 'it is the contrary that must be said: "myself" never coincides with my image; for it is the image which is heavy, motionless, stubborn (which is why society sustains it), and "myself" which is light, divided, dispersed' (Barthes 1982: 12). Barthes was aware of the play and interchange between 'self' and image. For him, there is no profound fixed subjectivity as a true origin for the image; rather the photograph, or the photographic act or performance, also creates the self. Ideas about the 'light, divided, dispersed' self are echoed in post-modern thoughts about the 'liquidity' of subject and culture, where the image has turned digital and thus itself seems to be in constant motion.

Current everyday amateur practices of digital self-imagery allow for visual experiments with free-floating identities, which reflect critiques of the post-modern subject as ahistorical as well as apolitical. Not being fixed in any 'real' context, its social relations have become 'liquid', unfixed and thus interchangeable, which goes hand in hand with global capitalism and consumerist liberalism (see, for example, Baumann 2000). In his influential

article on domestic photography and digital culture Don Slater (1995) argues that contemporary private snapshot practice has moved from time-bound representations to digital self-*presentation*. He views this presentism, as we might call it, as a symptom of the commodification of time: 'In a developed consumerism, the image is the way we present ourselves in the heat of the moment rather than the way we represent that moment as an object of reflection' (Slater 1995: 140). Following Slater, *Reverb* and *AutoBiography* can each be seen as a pinboard or photographic wall, which he uses as metaphors for the contemporary use of domestic photography beyond the traditional album: it 'evokes a haphazard, ephemeral and shifting collage which is produced by and within the activities of the present' where the photograph 'takes its place within a flow of other images' (Slater 1995: 139).

Going back to Barthes, he described the photographs of him and his family that were printed in *Roland Barthes by Roland Barthes* as belonging to his 'image repertoire'. Apart from short captions serving as content anchorage, these images present a purely pictorial narrative of the part of his autobiography that relates to the body and its prehistory (genealogy) – what Barthes calls 'the unproductive subject' (Barthes 1977). The biography of the 'productive' adult writer, however, has to be narrated by text. In other words, the writing repertoire, which in the book is fragmented like textual snapshots and told in the third person, surpasses the image repertoire. As Shawn Michelle Smith (2009: 250–1) writes on *Roland Barthes by Roland Barthes*:

> Here, then, photographs represent the domain of the discrete, auto-biographical, ultimately unproductive self, while writing represents the domain of the self that is liberated from its private definitions and made productive. The photograph adheres one to a body; the written text only to an abstract signifier.

This distinction between (analogue) photography, as something linked to the body and the physical world, and writing, as being a product of the

mind and thus potentially of the imagination, dissolves when digital image repertoires become sources for auto/biographical works.

Digital images are arguably not dependent on the indexical trace of light, but rather they are 'written' numeric images. 'The original sin of photography is light. The original sin of the digital image on the other hand is language,' Philippe Quéau writes.

> In reality the digital image is an abstract numerical image which can be altered at will. Given this fact, digitization opens up great possibilities which will doubtless change our way of seeing images, forcing us more and more to read them. (1996: 110)

Of course semiotics has shown that photography is always already a language too, but the digitization processes can be said to liberate photography's conventional role in autobiography as an anchorage in physical reality.

What then seems to be the challenge – often perceived as a threat – when digital imagery enters autobiography is a destabilization of the self and the idea of an inherent subjectivity. Sarah Kember describes these fears as 'virtual anxieties' over the loss of a dominant investment in the photographic real, which can also be said to be true of an idea of an autobiographic real (Kember 1998). But, as Kember reminds us, we need to think beyond such technological deterministic anxieties and instead explore the performative possibilities of digital mediations. Working with digital processes, Novak and Bojen and Ørum anchor the analogue photographs in virtual contexts that, rather than either extreme self-loss or extreme self-presentation, foster auto/biographies as encounters with the other.

In the following I see *Reverb* and *AutoBiography* as indirect problematizations of mechanisms of a post-modernist, hyper-individual and all-consuming digital culture. More importantly, however, the two works establish a strategy of critical, reflective 'de-individualization' in order to offer virtual biographies, where the virtual does not connote something 'un-real' (and thus completely devoid of context, historicity and responsibility), but

rather a Deleuzian or Bergsonian potential for expanding the ways in which we regard our own past and that of others (Grosz 2005: 105 ff.).

Game of Life

AutoBiography is a play with subjectivity and image repertoires in an endlessly varied narrative, which can be seen as a mimicry of the constantly circulating self-images in current digital culture. Furthermore, in applying automatic processes to the visual narration, Bojen and Ørum's 'memory machine' takes this play far beyond the realm of the individual.

Born in the 1970s, where amateur cameras and the snapshot practice had become an integrated part of most families, both artists have access to a great number of private snaps from their whole lives. The scanned photos from Bojen and Ørum's individual lives are united in a new, vast digital archive that serves as a source for the computerized tale of two – or rather multiple – identity formations. Due to photographic and cultural conventions, most of the snapshots, shown as slide shows on two large, overlapping wall projections, will trigger a degree of recognition in viewers. Interiors and styles of everyday clothes, furniture and kitchenware, as well as the slightly faded, grainy quality of the pictures themselves, are all signs of a certain time and place. But several disturbing factors are inserted into this three-dimensional album. Moving around in the installation, the viewer's ability to create a coherent meaning out of the pictures is blocked. First and foremost in a quite literal way by the almost monochrome colour screens hanging from the ceiling. Screens in front of screens are slowly turning and reflecting off one another just as the light from the projected images is reflected in the screens. The colours on these small screens are derived from the shades and colour schemes of the snapshots, thus extending the photowall into the space.

The soundscape is an abstract monotone sound of a sine wave and a computerized voice narrating biographies of 'Anders' or 'Kristoffer'.[5] Rather

10.1–3 Anders Bojen and Kristoffer Ørum: *AutoBiography*, 2011.

than a continuous story it consists of short informative sentences, at once personal and general. For instance: 'In the beginning of the Nineties Anders' personal development stopped // During this time Anders had trouble finding his place in the world and gaining independence // Anders never liked the local school; he often got into fights and skipped school a lot.'[6] All the elements are operated by a computer program that juxtaposes each scanned snapshot with an appropriate narrative. As a whole the installation feels like a dark, abandoned archive in a near future, where the only traces of human life are projected snapshots.

The oddness of the factual narrative increases as certain inconsistencies gradually emerge and names and facts reappear in new constellations while seemingly repeating a structural pattern. Consequently any aura of authenticity in the snapshots is challenged, and it turns out that the biographies are constructed according to the popular principles of identity formation in society first laid out by psychologist Erik Erikson (1902–94). He not only

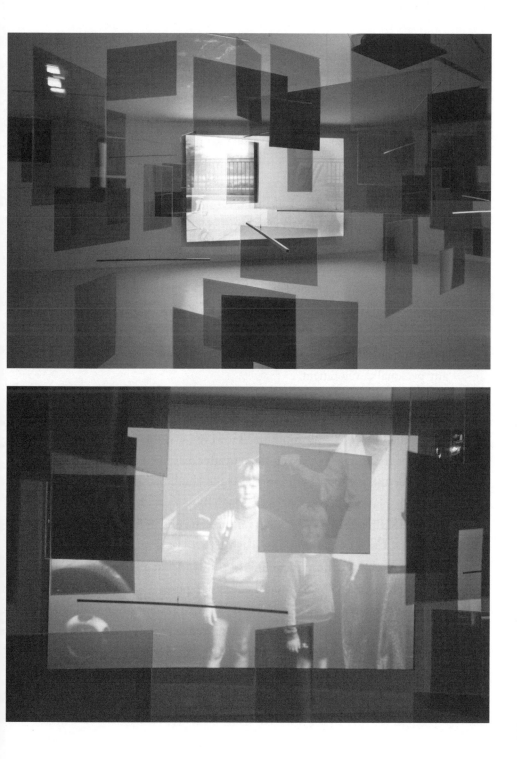

described the psychosocial development of a child but also created a system of eight stages in the lifespan of every individual. Each stage is defined by a conflict, for instance between trust and mistrust, initiative and guilt. It is the constructive resolution of these conflicts that make for a healthy development and result in eight 'virtues' or 'potencies'. An example of one such virtue resulting from the successful resolution of the conflict 'trust and mistrust' is hope.[7] By organizing their autobiographical notes according to Erikson's stages of conflict, Bojen and Ørum's subjective memories as well as their private photographs are objectified in a general system. The artists have collected anecdotes from each of their respective childhoods, focusing on moments of crisis in order to mimic the theory of development. The conclusions are either positive ('in spite of this, Anders had a safe childhood') or negative ('this made Kristoffer's first years very unstable').[8] What initially seems to be a satirical strategy forces the artists to focus on points of discomfort, inviting the viewer to consider the 'scriptedness' of any personal development.

Bojen and Ørum interpret Erikson's stages as a kind of game in which the goal is to achieve a virtue (hope, will, purpose, and so on) at each stage before the individual can 'move on'. However, it is the computer program that runs the game in selecting the narrative, based on a range of possible sentences and pictures. For example, at the childhood stage the computer randomly chooses 'Anders' or 'Kristoffer', 'Bojen' or 'Ørum', from a selection of 18 different first sentences followed by one of 33 different second sentences. Correspondingly, the image repertoire is treated more as 'text' or words without the indexical link to reality. All in all, the project holds 3–4 million potential psychosocial autobiographies. The single statements about 'Anders' or 'Kristoffer' are factual, but their juxtaposition with images and other sentences before or after the narrative creates a new 'truth'. The program always generates new versions of virtual biographies: not entirely 'real' but also not unreal. This corresponds to cultural theorists Antony Bryant and Griselda Pollock's descriptions of the word 'virtual' as a contranym, meaning both 'not really existing' and 'almost the same'. As they state, in

virtual reality 'users are "fooled" into thinking and experiencing things, environments, and interactions that do not have any material existence. This is not the same thing, however, as saying that they are not real; on the contrary, virtually generated experiences can be all too real in their effects' (Bryant and Pollock 2010: 11). The artists reveal their own image repertoire, but they are 'fooling' the system as well as the spectator by creating a fictive genealogy. The subject positions 'self', 'mum', 'dad', and so on, are interchangeable and fluid. This becomes obvious when we look 'behind the scenes' at the organization of the image archive from which the computer program chooses.[9] Here we find two 'mums', 'dads', 'selves' in each category, a result of the compilation of both artists' family snaps.

In the database we also find a category marked 'random' with seemingly failed shots of the kind that were common in amateur photography before digital cameras, including strange croppings and motifs that are impossible to decipher. According to the artists, one of their families owned a camera of poor quality that often produced unintentional pictures, while there were several photo enthusiasts in the other family who would create more intentionally informative and better-composed pictures.[10] The failed or simply strange photos allow us to focus on details like gestures, clothes and furniture or on non-figurative elements. One of the many subtly fascinating random photographs is one where the intended motif seems to have been three children whose coats and hoods are just visible within the edges of the picture frame. Maybe they have all been visible in the viewfinder on the (possibly 'bad') camera, but not on the actual negative. Instead the larger part of the picture is the clear blue sky, framed by the straight lines of a green building and a dark wooden fence. The three figures – red, yellow and blue – are of different heights and, we may assume, different ages. They could be read as referencing different stages in Erikson's theory of psychosocial development. Furthermore, they remind one of pieces in a board game, reflecting how *AutoBiography* follows a route or a pattern, a cycle of life. But the photograph almost resists any such figurative reading in its near abstraction. The picture is first and foremost made up of

primary colours and shapes (circles and squares): in other words, abstract colour fields, which correspond to the colour screens hanging from the ceiling in the installation. Just as this random, involuntary picture obscures a figurative reading, the mobile screens block the audience's view of the big projections and symbolically prevent us from establishing a coherent realistic narrative.

AutoBiography is full of such images that punctuate the narrative, which also contains internal markers of *Verfremdung*: the pseudo psychological lingo is at once comical and disturbing when combined with the depersonalized voice. The voice both describes and evaluates: for instance, 'Anders spent a lot of time trying to find a place in a community and to become independent' (Bojen and Ørum 2012: 2) and 'The many travels in Kristoffer's childhood helped him learn to take initiatives, which he still does to this very day' (Bojen and Ørum 2012: 4). Particularly unsettling is the profiling tone stating how events in childhood determine the personality of 'Anders' today. It indicates that 'Anders' is gradually being programmed to perform in certain ways later in life. Whereas in the beginning the snapshots might be read as proofs of this narrative – 'this is how it was' – the repeated, slightly altered biographies reveal themselves to be out of control. The combination of incoherent, fragmented and contradictory sentences and photos deconstructs Erikson's system in a clever mimicry, which further satirizes ideal biographies or narratives of perfect families or selves, in public online albums for example. I see the work's strategy of de-individualization as part of a general critique of the increasing, narcissistic quest for self-development in today's high-performance capitalist culture. *AutoBiography* is much more than ironic play with fictive selves; rather, there is a genuine vulnerability in letting external mechanisms edit and programme the complete private archive of snapshots and events, which includes disruptions, failures and fragile moments recognizable to the viewer. The piece reflects a willingness to let the incomplete self be seen beyond voluntary self-imagery and edited profiles and to let an auto/biography be told out of the author's control.

AutoBiography refers to dystopias and utopias of imagining the self in current digital culture, but the piece itself moves beyond technological determination or fetishism by pointing to what photographs – both analogue and digital – actually do in 'self-life-writing'. Echoing Don Slater Hubertus von Amelunxen compares digital pictorial montage to a puzzle, writing that 'its individual parts are now being allocated to each "player" to be formed as he or she wishes, whereby the target image too is affected by a technical process determination [...] Thus digitisation offers us new kinds of image spaces in which the possibilities of modulation are limited by arithmetic alone and in which the links with reality can be shifted arbitrarily' (von Amelunxen 1996: 118). Slater's notion of the self-image as being produced within activities of the present and in a constant flow of images is also mentioned by sociologist Celia Lury. Following Slater, Lury (1998: 84) claims that now 'the individual can discard old selves, try on personae and compare the multiplicity of subject-effects of retrodictive self-transformation'. This means that the 'experimental individual', as she terms it, may be dissociated from his or her biography, but may then as an artefactual person acquire a prosthetic auto/biography. In the case of *AutoBiography*, I propose using the concept of virtual biography. The 'virtual' here alludes to Deleuze's reading of Bergson, in which virtuality is productive and connotes actualization. Accordingly, virtuality refers to what could become actual but is as yet unrealized, a potential. This is a movement of becoming: as Elisabeth Grosz (2005: 15) explains, 'virtualities are real (in the past) and may be actualized in the present and future.' In the realm of virtuality, new narratives of the self that might not have been told before can be discovered.

Reverberations in Time

Lorie Novak's *Reverb* also works in the virtual sphere of an extended autobiography in which the self encounters (images of) others. The piece employs computer technologies in the creation of a filmic montage of photographs

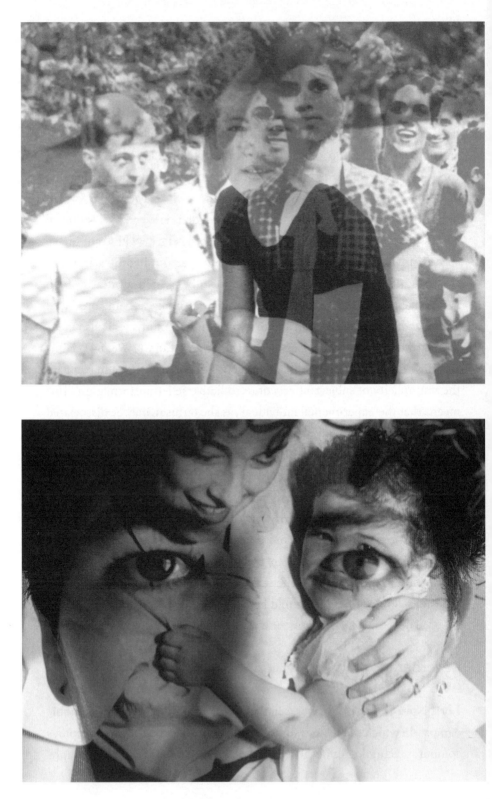

10.4–5 Lorie Novak: *Reverb*, 2004.

from a wide range of contexts that are anchored in the auto/biographical I. In earlier works Novak examines the communal potential in image sharing by way of dissolving the private pictures – and thus their 'privacy' – into a flow of multiple autobiographies (Novak 1999). A similar strategy is employed in *Reverb*, where pictures from Novak's image repertoire, including recent self-portraits, are merged with pictures from cultural history, particularly of conflicts and atrocities. The approximately 200 photographs fade into one another: some at a slow pace, appearing as double exposures, others as rapidly changing flashes. The most violent pictures of victims of war and torture are shown flickering at an increased speed. This visual rhythm reflects different ways of encountering imagery: from online surfing to the time-consuming handling of personal analogue archives.

One image section begins with a family snapshot, continues to a hand holding a picture of the artist as a child, then on to a picture of a hand holding a colour slide, to another hand holding a black-and-white portrait, finally ending with a woman holding a picture of Ayatollah Khomeini. So 'touch' – photographs touching and touching photographs – is a recurrent motif. The pictures are made to 'touch' each other, which is precisely facilitated by digital and computer technologies. Childhood photos of Novak herself dissolve into the well-known school or studio portraits of Anne Frank. Part of the artist's autobiography is thus linked to a Jewish heritage, while another is linked to women's history. The piece holds both a profound feminist undertone and a demand to look responsibly at injustice and atrocity. In other words, the dynamics of looking at (past) imagery are explored with the ethical claim of an embodied spectator.

Similar to the image content, the randomized sound collage of internet audio fragments is predominantly focused on issues of conflict, protest, war and trauma. A person talks about the power of images, another about personal injuries, and we begin to recognize the voices of Thatcher, Blair and Bush. There are accounts of specific events like the first African Americans to sit at a whites-only lunch counter in 1960, the riots following the Rodney King beating and 9/11. Novak thus investigates the dialectics between word

and image. The verbal narrative, which is traditionally given the authority to determine historical meaning, is always changing and out of sync with the visual narrative. *Reverb* works as a cycle, indicating how minority and majority positions as well as power positions are constantly shifting. Today's conflict between Israel and Palestine seen in relation to the Holocaust is an example of this cycle, which also functions on a metalevel of writing histories and biographies.

Hands and faces are focal points in the work and refer to the act of seeing and touching the other. Another image section shows the eyes of the artist dissolving into herself as a child and then into an image of 15-year-old Dorothy Geraldine Counts, who in 1957 was one of the first three African American students to attend a previously all-white high school in Charlotte, North Carolina. When images from different historical contexts in this way touch and overlap, new virtual contexts emerge that in my interpretation offer political and ethical depth to traumatic imagery – contrary to, for instance, Susan Sontag's legendary critiques of fragmented photography. In *Reverb*, not only the artist is immersed in the flow of images, sounds and all their historical contexts, but the viewer too is overwhelmed by the mass of information. There may be some recurrent themes (women's liberation movement, civil rights, US imperialism) that are anchored in Novak as narrator, but some of the pictures also sink their 'hooks' into the viewer, asking us to take part in the event. Even though the cultural events and images are structured around Novak's memories, it is far from a closed autobiography; rather it is collective. As Marianne Hirsch (2002: 258) states: 'For Novak, the autobiographical – both personal and collective – is the political.' This particular self-life-writing is structured on reverberation, and the persistent echoing does not just happen to the self-image but also to the image repertoire from cultural history. So rather than a one-way self-referentiality the performative autobiography allows for a meeting, an intersection or 'interface' (Smith and Watson 2002: 11). Novak is telling this story but is clearly also 'being told' by larger intersubjective histories, and we experience a de-individualized autobiographic display that is beyond the author's control.

'I am interested in the afterlife of images,' says Novak (2012: 283). 'Reverb' thus not only refers to the actual sound in the piece (the voices from history) but also to the 'echoing' of images as reverberations. Digital and digitized pictures have a different afterlife from material photographs, and *Reverb* makes apparent how, for example, online image archives offer new possibilities for preserving and sharing. This again offers a means of empowerment, a new political culture and 'a critically conscious self-representation that could for instance counter the dominant media', as Don Slater hopes (1995: 144). Encountering the 'presentism' of the constantly changing self-images in a digital hyper-individuality, Novak's piece reinserts time, historicity and political contexts into the auto/biographical narrative.

The piece questions the status of knowledge in relation to the intense flow of visual information in current digital culture, which not only affects our knowledge about ourselves (including our self-image) but also our knowledge about the other. As cultural theorist Ariella Azoulay (2008: 24) states:

> The widespread use of cameras by people around the world has created more than a mass of images; it has created a new form of encounter, an encounter between people who take, watch, and show other people's photographs, with or without their consent, thus opening new possibilities of political action and forming new conditions for its visibility.

In order to create a setting for a respectful encounter, Azoulay suggests the term 'contract' as an organizing principle in the gaze between spectator and the photographed persons. Novak's piece evokes a similar claim for an ethical regarding of the other's image, which is highly relevant in the current intense circulation of private and public images on the Web. The visibility and accessibility of images of injustice and atrocities in particular force us to ask whether our 'regarding the pain of others' can actually produce empathy, understanding and knowledge, as Susan Sontag (2003)

questions.[11] Among the violent images are the now iconic snaps from American soldiers torturing prisoners at Abu Ghraib. Sontag (2004) also wrote about those pictures as examples of a shift in the use made of pictures in present digital culture: 'less objects to be saved than messages to be to be disseminated, circulated'. This is both good and bad: 'The pictures will not go away. That is the nature of the digital world in which we live. Indeed, it seems they were necessary to get our leaders to acknowledge that they had a problem on their hands' (Sontag 2004). At the same time we need to take a responsible decision as to what to do with those pictures: 'Will people get used to them?' In *Regarding the Pain of Others* Sontag indicates that the effect of such traumatic imagery prevents the spectator from further understanding. But the flashes of violence in Novak's work are more than merely numbing shocks – they force us to reflect on the affective nature of our gaze.

Discussing some of Sontag's points, Judith Butler (2009) writes about torture and the ethics of photography, that photographs have a strong agency embedded in their structure. Butler refers to Emmanuel Levinas, who also comes to mind in relation to Novak's work with its insistence on the face as a primary site for encountering the other. For Levinas, it is exactly the face of the other that demands an ethical response. Butler (2009: 77) notes: 'it would seem that the norms that would allocate who is and is not human arrive in visual form. These norms work to *give face* and to *efface*.' Furthermore, 'our capacity to respond with outrage, opposition, and critique will depend in part on how the differential norm of the human is communicated through visual and discursive frames' (2009: 77). It is these frames that Novak seems to be looking for, and she asks the same of her viewers. In *Reverb* the most repeated motif is the artist as spectator – looking back at historical photographs and out at the camera, and thus at future spectators. This creates links not only to her own memory but also to a virtual memory enabling a face-to-face encounter with the other's past. In the words of Elizabeth Grosz (2005: 103):

The only access we have to the past is through a leap into virtuality, through a move into the past itself, seeing that the past is outside us and that we are in it. The past exists, but in a state of latency or virtuality.

Novak's at once embodied and de-individualized autobiography may be seen as such a leap into virtuality.

Conclusion

In the current digital culture anybody can reach into the circulation of images and grab fragments of the lives of self and others, which more than ever calls for an ethics of looking and being looked at. We are constantly creating or being inscribed in auto/biographies, where the conventional question of truth has turned into a question of trust (Bryant and Pollock 2010: 9). The endless possibilities may on one hand feed a problematic pursuit for the perfect self-image, but on the other they offer a new means of collective narrative.

Recent works by artists such as Novak and Bojen and Ørum combine analogue photographs and digital technologies in intertextual and interpictorial auto/biographies that surpass the conventional dichotomy between image repertoire and writing repertoire. Furthermore, their works investigate the affect, agency, engagement and means of editing, performing and narrating offered by digitized photographic archives. In the virtual realm the author can relinquish control over the self-imagery and offer herself to the biography of the other.

NOTES

1 In addition to the work of Lorie Novak and that of Anders Bojen and Kristoffer Ørum, this genre of 'virtual biographical archives' also encompasses art projects

by for instance Hasan Elahi, Maria Miesenberger, David Horvitz, Willem Popelier, Penelope Umbrico and Joanna Zylinska.

2 Liz Stanley argues for the term 'auto/biography' since differences between various life writings are not generic (Stanley 1992: 3).

3 I saw the piece installed at Skulpturi.dk in Copenhagen in 2011. Installation shots can be found at <http://www.skulpturi.dk/Bojen_og_orum>. *AutoBiography* has since been shown in New York and Seoul in 2012.

4 *Reverb* was first shown at ArtSway in England. A Web version was commissioned by SCAN; the software was designed by Jon Meyer.

5 The voice is that of the official announcements for Danske Statsbaner (DSB), the Danish railway company.

6 From an unpublished Danish script of computer-edited sentences. All following translations by this author.

7 At an artist talk Bojen and Ørum screened this small introductory film from YouTube, which stresses the popularity and accessibility of Erikson's theory: <http://www.youtube.com/watch?v=PC2G5oFliyk&feature=related>. It contains easily understandable, schematized psychology and is illustrated with stock photography.

8 In the programming, the stages are for instance dubbed 'Bad Toddler' or 'Good Adolescent'.

9 Bojen and Ørum kindly provided me with their digital archive as well as a 'script' of several variations of random autobiographies.

10 Email to the author from Ørum, dated February 2012.

11 Sontag's voice also appears in Novak's sound collage.

BIBLIOGRAPHY

Adams, T.D. (2000), *Life Writing, Light Writing: Photography in Autobiography*, Chapel Hill and London: The University of North Carolina Press.

Azoulay, A. (2008), *The Civil Contract of Photography*, New York: Zone Books.

Barthes, R. (1977; originally published 1975), *Roland Barthes*, London and Basingstoke: Macmillan Press.

—— (1982; originally published 1980), *Camera Lucida: Reflections on Photography*, London: Jonathan Cape.

Baumann, Z. (2000), *Liquid Modernity*, Cambridge: Polity Press.

Bojen, A., and Ørum, K. (2012), unpublished script of computer-edited sentences.

Bryant, A., and Pollock, G. (2010), 'Editors' introduction', in id. (eds) *Digital and Other Virtualities: Renegotiating the Image*, London and New York: I.B.Tauris.

Butler, J. (2009), *Frames of War: When Is Life Grievable?*, London and New York: Verso.

Danbolt, M., Rowley, J., and Wolthers, L. (2009) (eds), *Lost and Found – Queerying the Archive*, Copenhagen: Kunsthallen Nikolaj.

Enwezor, O. (2008), *Archive Fever – Uses of the Document in Contemporary Art*, New York: ICP.

Grosz, E. (2005), *Time Travels: Feminism, Nature, Power*, Durham, NC, and London: Duke University Press.

Hirsch, M. (2002), 'Collected memories: Lorie Novak's virtual family album', in Smith, S., and Watson, J. (eds), *Interfaces: Women/Autobiography/Image/Performance*, Ann Arbor: University of Michigan Press.

Jay, P. (1994), 'Posing: autobiography and the subject of photography', in Ashley, K., et al. (eds), *Autobiography & Postmodernism*, Amherst: University of Massachusetts Press.

Kember, S. (1998), *Virtual Anxiety: Photography, New technologies and Subjectivity*, Manchester and New York: Manchester University Press.

Lury, C. (1998), *Prosthetic Culture: Photography, Memory and Identity*, London and New York: Routledge.

Novak, L. (1999), 'Collected visions', in Hirsch, M. (ed.), *The Familial Gaze*, Hanover: Dartmouth College.

—— (2012), 'Photographic interference', in Batchen, G., Gidley, M., Miller, N., and Prosser, J. (eds), *Picturing Atrocity: Photography in Crisis*, London: Reaktion Books.

Quéau, P. (1996), 'Photo-virtuality', in von Amelunxen, H., et al. (eds), *Photography after Photography: Memory and Representation in the Digital* Age, Amsterdam: G + B Arts.

Radstone, S. (2000), 'Autobiographical times', in Cosslett, T., et al. (eds), *Feminism and Autobiography: Texts, Theories, Methods*, London and New York: Routledge.

Rosen, P. (2001), *Change Mumified: Cinema, Historicity, Theory*, Minneapolis and London: University of Minnesota Press.

Rugg, L.H. (1997), *Picturing Ourselves: Photography and Autobiography*, Chicago: University of Chicago Press.

Slater, D. (1995), 'Domestic photography and digital culture', in Lister, M. (ed.), *The Photographic Image in Digital Culture*, London and New York: Routledge.

Smith, S.M. (2009), 'Race and reproduction in *Camera Lucida*', in Batchen, G. (ed.), *Photography Degree Zero*, Cambridge and London: MIT Press.

Smith, S., and Watson, J. (2002), 'Introduction', in id. (eds), *Interfaces: Women Autobiography Image Performance*, Michigan: The University of Michigan Press.

Sontag, S. (2003), *Regarding the Pain of Others*, London: Penguin Books.

—— (2004), 'Regarding the torture of others', in *New York Times Magazine*, 23 May.

Stanley, L. (1992), *The Auto/Biographical I: The Theory and Practice of Feminist Auto/ Biography*, Manchester and New York: Manchester University Press.

von Amelunxen, H. (1996), 'Photography after photography: the terror of the body in space', in id. et al. (eds), *Photography after Photography*, Amsterdam: G + B Arts.

11

Mobile-Media Photography:
New Modes of Engagement

MICHAEL SHANKS AND CONNIE SVABO

April 2012. Instagram, a free photo-sharing app(lication) for mobile phones, is bought by the social-networking giant Facebook for $1 billion. Instagram is a small Silicon Valley start-up with less than two dozen employees and 30 million users. Their elegant app lets you filter your photos, usually making them look like something taken on an old camera from the 1960s, and share them with friends. The app is typically accessed from an iPhone, the most popular camera on earth. The 16-GB device holds around 15,500 photos and is in the pockets and purses of more than 100 million people. When the app was made available to the Android platform a month earlier, over a million downloads were made in 12 hours. Facebook was not buying into the photo-sharing world. At the time of the purchase over 250 million photos were being uploaded daily by Facebook's 800 million users. But the mobile app for Facebook is clunky; Instagram lets you simply and easily tell visual stories: visuality and mobile presence are the keystones of the online social experience. And Facebook has just bought the memories of those 30 million Instagrammers – thus owning the intellectual property. Each photo is geo-tagged: Facebook can tell what you like, when, with whom, and where – rather useful information for the advertisers that supply its revenue base.

Three months earlier, in January 2012, Eastman Kodak, the 113-year-old pioneer of film photography, the company that dominated the photo world of the twentieth century, inventor of the snapshot and popular photography, filed for bankruptcy.

Mixed Realities: The Intertwinement of Digital and Physical

Media have gone to ground. Media affect the way people make sense of the world, and with the spread of mobile media this power and function is ever more pertinent. Mobile media and ubiquitous computing create mixed and hybrid realities where the digital realm and physical environment are intertwined. The World Wide Web is everywhere: omnipresent mobile phones with inbuilt sensor technologies such as location awareness, Bluetooth and RFID are creating a massive, interconnected real-time digital network. Every bit of digital information can be mapped back to the social and cognitive prosthetic device that we know as a phone (Davis 2012). An aspect of the intertwinement of the physical and digital is that pervasive, multifunctional and internet-capable mobile phones are used for frequent photographic engagements with the everyday. The internet and mobile media devices are translating photography into new media practices in which the production and consumption of media content is accessible to large numbers of everyday users in all sorts of everyday situations and locations.

This evolution of media has, of course, been noted in academic work. A 'spatial turn' has been proclaimed in media studies (Falkheimer and Jansson 2006) and, more generally, in the human and social sciences (Bjerre and Fabian 2010). At the same time there is a reverse orientation towards media and mediation in traditional 'spatial' disciplines such as geography (Adams 2010: 37; Thielmann 2011).

This chapter engages with phone photography. Studies of personal photography, digital photography and camera-phone photography show

that camera-phone photography is a proliferating version of snapshot photography (Van House 2011). The camera is used as a means of personal expression and as a vehicle for the visual documentation of everyday situations, things and places. Camera-phone photography does not radically change the genre, but the multifunctional and ubiquitous device does result in more images of more mundane things.

This kind of personal photography must be seen in relation to the ubiquitous hand-held computing device that the phone is. The camera phone is not only a phone and a camera, but also an internet-capable portable minicomputer that has the ability to transform and disseminate various media formats and modes of communication easily. Mobile media photography operates in heterogeneous flows of linkage and exchange, and making pictures with camera phones is mediated by the pervasive, networked and multifunctional character of phones.

Digital media are conversational in character: they are time-based and in continual flux. This has implications also for photography. Although the image prevails, photography is shifted towards process. Due to the incessant flow of images, photographic activity, the process of documentation and the deflective character of looking are highlighted. Mobile media photography marks a shift in orientation from the image towards photography as a *mode of engagement*. This leads us to explore the *processes* of experience and documentation that mobile media help to constitute. We unfold two aspects of the process of photography: photography as temporal, archaeological engagement, and photography as spatial, geographical engagement. Finally, as a closing perspective we point out that vernacular photography may be read as an intersection between a personal means of expression and corporate financial interest, whereby images that are the output of personal photography, and that people upload and share, are used as trading stock. A comment made by a new-media blogger pinpoints this in relation to Web-based services: 'if it's free, you're the product' (Fannin 2012).

Two Situations of Mobile Media Photography

Imagine a situation where you are having dinner with some friends. At one point somebody pulls out their phone. Maybe they want to show you an image of a child, a friend, a memorable situation. At some point the phone is used to make an image, an image of this situation. This image then, in the moment, is shared. It is sent by MMS, perhaps, to the two other participating friends – who meanwhile are busy with yet another phone. They work on an image of the served meal. The food is filtered in a particularly cool app, and afterwards the resulting image is circulated. It can be seen, saved, commented on or discarded.

11.1 An image of a dinner situation, shared instantly via the mobile media device. The second camera is being used to filter an image which has just been made of a glass of beer and some mussels.

11.2 A glass of beer and plate of mussels worked through the mobile media app Awesomizer. The image is also available at http://archaeographer.com under 'awesomized' (Shanks 2012b).

Imagine another situation… In this situation I am having coffee on the street. I am visiting Stanford for two months, working at Michael Shanks's lab. Seated outside Starbucks on California Avenue in Palo Alto, California, I take a picture of my empty cup, create a blog post called 'caffè latte = paper cup + plastic lid'. The photography is carried out with a used 3GS iPhone, purchased upon arrival in Palo Alto. Information about the location at which the image is made and at what time automatically shows up in the latest addition to my new and first WordPress photoblog. I might have taken a picture of myself and uploaded it to Facebook to share with my family and friends at home. I certainly did make a lot of those kinds of images, but this one was an image of rubbish, uploaded to a

11.3 Cup, plastic lid and paper bag depicted on a blog post from
17 April 2012 in the photoblog 'My American Plasticscape' documenting
the traces of plastic from two months of eating food on the move
http://plasticscapes.wordpress.com (Connie Svabo 2012).

photoblog titled 'My American Plasticscape'. Coming from Denmark for a
two-month stay in the US, one thing that strikes me is the trace of plastic
created by every meal I have while I am on the go. The blog documents the
traces of plastic and other material remains from my eating food on the move.

Personal Photography

Photography has been an integral part of popular culture throughout the
twentieth century, and alongside phone cameras new practices of vernacular
photography are emerging.

> The snapshot camera, which was introduced by Kodak in 1883, is an
> old portable medium that allows users to record personal experiences.
> The camera makes it possible for anyone to visualize his or her being

in the moment, thus pursuing democratized aesthetics. However, these possibilities were not fully explored, as snapshot practices were institutionalized mostly as constituents of family rituals and tourism. (Lee 2010: 266)

Photography is already a common cultural practice, but with mobile phones photography becomes an even more inherent aspect of everyday life (Lee 2010; Van House 2011). The number of mobile phones in use in 2011 was well above 5 billion globally. For many of these phones the camera is an integral function that allows people the possibility of taking pictures in all sorts of situations while going about their everyday activities. Mobile camera phones give users the option of visually documenting and reflecting on their every day. There is also the option to publish and distribute images through messaging or publication via social networking, photo sharing and other websites.

Pervasive camera phones expand the genre of vernacular photography to include spontaneous and erratic photography of the everyday; the utterly mundane becomes notable, if not always memorable (consider the new genres of photographs of ordinary meals, or of completely heterogeneous points of interest). These photographic engagements have not supplanted typical motifs in snapshot photography such as the family or situations of leisure or tourism, but camera phones are used for taking more pictures of more ordinary things – a tree, the supermarket, the gym, me inside the elevator, and so on (Lee 2010).

From research into personal photography Van House (2011: 130) reports that people pursue personal photography for four primary and overlapping purposes: for memory, for creating and maintaining relationships, for self-representation and for self-expression. What do people do differently with digital technologies? Van House and colleagues report that people take pictures more frequently, and that these images are better and more varied.

Images can be made at any time, in any place, without prior planning. Digital cameras and especially camera phones support spontaneous,

opportunistic image-making and experimentation. While people still make traditional kinds of images, what is considered photo-worthy has expanded to include the everyday (Van House 2011: 127).

The finding that the mundane, the everyday, is increasingly the object of camera-phone photography is also reported in other studies. In a study of camera usage in everyday life in Japan, Okabe and Ito found that camera phones led to more pervasive photo-taking of 'interesting or unusual things in everyday life'. Mobile camera phones are used for taking photos of incidental occurrences and sightings; pictures are taken of everyday things, situations, places and people (Kato et al. 2005: 305).

Networked Mobile Devices

The internet and mobile media devices are translating photography into new media practices. Users carry a phone-cum-camera-cum-computer with them at all times, and one of the central things that the device does is to provide 'fluid, individualized connectivity' (Chun 2006: 1). Mobile devices are central entryways to the internet.

Throughout the past decade, Japanese internet use via mobile phones has been a heavy counterweight to the otherwise perceived orthodoxy of stationary computer use, based upon desktop immersive engagements. Mobile devices in Japanese everyday life show patterns of use that are now also increasingly common in the US and Europe, namely internet access as ubiquity, portability and lightweight engagement (Ito 2005: 6). Japanese mobile internet use is the highest in the world with more than 88 per cent of adults owning a mobile phone and 97 per cent of those being phones with access at least to 3G internet (Shimoda 2011). As of February 2012, 46 per cent of American adults were smartphone owners; the same figure applies to the UK, which is the EU country with the highest rate per capita of smartphones, followed in second place by Spain's 45 per cent (Smith 2012). A tangible example of the growing importance of mobile digital

culture in the US and Europe is that in the spring of 2012 it was reported that it is now more common for Facebook users to access their accounts via mobile devices than on stationary computers. The growing orientation towards mobile hand-held devices as central entryways to the internet is also causing a shift in investment in digital services towards mobile-based services.

So cameras are no longer cameras. They are hybrid, morphing, multi-functional devices. And they are not just devices. They are internet-capable assemblages. At the heart of mobile media lies the interoperability of global networks, physical infrastructures of cabling, production and management facilities, server farms and satellites, and the standards upon which interoperability is established – agreements over data and transmission formats, regulation of patents, intellectual property and access to bandwidth. The mobile media device is, relationally, a sociotechnical assemblage (Van House 2011). And increasingly the visual is offered as a key component: pictures, moving and still, increasingly accompany every function. The camera has become a protean and invasive network. Its images are pervasive, viral, sticking to everything, propagating everywhere. Photography has broken free from the networks of old snapshot photography (one of the features of the everyday in the twentieth century) where 'easy' picture-taking depended upon infrastructures of manufacture and supply (cameras, film, chemicals), processing, distribution, standards of chemistry and format (35mm, Kodachrome, APS, and so on). Much of the value of photography now lies in instantaneous linkage – and the more heterogeneous connections the better.

> The photographic image is no longer a printed image, it is much more likely to be seen on a screen than on paper. Images can be easily shared and disseminated via the web, which has superseded the traditional modes of presentation and publication. They can be tagged and commented on and archived for prosperity. Photography has never been so instantaneous or so disposable, one click to capture and another to delete (Vickers 2006:9).

Photography carried out with mobile devices is one of various interrelated forms of multimedia communication. The device has the capability to interact with various modes of communication such as images, text and sound (Okada 2005: 47). At the heart of the digital is fungibility: the ability to transform and morph from one form into another while retaining the fidelity of an original. Fungibility makes the original multiple. The choreography of previously diverse and discrete materials (image, text, sound, video) through the digital realm inevitably breaks down the structural properties of what have been commonly referred to as 'media'. The term medium has usually referred to an institutional agency of communication, such as TV, or the materials and methods used in the production of an artwork, such as oil on canvas. Media have typically been seen as formalized methods for conveying specific kinds of information to specific participants, involving issues of control and negotiation, for example in relation to institutional control of technologies. This is changing (Jenkins 2006).

Media as Modes of Engagement

Fungibility, the fluid manner in which visual material, for example, is turned into animation, photographic print, video, online album, blog, and so on, means that material form is less and less important in defining the 'medium' of the product generated. Instead, and in celebration of Roland Barthes's notion of the 'death of the author', the way in which a reader or viewer is engaged by those agencies that distribute cultural works, and the specific ways, occasions and sites in which authors/makers engage their audience, is increasingly a significant factor in any attempt to mark the difference between given works. Hence we propose that the notion of the mode of engagement offers a more accurate and useful way to categorize the format and placement of cultural works in the public or private arena. Crucially, these formats are not driven so much by subject matter or discipline (one concern of academic discourse), nor are they driven by the material or form

(one concern of art's discourse), but rather by an interface or hybridization of distributing institutions, individuals, families and social or professional groupings, as we have illustrated with our two anecdotal examples. Media are now so evidently about socio-cultural groups making themselves via things/interactions/information transfers. As the revenue problems of the traditional media industries like journalism and film show, media are now less material/technological forms or forms of discourse (TV, publishing, films, the music industry). Media are not 'media' per se – coming between, mediating units that are given, a posteriori, primacy – but are intimate aspects of the fabrication of the social and cultural.

Consider the many modes of engagement with a digital image: projected onto a large screen in a lecture theatre and viewed together by a large audience of enthusiasts for its subject matter, printed in a photo album and shared in the family kitchen, viewed absent-mindedly from a car on a billboard alongside a highway, scrutinized on the high-resolution screen of a mobile phone held in the palm of one's hand as one walks a pet dog. An oil painting viewed upon a wall may well have been copied as an engraving or a photograph and subjected to different modes of engagement, for example in a book, but what now is different is the ease of translation from one type of engagement to another. The exact same (original) digital image file is shared among all the experiences that are otherwise very different in their location, circumstances and rhetoric.

Mobile media are part of this new landscape of digital media production, dissemination, consumption and discarding. Mobile phones form part of a new internet- and network-based, decentralized media reality, where the internet is both a central repository for known cultural forms (Miller 2010:14) and a constituent feature in new forms. One central aspect of this new media reality is that the production of media content (images, stories, and such) is dispersed. Centralized media production and transmission is being supplemented by user-driven media production and distribution, where the role of the user is to choose, produce and alter content as well as to consume it (Jensen 2000:49).

A pertinent and major example here is that of journalism. From the point of view of news corporations, reporting is in crisis because people with mobile devices at the location of a news event can share that event, offering access, presence, a sense of authenticity, long before a professional reporter gets to the scene (consider the rationale behind CNN's new distributed news service 'Open Stories': <http://ireport.cnn.com/open-stories. jspa>; consider the range of debate evidenced by a simple Google search on 'journalism in crisis'). The ongoing manifestation of a news event has come to take precedence over a scripted and polished report, as the CNN initiative has indicated. Twitter, for example, is often the quickest place to find first-hand news directly from the event as it happens. The result is that media companies cannot maintain journalism in the way they once did and have lost their monopoly on broadcasting stories about the everyday. Instead, savvy newspapers and news agencies have turned to offering features analysis and the *curation* of news – organizing, packaging and presenting aggregates or assemblages of ongoing documentation. Again process – mediated experience of newsworthy events, real-time accounts of being there and witnessing – is taking precedence over media product, the news story. A central feature of digital media is this interactive, distributed and dynamic character.

Processes of Photography

Digital media are processual, time-based media; they and their users are in continual flux. This implies that they are manifestations of flows of experience and conversation. The way in which photography is carried out as new media practice invites us to shift our understanding of photography from the image – the cleaned-up reality of the mise-en-scène, the picture-perfect moment arrested for memory (Shanks 1997) – and consider photography as unfolding in the present, as a continuous process of looking. This takes us from the object, the document, towards event and processes

of documentation; it takes us from the image to the voyaging and deflective character of looking.

> In general, the bearer of the look, in traditional philosophy, does not move: it sits down to look, through a window at the blossoming tree: a statue posed on affirmations and theses. But we see things rarely in a condition of arrest, our ecological niche incorporates innumerable movements […] The earth turns, our global position of vigil lost its stability long ago; even the sun, the giver of light, is in motion, en route to some other part of the universe. (Serres 2008: 304)

According to Serres, vision is disparate, deflective in character. It is on the move, occurring almost in a haphazard manner, again and again, as flickers of intensity, sensing, seeing, moving to and fro, displacing. Vision is intimately related to the changeable (Connor 1999; Serres 2008); it is dialogical, in conversational flux, in oscillation between registering and moving on. We may connect this insight to pervasive mobile media photography: while each image is an act of marking out something as notable, what is most striking is not so much the singular image, but rather the stream of images, the continuous process of documentation.

Photography as Temporal, Archaeological Engagement

Photography as process of documentation bears relations to archaeology. In excavating a ruined site, the archaeologist does not discover the past, but mediates between the past and the present. The archaeologist establishes connections with what remains of what was, works on those remains, conserving, identifying, recording, displacing them into an archive or collection, transforming them into an account, a narrative, a museum exhibition. In searching through the ruins and everyday garbage of the past, anything, literally anything, might be of interest, significant as information, as evidence.

This is a forensic attitude and relates to proof in a manner that is parallel to criminal investigation – at a crime scene anything might be relevant (Shanks 2012a). Anything could matter; the key to a case may be an otherwise over-looked fragment or trace. The archaeologist scans a site looking to collect things that might matter. Everyday mundanity is charged with potential.

The homology between archaeology and photography concerns time, duration, materiality, memory and displacement (Olivier 2011; Shanks 2012a). The ruin, the archaeological find, the photographic image bears testimony to the past in the present. Materially, the past does not exist as a sequence of events, and never did. Archaeologists never encounter time as flow or sequence. Ontologically the past is all around us, mingling, merging, decaying, disappearing in the present. The past does not exist as a sequence in any consistent or coherent sense or indeed as past substance, but as inter-mingling remains that persist through time by virtue of qualities of durability. Every object, every site, every place contains vestiges of its history, because the past, in its materiality, hangs on. Not everything does: some things are more durable than others, or can be made more durable. Duration is one aspect of this archaeological temporality. The other is actuality: the conjunction of past/present at the site of encounter and the recovery of (the remains of) the past, in working on the past-in-the-present, just as memory is not a coherent account of the past but a process of discrete iterative acts of recollection – present moments prompting connections with something that remains.

So photography is part of a particular nexus of modern and post-modern engagements that make up memory practices, archaeology included. These articulations of past and present through moments of encounter and capture create an archive of lapidary material forms (even when they are digitally bitmapped silicon). Photos are taken and displaced into collection. However mundane the image is, it bears testimony to a past, a temporally located moment of capture. With digital photography the Web has become a vast archaeological archive that begs acts of reconnection, in a Google search, in tagging someone on Facebook, in posting favourites on Flickr. Images are potential evidence witnessing the past.

Photography as Spatial, Geographical Engagement

Photography is a spatial engagement: the 'camera' is a room. We can note its origin in antiquity – a small aperture in a temple wall projected an image of the outside world, upside down, onto the wall opposite: this is the camera obscura. Renaissance optics added a lens to the window or aperture on the world and shrunk the room to a wooden box. Modern photography added a means of fixing the projected image, but the architectural arrangement remains the core of photography.

The miniature 35-mm camera of the twentieth century and fast image capture through improved film emulsions freed up capture to take on more of a nervous scanning character than had been possible with larger-format tripod- and studio-based arrangements: the camera went out into the world. And this journey continues with the new dimension of geo-tagging images, making it an option to view images sorted by location, instead of in the conventional camera-roll mode of temporal organization. There are variations in the relationships of viewer, window, viewed subject and room, but the spatial, architectural and geographical dimensions of photography remain central.

The act of photography is a spatial practice – and photography is a way of experiencing a physical environment, place and location. With reference to spatial theory across philosophy, anthropology and geography, Sarah Pink (2011: 93) argues that the making, collecting and sharing of photographs may be seen as a way of perceiving and experiencing place:

If we can, following Ingold (2000), take the idea as a starting point that we are moving perceiving beings, then the experience of place can be seen as the experience of moving through and participating in an environment. The taking, manipulation and viewing of amateur photographs is part of this perceptual and experiential activity.

Viewed in this way, photography is an experiential and perceptual activity. Making images of rubbish and instantaneously publishing them in a digital

depository, as in 'My American Plasticscape', is a way of perceiving, experiencing and reflecting on an everyday situation in a specific kind of physical, social and cultural environment. The making and immediate publishing of images is a way of experiencing and enacting a place – although place here is not characterized by the specifics of locality, but is rather about the remains of mobility. Making and publishing images is a hybrid spatial and experiential encounter in which the social and cultural is both fabricated and reflected upon.

Documentation, Territory, Commodity and the Power of the Vernacular

Networked mobile media photography may be seen as ongoing microprocesses of documentation and territorialization. Everything, every moment, every location is registered. Temporal registration goes on as photography is used to document even mundane moments, situations, objects, meals, traces of meals as memorable in one way or other. This propensity to document becomes an aspect of experiencing. The same applies to location: every location is worth registration, and with georeferenced images and Web-based services like Google Earth it seems that not only is photographic documentation carried out as incessant flickers in every moment, but it is also – at least in principle – extended to every nook and cranny of the earth. This may be seen as the ultimate Enlightenment project: the categorization of everything, both spatially and temporally, is within reach. We can now truly say that we can see everything, we know everything; information is ubiquitous.

Vernacular Expression and Financial Interest

There is an interesting intersection between vernacular creativity and the politico-economical aspects of this media-domesticated reality. On the one

hand, the digital is precipitating shifts in the balance of access to authorship and dissemination or publication. Howard Rheingold (2002) notes the rise of smart mobs, and Clay Shirky (2009, 2011) notes how crowd-sourcing and collaborative authoring unleash the extraordinary creative potential of cognitive surplus, while lawyer Lawrence Lessig (2002, 2005) has pioneered new instruments for managing copyright and intellectual-property rights so as to avoid their monopolization by wealthy corporations and institutions. At the core of these shifts is the quotidian – the creative constitution of the structures of contemporary society and culture in ordinary everyday practice. The concept of the vernacular captures well what is at stake. The vernacular, etymologically, is the world of the *verna*, the household slave. The term immediately, though implicitly, refers us to agency, dominance and subordinance in access to means of speaking, authoring, building and sharing. Public and private are (again) matters of dispute as Web-based media offer stages for self-expression, while the information generated achieves astronomical capital value, as in the example of Instagram, with which we began this paper.

Information generated in vernacular digital engagements is transferable between parties. In other words, it can be sold. A lot of social media are free to the user, and this raises the question of how these media firms can make money. Their central asset is the personal data of millions and millions of users (Fannin 2012). And *personal data* is not just a record of sites visited through clicks and searches, but also location-referenced photos as well as video and audio recordings. The millions of images that are created in mobile media practices are the documented memories, localities, likes and preoccupations of millions of people. Mobile media devices know where they are to within a few metres; locational information is a key component of many of their functions, whether that is simply to offer maps of immediate and distant vicinity, a review of the restaurant across the road or notification that a friend is around the corner. Each image is now typically georeferenced. Every bit of digital information on the World Wide Web can be mapped back to the user: to who you are, what you are interested in, who your friends

and acquaintances are, where you are, who and what is around you, where you have been and where you plan to go. This raises central and complex privacy issues: who has the right to this kind of information and what may it be used for? (Davis 2012)

Vernacular photography thus constitutes an intersection between personal experience – where mobile media are used for self-expression, self-representation, memory and relationship creation – and corporate financial interest where the images that are the output of personal photography may be used as trading stock. All of this is embedded in the assemblage that is the Instagram snapshot of an evening's restaurant dinner, which looks as if it were taken on outdated film stock by a 60s plastic toy camera and posted on a Facebook account for all to see in celebration of personal style, purchasing power and zip code. Or in the georeferenced, instantly uploaded blog post that bears witness to a plastic cup piled on top of a Palo Alto garbage can that is already filled to the point of nausea.

BIBLIOGRAPHY

Adams, P.C. (2010), 'A taxonomy for communication geography', *Progress in Human Geography*, 35(1): 37–57.

Bjerre, H.J., and Fabian, L. (2010) (eds), 'Vendingen mod rummet', *Slagmark*, 57.

Chun, W.H.K., and Keenan, T. (2006) (eds), *New Media, Old Media: A History and Theory Reader*, New York: Taylor & Francis.

Connor, S. (1999), 'Michel Serres's five senses', [online], <http://www.stevenconnor.com/5senses.htm>, accessed on 21 June 2012.

Davis, M. (2012), 'Rethinking personal data for mobile social media', [online], <vimeo.com/42516383>, accessed on 29 June 2012.

Falkheimer, J., and Jansson, A. (2006), *Geographies of Communication: The Spatial Turn in Media Studies*, Göteborg: Nordicom.

Fannin, T. (2012), 'Social media – …if it's free, you're the product', [online], <http://bebranded.wordpress.com/2012/02/21/social-media-if-its-free-youre-the product/>, accessed on 29 June 2012.

Ingold, T. (2000), *The Perception of the Environment*, London: Routledge.

Ito, M. (2005), 'Introduction: personal, portable, pedestrian', in Ito, M., Okabe, D., and Matsuda, M. (2005) (eds), *Personal, Portable, Pedestrian: Mobile Phones in Japanese Life*, Cambridge, MA, and London: MIT Press.

Jenkins, H. (2006), *Convergence Culture: Where Old and New Media Collide*, New York and London: New York University Press.

Jensen, J.F. (2000), 'Medielandskabet post mediasaurus? Udfordringer til medieforskningen efter massemedierne', *MedieKultur*, 16(31): 47–65.

Kato, F., Okabe, D., Ito, M., and Uemoto, R. (2005) (eds), 'Uses and possibilities of the keitai camera', in Ito, M., Okabe, D., and Matsuda, M. (2005) (eds), *Personal, Portable, Pedestrian: Mobile Phones in Japanese Life*, Cambridge, MA, and London: MIT Press.

Lee, D.-H. (2010), 'Digital cameras, personal photography and the reconfiguration of spatial experiences', *The Information Society: An International Journal*, 26(4): 266–75.

Lessig, L. (2002), *The Future of Ideas: The Fate of the Commons in a Connected World*, New York: Random House.

—— (2005), *Free Culture: The Nature and Future of Creativity*, New York: Penguin.

Miller, V. (2011), *Understanding Digital Culture*, Los Angeles: SAGE.

Okada, T. (2005), 'Youth culture and the shaping of Japanese mobile media', in Ito, M., Okabe, D., and Matsuda, M. (2005) (eds), *Personal, Portable, Pedestrian: Mobile Phones in Japanese Life*, Cambridge, MA, and London: MIT Press.

Olivier, L. (2011), *The Dark Abyss of Time: Archaeology and Memory*, Lanham, MD: AltaMira Press.

Pink, S. (2011), 'Amateur photographic practice, collective representation and the constitution of place', *Visual Studies*, 26(2): 92–101.

Rheingold, H. (2002), *Smart Mobs: The Next Social Revolution*, Cambridge, MA: Perseus.

Serres, M. (2008; originally published 1985), *The Five Senses: A Philosophy of Mingled Bodies*, London and New York: Continuum.

Shanks, M. (1997), 'Photography and archaeology', in Molyneaux, B.L. (ed.), *The Cultural Life of Images: Visual Representation in Archaeology*, London: Routledge.

—— (2012a), *The Archaeological Imagination*, Walnut Creek, CA: Left Coast Press.

—— (2012b), 'Awesomized', [online], <http://www.archaeographer.com/>, accessed on 1 July 2012.

Shimoda, S. (2011), 'The big thing in Japan: mobile SNS and games', 7 October, [online], <http://www.clickz.com/clickz/column/2281731/the-big-thing-in-japan-mobile-sns-and-games>, accessed on 8 August 2013.

Shirky, C. (2008), *Here Comes Everybody: The Power of Organizing without Organizations*, New York: Penguin.

—— (2010), *Cognitive Surplus: Creativity and Generosity in a Connected Age*, New York and London: Penguin.

Smith, A. (2012), 'Nearly half of American adults are smartphone owners', Pew Internet & American Life Project, 1 March 2012, [online], <http://pewinternet.org/Reports/2012/Smartphone-Update-2012/Findings.aspx>, accessed on 21 June 2012.

Svabo, C. (2012), 'My American plasticscape', [online], <http://plasticscapes.wordpress.com/>, accessed on 1 July 2012.

Thielmann, T. (2010), 'Locative media and mediated localities: an introduction to media geography', *Aether: The Journal of Media Geography*, 5: 1–17, [online], <http://130.166.124.2/~aether/pdf/volume_05a/introduction.pdf>, accessed on 21 June 2012.

Van House, N. (2011), 'Personal photography, digital technologies, and the uses of the visual', *Visual Studies*, 25(1): 125–34.

Vickers, R. (2006), 'Photography as new media: from the camera obscura to the camera phone', 4th International Symposium of Interactive Media Design, Yeditepe University, Istanbul, Turkey, April 2006, [online], <http://newmedia.yeditepe.edu.tr/pdfs/isimd_06/26.pdf>, accessed on 13 April 2012.

INDEX